THE DREAM OF ICARUS

THE DREAM OF ICARUS

Kenneth Coutts-Smith

HUTCHINSON OF LONDON

HUTCHINSON & CO (Publishers) LTD
178–202 Great Portland Street, London W1

London Melbourne Sydney Auckland
Bombay Toronto Johannesburg New York

First published 1970

This book has been set in Garamond, printed in Great Britain
on Antique Wove paper by W. Heffer & Sons Ltd., Cambridge, and
bound by Wm. Brendon, Tiptree, Essex

09 099790 5

Contents

1 'Is creation possible? Is the revolution possible?' 1

2 'All students are bolshie . . .' 9

3 '. . . for the individual termite, the greatest freedom is the termitary' 15

4 'Who are the real conspirators, us or them?' 25

5 'The causes of alienation can be many' 36

6 'Theatre takes place all the time, wherever one is' 48

7 'Existence is . . . that which actualizes Essence' 55

8 'It serves us right if we are given only what we ask for, the motley wrappings rather than the concrete core' 65

9 'Anything really new is repulsive, because it is abnormal and unreasonable' 75

10 'Nature imitates life' 84

11 'The world consists of "to-whom-it-may-concern" messages' 90

12 'Man became man through tools' 98

13 'The painter is the bearer of a kind of singular and tragic grace, the grace of The Unconditional' 110

14 'The antipodes of the mind . . .' 121

15 'I am ruled by external circumstances which appear to offer little scope for freedom. The freedom of imagination *is* available to me through the medium of art' 130

16 'One cannot speak about mystery, one must be
seized by it' 139

17 'Science has become as true a stuff of poetry as were
the wanderings of Odysseus and the tragedies of the
House of Atreus' 147

18 'Together we shall voyage towards the stars' 155

19 'The very conceptions of twentieth century science are
finding expression in modern abstract art' 165

20 'Intuition should be regarded as a marginal bonus, a
mytserious sharpening of the senses' 174

21 '. . . (a) conception of non-terrestrial space' 180

22 '. . . the media landscape' 187

23 'the appearance of movement in art accompanies the
modern adventure that has enabled us to become
aware of essential forces formerly invisible' 196

24 '. . . in a decaying society, art, if it is to be truthful,
must also reflect decay' 205

Illustrations

Between pages 36 *and* 37

Riot police, Paris, May 1968 (*Photo Topix*)

Poster, Hornsey College of Art, July 1968 (*Photo Topix*)

Joe Tilson, *Transparency, Che Guevara*, 1968, a screenprint on acrylic and cellulose on wood relief, 12″ × 12″ × 1″ (*Courtesy Marlborough Fine Arts*)

Sit-in at the London School of Economics 'poster shop,' October 1968 (*Photo Topix*)

Hippie Festival at Woburn Abbey, August 1967 (*Photo Topix*)

Members of the Apocrypha Chapter of the Hells Angels (*Photo Topix*)

Drag Car racing at Poddington, Northants, August 1966 (*Photo Topix*)

Peter Phillips, *Motorpsycho-Tiger*, 1961–2, oil on canvas and board, 81″ × 60″ (*Courtesy I.C.A.*)

Jean-Jacques Lebel, Happening, *Les 120 minutes dedicées au Divin Marquis*, Paris 1966, (Cynthia, the Hermaphrodite Nun, being showered with sugar-cubes) (*Courtesy the artist*)

Robert Rauschenberg, *Wall Street*, 1961, mixed media, 158 × 195 cm. (*Courtesy Mme. Ileana Sonnabend*)

Jean-Jacques Lebel, Happening, *Funeral of Tinguely Machine before its burial in the Grand Canal*, Venice 1961 (*Courtesy the artist. Photo Horace Dimayo*)

Jean Tinguely, *Metamatic* (painting machine), 1961, welded rubber and steel, 22″ × 30″ × 15″ (*Courtesy I.C.A. Photo Cameraphoto-Venice*)

John Latham, *Chambers Encyclopaedias over London*, 1966 (*Courtesy the artist. Photo Michael Broome*)

John Latham, *Omniscientist*, 1963, construction, wood, books, paint, canvas (*Courtesy Kasmin Gallery. Photo Cooper*)

Wolf Vostell, *Les Defilies—ils le rendient anxieux mais il ne pouvait s'en passer*, Dé-collage 1964 (*Courtesy the artist*)

Yves Klein, *Empreinte ANT* 74, (nude imprint), 1960, 150 × 228 cm (*Courtesy I.C.A.*)

Aubertin, *Fire Object*, aliminium and matches (*Courtesy The New Vision Centre. Photo Peeters*)

Between pages 84 *and* 85

Constant, *Concert Hall for Electronic Music* ('*New Babylon*'), maquette, 1961 (*Courtesy The New Vision Centre. Photo Peeters*)

Briget Riley, *Blaze L*, 1962, emulsion on board, 43" × 43" (*Courtesy the artist. Photo Brompton Studies*)

Dan Flavin, *Installation*, 1964, fluorescent light (*Courtesy Kornblee Gallery. Photo Rudloph Burkhardt*)

Don Judd, *Untitled*, 1965, galvanized iron, 108" × 40" × 31" (*Collection Henry Geldzahler, New York, courtesy Walker Art Centre*)

Philip King, *Tra*, 1965 (*Courtesy Rowan Gallery. Photo Feruzzi*)

Ennio Morlotti, *Paesaggio Ligure* 1966, oil on canvas (*Courtesy Galleria Odyssia. Photo Foto-techniche*)

Australian Aboriginal Bark Painting, 48" × 48" (*Collection Rex Rienits, Courtesy Zwemmer Galleries*)

Hans Bellmer, *La Poupée*, 1965, painted aluminium 19½" high (*Courtesy I.C.A.*)

Jerzy Kujawski, *Evocation* 1967, mixed media on canvas, 25" × 19" (*Courtesy Grabowski Gallery*)

Ivan Stepán, *Une Raison Objective* (*object* 92), 1966 (*Courtesy Manes Society, Prague. Photo R. Kedro*)

Wolf Vostell, *Melting Dé-Collage*, New York Environment, 1963 (*Courtesy the artist. Photo Peter Moore*)

Ernst Fuchs, *Delila mit den Dagon*, 1963, etching (*Courtesy Walton Gallery*)

Henri Michaux, *Painting with Chinese ink* (mescaline painting), 1965, 75 × 110 cm (*Courtesy Le Point Cardinal. Photo Jacqueline Hyde*)

Light Projection experiment at Hornsey College of Art 'Sound-Light' workshop (*Courtesy Clive Latimer. Photo Mike Leonana*)

Guy Harloff, *Le Philosophe . . . (which way?)*, 1968, gouache (*Courtesy the artist*)

Jain Painting, *Mandala* (*psycocomogram*), painting on cloth, Gurjrat 19th C, 75 × 75 cm (*Courtesy Gimpel Fils*)

Between pages 164 *and* 165

Laurence Burt, *Machine A.D.* 1965 (*Depopulation of the world and the degradation of man*), 1965, bronze, iron and wood, 64" × 36" × 30" (*Courtesy Drian Galleries. Collection, Welsh Arts Council*)

Mervyn Baldwin, *Column Fallen under its Stone*, 1968, plaster for polyester-fibreglass, 11″ high (*Courtesy Grabowski Gallery*)

Terry Setch, *Four in One*, 1965, anodized aluminium, plastics, ceramic, and brass (*Courtesy Grabowski Gallery*)

Roland Piché, *Deposition*, 1965, a glassfibre and steel, 88″ × 60″ (*Courtesy Marlborough Fine Arts. Photo Hylton Warner*)

Barry Flanagan, *Four Casb*, 1967, sand and canvas, 90″ × 102″ × 102″ (*Courtesy Rowan Gallery, Photo Errol Jackson*)

The first "Electrical" flying machine from la Folie, *Le Philosophe sans Pretention* (*Courtesy the National Science Museum*)

Francesco Lana's flying machine, from Bernard Zamagna, *Navis Aeria* (*Courtesy the National Science Museum*)

Matta, *Untitled*, 1963, oil on canvas, $57\frac{1}{2}″ \times 51″$ (*Courtesy Robert Fraser Gallery. Photo Robert David*)

Colin Self, *Nuclear Victim*, 1966, mixed media, $67\frac{1}{2}″ \times 27″ \times 12″$ (*Courtesy I.C.A.*)

David Medalla, *Cloud Canyons*, 1964, machinery, foam, water (*Courtesy Signals Gallery. Photo Clay Perry*)

Iris Time, (No. 11), bulletin of the Iris Clert Gallery (*Courtesy Iris Clert Gallery*)

Gerald Gladstone, maquette for welded steel construction 1964, wood (*Courtesy Hamilton Gallery. Photo John Reeves*)

Van Hoeydonck, *Antiveys*, 1964, plastic, emulsion, board (*Courtesy the artist*)

Between pages 212 and 213

Denis Bowen, *Zond four*, 1968, oil on canvas, 36″ × 24″ (*Courtesy the artist. Photo Clay Perry*)

Richard Hamilton (*Courtesy Tate Gallery. Photo Richard Hamilton*)

Phillipe Weichberger, *Untitled*, 1961, oil, on canvas, 81 × 100 cm (*Courtesy Drian Galleries*)

The first photograph of the decay of a V-particle in a cloud chamber (Rochester and Butler) (*Courtesy the National Science Museum*)

Gianni Secomandi, *Untitled*, 1964, mirror, cold-cast metal and emulsion on board, 40″ × 36″ (*Courtesy New Vision Centre. Photo Markiewicz*)

Edouardo Paolozzi, *A Page from General Dynamic F.U.N.*, 1968, silkscreen (*Courtesy Alecto Gallery. Photo Deste*)

Nicholas Schoeffer, *CYSP*, 1956, metal, machinery, photoelectric cells (*Courtesy I.C.A.*)

Georg Ness, *Corridor*, cybernetic drawing, programme written in Algol, run on a Siemmer 2002 computer and plotted with a Zuse-Graphomat, 1968 (*Courtesy I.C.A.*)

Jules de Goede, *On its Way*, 1968–9, acrylic on shaped canvas, 50″ × 50″ (*Courtesy Grabowski Gallery*)

Eddie Wolfram, *Booster*, 1964, P.V.A., crylla and polythene on canvas, 60″ × 60″ (*Courtesy the artist. Photo Markiewicz*)

Klaus Geissler, *L'Envontement*, 1963, space chamber, welded iron, 57″ × 27″ (*Courtesy Hanover Gallery*) Exterior view.

Klaus Geissler, *L'Envontement:* Interior view. 'Head' seen through 'porthole'.

Bruce Lacey, *Rosa Bosom*, (R.O.S.A.—Radio operated simulated actress), 1965, electronic parts, aluminium, batteries, motors etc., 24″ × 36″ × 72″ (*Courtesy I.C.A.*)

Takis, *Telephota I*, 1961, electronic parts, magnets, mercury vapour lamp etc. (*Courtesy the artist*)

Lilian Lijn, *Continuum*, 1965, perspex, water, lamp etc. (detail) (*Courtesy the artist*)

Werner Schreib, *Semantic Painting*, 1965, resins and mixed media (detail) (*Courtesy the artist*)

'Out of chaos we make a world, a consequence of art, which in return reveals our proper structure to us.'

OZENFANT

In the 1940s intellectuals used to talk about a 'crisis of conscience'. This was more than a question of moral values, it was also a crisis about the role of intelligence and imagination, a crisis of interior values. Today, there seems to be a crisis of *exterior* values. A crisis of objectivity. This crisis of objectivity seems to ask questions as to what art is all about at the present time. What, exactly, is the function we demand of it? What do we hope of it, what are the emotions we invest in it?

Art is the objectification of the *real*. But what, as Antonioni demands in his film *Blow Up*, is the real in our society? Can it be, one sometimes wonders, that the content of art has now become an invisible tennis ball? The subject matter of art seems now frequently to be art itself. What we appear to have before us is something that is rapidly becoming a closed system, a repetitive structure of parallel mirrors, where images are made about other images. The current closed-circuit feedback system has not only obliterated the frontiers between the 'popular' arts of mass-media and the fine arts, but it has also obscured the frontiers between art and 'life'.

As art becomes synthetic (often deliberately and consciously so) it is life and reality which fall the casualties. The current fashion of withdrawal, the lowering of emotional temperature, the ethic of 'keeping your cool', tends to strip the objective world of meaning; things are demystified. It may well be that this is a logical defence in the face of increasing social pressures in a technological society, but it could also be a specific aspect of these very social pressures. It is, however, a suggestion worth considering that, while the function of art from the middle of the nineteenth century until recently was essentially visionary in nature (exploring uncharted areas of sensibility, extending emotional experience), a great deal of art today would appear to have taken the opposite role; it is essentially defensive, even to the extent of erecting barriers between the individual and the world.

Is the basic nature of the function of art in our society undergoing a change, or are recent shifts in perspective and intention

part of larger upheavals? The fact that art is frequently considered and discussed as a hermetic self-enclosed activity does not help to make it easy to answer this question, and in talking about the 'relationship' between art and society we find ourselves in some difficulties for to regard them as two entirely separate functions is analogous to examining two separate effects, believing one of them to be a cause. There is, and always has been an active process between the two, each conditions and exerts pressure upon the other. Nevertheless, as we shall see, the tendency to regard art as a specialised and self-enclosed activity is itself significant, and reveals important attitudes and conditions imposed upon the role of art.

The Beaux Arts approach to the artist's activity appears to be discredited largely in central or 'mainstream' areas of the art-scene and in art-education. The concept of art being one way among others for the individual to come to terms with the human condition is less generally held than one in which art assumes an aesthetic public-taste function; the individual painter being awarded a sort of shamanistic role responsible for the aesthetic well-being of the community, rather as the doctor or the priest has been imposed with similar roles in the past in terms of medical or spiritual health and 'correctness' of attitude. The painter has become less someone who acts in a certain way than someone who represents a point of view; and as with other sectors of our contemporary society there are signs of emergent consensus and totalitarian aspects in the art-scene.

From the beginning of the Romantic Movement in the nineteenth century, the artist assumed the heroic stance of *The Outsider*, a specific anti-bourgeois and anti-authoritarian position, extending even to opposition to deity, universe and the natural order itself. In terms of the fine arts this is a tradition that is generally thought to have begun just before Delacroix and to have endured up until the Surrealists; we shall see that this is still very much an active tradition in certain areas, though by and large outside of the mainstream. Since the revolution in art during the first decades of this

century, however, the artist has been very sensible of his alienation from society, and along with the development of the technological environment has progressively attempted to abandon his private and insurgent role in favour of one that was more meaningful within the community and as we shall later discuss, this may well have been a retrograde step.

Quite naturally, in the face of the romantic artist's earlier inherent iconoclasm, the bourgeoisie have wished to have little to do with him. They defended themselves, as it were, and especially in the Anglo-Saxon countries, by displaying apathy towards the arts; philistinism was perhaps a form of social armour. By proxy of the spectrum stretching from Ruskin to Sunday Supplement Magazines the artist campaigned for his acceptance by the educated and middle classes, art-education developed theories and directed action towards the discovery and exploiting of a role for the artist in industrial society. The battle which the Bauhaus and others have so closely fought during the immediate past has today been largely won, but it might be said to be something of a Pyrrhic victory.

Nevertheless, whatever the relationship between the individual artist and his social environment, his work can not in any way be divorced from attitudes and ideas held by the group. The notion (held by individuals who sentimentalize the 'genius') that the artist is 'before his time' is nonsense, the creative personality is very much immersed in his own epoch. He is 'visionary' or 'prophetic' only in that he sees deeper; his instinct and sensibility is closer to the pulse of actuality, if you like, and it is the bourgeoisie by and large who are dragging their feet in history. Art itself is one visible aspect of society, one way in which its preoccupations and fantasies are objectified. But like fantasies in the psychiatric sense, they not only reveal the hidden currents, they also act as signposts for subsequent action and tend to condition the future. In as much as this is true, art must be regarded as Utopian in nature; and it is this premise that we shall examine in the following pages.

'The revolution and the art of the twentieth century', says Albert Camus, 'are tributaries of the same nihilism and live in the same contradiction.' And he also says, 'In art, rebellion is consummated and perpetuated in the act of real creation, not in criticism or commentary. Revolution in its turn can only affirm itself in a civilization and not in terror or tyranny. The two questions posed, henceforth, by our times to a society caught in a dilemma—Is creation possible? Is the revolution possible?—are in reality only one question which concerns the renaissance of civilization.'[1]

Camus has here firmly linked the idea of creative art with that of revolt. The quotation is from his well-known study *The Rebel*, where he put forward the idea of rebellion as a 'fabricator of universes', of the act of dissent being a necessary ingredient of the condition of human dignity, of freedom itself.

He maintains that this is an inevitable action in any society, or at least he does not appear to be able to envisage an alternate society sufficiently ideal, sufficiently just and rewarding, to preclude its necessity. It seems a somewhat depressing thought that he may well be right, but for reasons that appear to be more central to human behaviour than the essentially social pressures he discussed. Since Camus died, there has developed a body of thought which holds that aggression is an extremely important instinct necessary to the biological survival of the human individual; in this context one only has to mention the work and conclusions of Konrad Lorenz and Robert Ardrey.

It rather looks as if the sublimation of violence in social activities, particularly as these are becoming more and more circumscribed in a progressively centralized and controlled society, is liable to develop intolerable pressures which must break out in one way or another. Warfare, under the ultimate menace of nuclear weapons, is now no longer a socially approved-of safety valve for the group aggressions of a community. Yet military conflicts of one sort or another continue to savage various parts of the globe; but these struggles are no longer the ritualistic and

emotional territorial disputes of the past. They are ideological in nature, and offer no scope for social catharsis. The communal anguish of divided motivation produced by such a situation is only too clear in America's current involvement in Vietnam.

Whether or not we must come to accept that violence is endemic to human nature, an idea from which we can draw little comfort for the future, it is perfectly clear that it *is* endemic to the current late-Capitalist society of advanced technological countries. Tensions are currently building up in these areas which are denied the traditional outlet of communal aggression provided by national conflict. In the past the frustration and alienation of individuals within a group, a factor which, indeed, due to increased mechanization and growing population seems to be developing in some sort of geometric curve, could be dissipated by occasional bursts of group-concerted activity directed towards a common end.

It is notable that in a military situation, particularly at a period of strategic reverses, a peculiar spirit seems to take hold of a community. The most frustrated and inhibited members of a group are convinced of their right to belong, class and other barriers seem temporarily to melt away, dull responsibilities and irksome duties no longer seem relevant, and a curious elation takes their place. Despite a specific looming threat, indeed because of it, everything seems possible. There is a near-millenial sense of universal brotherhood. For instance, many people who lived in London through the autumn of 1939 remember it as an oddly luminous and golden period. In retrospect it seems that no summer since has presented us with such long hot summer days, such clear blue skies, and even the barrage balloons are remembered as if they were silvery decorations off some enormous Christmas tree.

There is a common psychological reaction of elation which manifests itself in extreme situations of danger, peril or disquiet, which has been examined by, among others, Martha Wolfenstein in her essay *Disaster*.[2] One example of this, albeit on a small scale, was recently evident during the floods which hit the Home

Counties and the South of England in the summer of 1968. One popular newspaper commentator reporting the flood which put the main street of the town of Maidstone under several feet of water, remarked on the general air of gaiety, a sort of festival climate with even the hard-pressed policemen joking and smiling, and drew an apparently astonishing parallel between this and 'the Spirit of the Battle of Britain'. Incipient, indeed actual violence, seems to breed a certain solidarity which is, by and large, quickly abandoned when the threat is passed.

This solidarity is a sense of belonging to a community and to one's fellows which is forced upon individuals by actions outside their control.[3] It is of course nothing new to comment that crisis has a tendency to integrate and nullify unreasonable and selfish behaviour; social and political prophets, above all those of a millenial persuasion, have pointed this out in the past. Ideologues have also demonstrated that the artificial creation of crisis opposes the alienations built into our society, and it is clear that rebellion, apart from gesturing towards a more ideal, that is utopian, situation, also implies solidarity with one's fellow rebels.

As we shall see there is a specific order of clandestine groups in society, membership of which bring as a reward the sense of brotherhood and unity in the face of an environment that is felt to be either hostile or indifferent. This is very clear in the case of individuals who, suffering various feelings of social inadequacy, compensate by joining various esoteric groups and cults. We shall later examine some of the incredible beliefs people feel that it is necessary to defend in order to claim some sort of toe-hold in society. This is a chiliastic, that is to say, a millenial mechanism.

The Chiliasts[4] were members of a medieval sect who held that the imminent Second Coming would usher in the ideal paradisical condition when all inequalities and suffering were to be resolved. This age-old utopian tradition finds it continuance today in a spectrum ranging from the ridiculous of Flat Earth Societies and Flying Saucer Cults to the sublime of revolutionary political theory. For it is the belief of this author that these extremes are

interconnected by the same fundamental impulses. This is not in any way to place social and political revolution in the same subjective category of cultism. The two, though linked, are defined by the fact that revolution is directed towards *practical* ends, and it will become clear that the opinion of the present writer is that not only is revolution possible, but that as a more or less permanent condition it is necessary.

As far as we know, no previous parallel has been drawn between the radical political left and the radical 'art' underground. Both stem from the same roots and causes, both are groping towards the same ends and both are inter-related in the same utopian tradition. It is clear that to understand the more extreme aspects of the fine art scene today it is necessary to have a grasp of the wider political continuum of which it is part. It follows that the acceptable mainstream, what we shall define as 'official' art, is equally related to the bourgeois and capitalist system of ethics and values of Western society at large, and to be comprehended must be seen in this light.

Therefore to arrive at any conclusions regarding the current overall state of the fine arts in advanced technological countries we must first examine the self-consciously revolutionary underground of the arts. This, as we have stated, is not an isolated phenomenon, but parallels the political opposition of the 'extra-parliamentary' political left, a movement, which we have become well aware, that has been very much active in the immediate past. Indeed their recent opposition to the bureaucratic state has been so intense and has developed so quickly as to have in a certain sense overtaken the intentions of this current book. When this study was first projected, it was proposed to examine the so-called student revolt in some depth. Paris, May 1968, and subsequent events have, however, overtaken this plan; for a great many studies, both historical and speculative, have already been published on this subject. The immediate roots of grievance and the romantic and anarchist political alternatives are by now already well known. Later we shall of course examine specific

educational problems that have been raised, notably those applic-
able to art education; but for the purposes of our current argu-
ment it is necessary to briefly recapitulate the broad stream of the
popular 'intellectual' revolt.

2 'All students are bolshie . . .'

In the Spring of 1968 an extraordinary and unprecedented political event took place. A group of French students at the Nanterre annexe of Paris University, restless with certain grievances concerning their curriculum, staff-student relations, and specifically the manner in which authority tended to treat the students as less than adult, led to a revolutionary explosion that all but toppled the State.

'All students are bolshie', points out Patrick Seale and Maureen McConville in their excellent book on the Paris events, 'students of sociology are more bolshie than most. If this phenomenon is true anywhere it is true at Nanterre, where the sociology department was the nursery of the revolution. It is a discipline which, by its very nature, makes those who study it critical of any questioning about the society in which we live.'[1] The immediate roots of dissent in France are familiar; similar to those of student unrest in universities and colleges of higher learning in America, England, Germany, Japan and elsewhere. Students in most industrially developed countries are today demonstrating a growing dissatisfaction with the processes of a teaching situation which appears to be geared to 'training' rather than true education, to the concept of a 'Multiversity' which is 'a massive production of specialized excellence', to the sausage-machine in which the individual graduate is the product.

Apart from problems of curricula and questions about aims and ends of education, the fast growing student populations of the technologically advanced countries are experiencing a growing alienation with their professors, tutors and other staff members. This is, of course, partly due to the increased pressure of numbers, to overcrowded classes and lack of equipment and facilities. Staff, however, are much to blame, for a great many teachers (in some institutions the majority) have shown themselves incapable of understanding the sophistication, self-reliance, and maturity of young people today. To treat young men and women, who are often in their early twenties, as if they were sixth formers is to invite trouble.

An incident at Nanterre which received wide publicity is an example. For some time a bone of contention on the campus was the strict segregation between the residential blocks of the male and the female students. 'The climate was pretty electric', according to Seale and McConville, 'when the Minister of Youth and Sports, Francois Missoffe, came down to Nanterre to inaugurate his Ministry's pet project; the splendid new swimming pool, part of a half-million pound sports complex. He was walking into a hornets' nest. There were rumblings of outrage in his cortege when it was discovered that the *enragés* had issued tracts announcing "Vandal Orgies" at the swimming pool for the time the Minister was due to cut the tape. The Minister himself was somewhat unnerved to see obscene inscriptions scrawled on the walls of his official route, including an enormous phallus. As it happened, the ceremony was uneventful; there was no bacchanal of nymphs and satyrs. But, as the Minister was on the point of leaving, a bouncy, slouching red-head stepped from the crowd and addressed M. Missoffe in the confident, hectoring tone so soon to become familiar. Cohn-Bendit has the sort of chest which makes the microphone superfluous.

"'Mr. Minister, you've drawn up a report on French youth 600 pages long (a reference to a Ministry document which had just appeared). But there isn't a word in it about our sexual problems. Why not?"

"'I'm quite willing to discuss the matter with responsible people, but you're clearly not one of them. I myself prefer sport to sexual education. If you have sexual problems, I suggest you jump into the pool." The Minister had lost his temper.

"'That's what the Hitler Youth used to say," Cohn-Bendit retorted brazenly.'[2]

Certainly the student was discourteous, if not insolent. But in the face of such a total lack of comprehension of the student situation, in the face of such a patronizing attitude as could only confirm the suspicion on the part of youth that it is being used and manipulated, in the face of a dialogue that not only had broken

down but was totally out of kilter, clearly no alternative route was open for protest. Indeed this limited form of exchange was to be rapidly obscured, swamped in the events of four months later when the authorities of the Sorbonne, in an incredible display of panic, were to call out the riot police and be responsible for more than simply condoning the brutality and violence of armed force, and sharply demonstrating a state of near moral-bankruptcy at the core of the educational system.

Active dissatisfaction with college aims and administration was not a new thing, nor, of course, was it confined to France. Opposition to the 'education factory' had been eloquently voiced, for instance, by Brad Cleveland, a University of California under-graduate, in 1964, when he protested that '. . . the Multiversity is not an education centre, but a highly efficient industry; it produces bombs, other war machines, a few token "peaceful" machines, and an enormous number of safe, highly skilled and respectable automatons to meet the immediate needs of business and govern-ment'. The rejection of the idea that a university is a 'training' centre for skills and qualifications controlled by '. . . Regents, who run private corporations, just as the politicians who run public corporations, (and) desire highly skilled, but politically and economically *dumb* "personnel"'[3], is far from recent. As long ago as the 1940s, Paul Goodman was proselytizing for a new form of education, and it is largely from him that the idea of a 'Free University' has developed. He advocated a concept of community with both staff and students operating together in a 'learning' situation, one aimed towards a true educative process rather than the mere production of 'technological and specialized morons'. Many such experiments have been attempted, some failing lamentably for various reasons; but successes have ranged from the pioneering Black Mountain College to the more recent but brief 'soviet' at Hornsey last summer and the Berlin Commune No. 1.

Educational and internal administrative problems are not the only, indeed not the most significant, aspect of student dissidence.

Ever since the mid 1950s there has been a growing political awareness and social conscience amongst young people. Stimulated by different particulars in various countries; in America by the moral question of the Vietnam War and the oppressed negro, in Germany by the rising tide of neo-Nazism and the cynical right as exemplified by the Springer chain of newspapers, in France by the Algerian War and the autocracy of de Gaulle, extreme militants have moved to outright, if frequently naive, political conflict. It seems clear that the social and public violence endemic in our society breeds a reaction of anarchist and private violence, and that some student groups are beginning to think in terms of the nineteenth century Italian of American 'Propaganda of the Deed'.

Just before the Paris crisis, greatly influencing it and indeed providing a rallying-cry and banner for the militant core, a left wing student commando exploded plastic charges, blowing in the windows of the Paris offices of the Chase Manhattan Bank, the Bank of America, Trans World Airlines and the American Express. Countering this Vietnam activist protest, the police arrested two young men and three schoolboys on the 22nd March, all members of an extremist organization; and it was on the evening of that day the students of Nanterre, meeting to protest the arrests, staged an over-night sit-in on the campus and spontaneously formed themselves into the students' council that sparked off the May Revolution.

We have had organized social protest, of course, since the mid 1950s; movements and demonstrations, sit-ins, pickets, placards and buttons. New techniques of pressuring authority have not only been invented and developed during the last fifteen years, but they have rooted themselves into our society, become almost an accepted way of life, so much so that the staid housewives who certainly tut-tutted about the C.N.D. sit-downs a decade ago will now willingly and stoically expose themselves to discomfort and wet bottoms in order to have a street-lamp replaced, a zebra crossing resited, a traffic meter removed. The

demonstration has almost become respectable and replaced the traditional letter to *The Times*.

Yet the character of demonstrations is changing. From Ghandi, via Russell to Martin Luther King, the demonstration operated within the parliamentary fabric; it was a massive display, not of force, but of the will of the people, a manifestation of their wishes that could no longer percolate through the electoral channels to the seats of power and decision. This is changing, and possibly it was the assassination of Martin Luther King that finally soured the idea of non-violence, the murder of the Kennedys that ultimately persuaded people to accept Marcuse's contention that the liberal approach contains within itself its own inherent violence, that 'the Welfare State is a state of unfreedom'. Our attitudes are becoming more and more polarized; that much is evident in the world-wide disillusion, the unrest, cynicism and anger of men and women under thirty, all experiencing an alienation that far transcends the perennial adolescent rejection of the generation gap. And it may well be that before long we will all of us have to choose between a consenting or a radical posture.

The old forms of democratic social protest by means of pressure demonstrations within the structure of the existing order, a tradition a decade and a half old, is evolving into a militant and activist movement. The events at the Sorbonne, at Berkeley and at Hornsey, at the Universities of Berlin, of Rome and Belgrade during the summer of 1968 marked a turning point. For, the students, who were at first acting only against the enervating and suffocating bureaucratic machine of the college, met up and joined forces with the radical and political movement outside. What began as an instinctive gesture of revolt against an impersonal structure, the spawning, self-perpetuating Multiversity, has become a confrontation with society itself.

Seal and McConville's description of Nanterre, with its ugly anonymous buildings dumped down in an industrial suburban wasteland, a social vacuum inhabited by '. . . a student crowd (that is) born as dense and faceless as an industrial proletariat, with

its own grievances, its own leaders, its growing sense of power'[4], is sheer Alphaville. Resistance at first, as the English experience at Hornsey and Guildford have shown, is to depersonalization; grievances are specific ones about the faculty, about the curriculum, the working and studio facilities, the canteen and the Union. But the students one day realize that the college is a microcosm of the State itself. The enemy is not the Principal or the Board of Governors after all, but the very structure, the machine itself.

To imagine, as many do, that student revolt is a 'passing phase', one aspect of the eternal and necessary adolescent process of the individual freeing himself from paternal authority in order that he may eventually discover his own unique identity, would be very stupid indeed. It is unlikely that today's radical youth will settle for the ordered patterns of society that have been ordained for them; naturally the camp-followers will drop out if Capitalist society will offer its rewards, but a hard core, numbered on a progressively ascending graph, will remain politically alert, will not only want to change society, but will actually attempt to do so. The urge to revolt is proceeding inevitably towards the act of rebellion, the desire for reform is changing inexorably into the need for revolution.

3 '. . . for the individual termite, the greatest freedom is the termitary'

'A comfortable, smooth, reasonable democratic, unfreedom prevails in advanced industrial civilization,' says Marcuse, 'a token of technical progress. Indeed, what could be more rational than the suspension of individuality in the mechanization of socially necessary but painful performances; the concentration of individual enterprises in more effective, more productive corporations; the regulation of free competition among equally equipped economic subjects; the curtailment of prerogatives and national sovereignties which impede the internal organization of resources.'[1]

Unfreedom? One can hear the question asked. What is the nature of this 'unfreedom'? The social democrat, even the extreme reformist left wing liberal finds it difficult to accept such a contention; in such an argument he sees an extreme radical position that appears to threaten the very basis of civilized values. Is not, he argues, the parliamentary system the one that offers the best chance for reason and humanism? He feels that the 'extra-parliamentary opposition' is appealing to emotion and nihilism, inevitably heading to Fascism, and draws uncomfortable parallels with Germany in the early 1930s. In the classical democratic sense, England seems to him to have less obvious unfreedom than most other countries; our police have strictly limited powers, we do not live with packed suitcases under our beds. It is arguable that we have the machinery to curb private greed and public squalor, that laws exist to implement equality, to curb racialism, to care for the Cathys. Yet despite goodwill and intention we are clearly moving into a society that, instead of being dignified and humanitarian, one making use of the new recourses of technology, appears to be crumbling around our ears. The young, instead of appealing to existing process of democratic law for reform seem to be going against all canons of civilized behaviour, and with a certain political naivety, resort to planting bombs in banks, making romantic and nihilistic gestures as if they were members of the Black International.

The liberal is confused, doubly so when his good intentions are

thrown back in his face and he is informed that he is both con-
ning himself and being conned, and that liberalism is a sham
concealing the most rigid and effective apparatus of control and
repression.

The totalitarian, Marcuse tells us 'is not only a terrioristic
political co-ordination, but also a non-terroristic economic-
political co-ordination which operates through the manipulation
of needs by vested interests. It thus precludes the emergence of an
effective opposition against the whole. Not only a specific form of
government or party rule makes for totalitarianism, but also a
specific system of production and distribution which may well be
compatible with a "pluralism" of parties, newspapers, "counter-
vailing powers", etc. . . . Technology serves to institute new, more
effective and more pleasant forms of social control and social
cohesion . . . the technical notion of the "neutrality" of technology
can no longer be maintained. Technology as such cannot be
isolated from the use to which it is put; the technological society
is a system of domination which operates already in the concept
and construction of techniques.'[2]

Marcuse tells us here that the advent of technology has resulted
in even more effective and widespread controls, and that these
are conscious and deliberate. Michael Harrington approaches the
question from a slightly different viewpoint; he maintains that
technology has crept up upon us sideways, as it were, and that
political attitudes have not adjusted to the new realities posed by
an automated and 'abundant' society.

'The chasm between the technological capacity and economic,
political, social and religious consciousness—the accidental
revolution in short,' he says, 'has unsettled every faith and creed
in the West . . . these most conscious and man-made times have
lurched into the unprecedented transformation of human life
without thinking about it . . . technology is essentially under
private control, and used for private purposes; this situation is
justified in the name of a conservative ideology; and the by-
product is a historical change that would have staggered the

imagination of any nineteenth century visionary. In following their individual aims, industrialists blundered into a social revolution. There is indeed an invisible hand in all this. Only it is shaping an unstable new world rather than Adam Smith's middle-class harmony. In one sense this represents a familiar process. History, after all, has always been stumbling into new social systems. The industrial revolution and the capitalist economy were neither anticipated nor planned. The English of the seventeenth century thought that their upheaval was over theology, the French of the eighteenth century that theirs was over philosophy. In retrospect each event had more to do with the rise of a business civilization than with either God or Man. . . . The coming of Megapolis wrote a cruel dénoument to many a nineteenth-century vision. For what happened is that a revolution took place without conscious revolutionaries, Megapolis, and the age it represented, constituted a most radical reconstructuring of the experience of life itself. There had truly been a "devaluing of all values" as Neitzsche said there would be. But the event did not summon up a new race of aristocratic and stoic supermen. The bohemians who acted in Neitzsche's name would have been despised by their master. Capitalism had, as Marx announced, been unable to contain its own technology within the bounds of its theory and practice, but it had not been succeeded by a socialist leap into freedom. In short the material transformation have exceeded the wildest imaginings of the science and social fiction of the last century, and so has the conservatism of man. Instead of emancipated proletarians as in Marx, or sensitive slave owners as in Nietzsche, there are teen-agers, organization men and suburban housewives.'[3]

The technological environment, Megapolis, is the increasingly present and inevitable future of our society. Technology itself, let alone the vested interests of industry, is grinding inexorably towards larger urban units, towards corporate and centralized structures of decision and authority, towards a situation in which the individual feels progressively more depersonalized and anonymous. Technological innovation has historically been the

vehicle of social change, and it has often been argued that innovations in communication are more responsible for mutations in society than innovations in any other field; that it was first the waterways, then the railways that deflected society into the industrial revolution rather than the power loom. Today we are conditioned by the motorcar and electronic mass-media. Megapolis is clearly partly the product of the automobile, and increasingly large areas of our environment are specifically geared to this factor. The 'global village' (to use McLuhan's term referring to a developing shared set of common cultural values) is equally the result of mass-media; and a rapidly rising population, with the concomitant problems of food and essential-service production and distribution, is due to the so-called 'death control' brought about by new medical discoveries and techniques. Each of these seem to be factors contributing to the depersonalization of the individual, to a mounting frustration and discontent expressing itself in explosions of violence and aggression.

It cannot, of course, be argued that technology itself is the cause of this, and should be therefore abandoned. The old dichotomy between the 'sciences' and the 'humanities' is today irrelevant; the technological environment is a fact which cannot be gone back upon, and the split, increasingly recognized by the arts and demonstrated by the tendency of different medias of expression to merge, is a false one. Technology, further, is a tool which we must learn, to use; unfortunately, as a tool, it is one that is evolutionary in nature, that is to say it is one which by its very appearance has profoundly altered not only the nature of our environment, but also the nature of our society at its deepest levels, at those of our fundamental attitudes to the relationship between individuals and the group, between individuals and each other, and between individuals and the cosmos. Yet it would seem that society at large has not even begun to accept the existence of, let alone assimilate, this social mutation.

As both Harrington and Marcuse have pointed out, technology is in the hands of Capital; corporate and managerial capital perhaps

rather than the more traditional individual version, but Capital nevertheless. There is absolutely no question that Capital in the West is developed and manipulated for the private profit of shareholders and investors, for the sole purpose of enriching a minority. Mass media, the automobile, the electronics, plastics and pharmaceutical industries, research in nuclear physics, biology, cybernetics and other fields are all *manipulated* in fashions outdated by the new concepts arising from these innovations and diciplines. Not only the possible benefits of technology, but also the implied responsibilities necessary to handling and operating it at anything near maximum efficiency presupposes co-operative effort. Regrettably technology today is being managed by co-operative effort.

The technological Utopia would not seem to be around the corner; the life of abundance as opposed to selective affluence is not shown on the present political cards to be imminent; the concerted intelligent use of machinery and technique to develop resources for the benefit of mankind, for both his material needs and spiritual comfort, would not appear to be the logical extension of our increasing control over our environment and over inanimate nature. Indeed, it looks as if the very reverse is both currently taking place and is determined for the future.

Nearly all misery in the world today, from the obscene inhumanities of Vietnam and Biafra to the continuous and petty dehumanizing frustrations of urban life, to anonymous supermarkets, to traffic jams, to the isolation of individuals in a concrete jungle, to the progressive regimentation and the invasion of thought by potted concepts and ubiquitous advertising, all devolve from technology being misused, being manipulated in the case of our society towards the ends of Capital. This question of Capital is clearly the case in the 'Western' world; but in the majority of socialist states the situation is not much different. In Europe, with perhaps the exception of Yugoslavia, and briefly of Czechoslovakia, the corporate monolithic structure of post-Leninist Communism has tended to develop along similar lines.

There is today less and less to choose between the corporate structures of Russia and America. Where, in the States, Capital provides the élite who manipulate technology for their own short-term benefit, in Soviet Russia and the hard-line satellites, it is the Party 'bourgeoisie' who operate in this way.

It can tolerably be argued that the Communist revolution was a less fundamental shift then has previously been thought, for it seems to be coping no more effectively with the realities of the social mutation imposed by the technological revolution of our century. Marxism, clearly, on paper at least, is a step in the right direction, though in practice it has signally failed its idealistic intentions; this, however, is a matter of interpretation rather than of fundamentals. The Stalinist atrocities, the continuing arrest of writers and intellectuals, the cynical Party opportunism, does not invalidate the Socialist premise, does not alter the fact that Capitalist values are nineteenth century ones attempting to cope with twentieth century technology. Communism, also, though perhaps a step ahead, is by and large still embedded in the nineteenth century, and it must be remembered that Marx was writing and theorizing about the political, economic, and *technological* situation of European society in the 1840s. The *Communist Manifesto* was written more than 120 years ago, a date, that due to the technological revolution, is emotionally closer to the Renaissance than it is to today.

It may well be that 1917 was a historically less important date than has hitherto been considered. It is possible that the real revolution is yet to come. There are many signs and signals that this may be so, the events in Paris, May 1968, not least among them. The alternative to a total social reorganization in the near future (and all social reorganizations are violent) is far from an optimistic one: 1984 could well be here within Orwell's predicted date.

'For the termite', wrote Aldous Huxley, 'the greatest freedom is the termitary.' The social organization that we are progressing towards is clearly the 'termitary'. It may well be, as Harrington insists, that we blundered into the first stages of the termitary by

accident; but we no longer have that excuse. Quite apart from the damage that we are well aware we are inflicting upon society considered as an organism, we are permitting the termitary to destroy its very own environment. We know full well that we are permanently damaging the ecological balance of the planet, that we are poisoning the land, even the sea, with chemicals and fertilizers, that we are altering the balance of the atmosphere with fumes that might well create a 'hot-house' effect, that we are inflicting God-knows what anomalies upon the genes of the yet unborn, yet we continue doing these things in the name of short-sighted profits. We are destroying our environment and devaluing ourselves. Without respect for organic nature, without respect for our fellow inhabitants on the planet, all those creatures being destroyed and rendered irrevocably extinct in the name of material 'progress', we ultimately cease to respect each other, and finally to respect ourselves. At this point we create the ultimate termitary, we become those Science Fiction monsters, androids, synthetic men. And, along that process towards the termitary there must be a point of no return, where the process has solidified and discovered its own momentum. At that point, revolt by the individual is no longer possible; and who is to say how close we are to that point today?

Technology presupposes an urban culture, it presupposes an increasingly synthetic environment. This is inevitable. One cannot turn the clock back, or attempt to regress to a 'primitive' life. History is inexorable, and the 'ivory tower', the isolated 'community' or 'artists colony' whether in Maine, St. Ives or the Balearic Islands, is nothing more than totally opting-out. It can never be more than a private solution; at best it is anti-social, at worst it is downright dishonest. Opting-out is, as we shall see, one aspect of the contemporary artistic scene, and it takes different forms. In each case it is motivated by a total rejection of the technological realities of society. In rejecting the whole along with its misuse, such an attitude compounds the termitary, it acquiesces to it ultimately through selfishness.

There is, however, no reason why technology should necessarily be in itself dehumanizing. Certainly psychologists tell us of traumatic effects in feeling disassociated from our roots, often symbolized in the case of modern man as being cut off from rural nature. The instinct to feel related to the natural order is clearly an important one, and one that must be kept alive; to a certain extent this is central to tourism and sea-side holidays. But often the holiday abroad or the weekend visit to the nearest coastal resort defeats itself. The individual instinctively seeks a sort of psychic recharging at 'roots'. In the city he feels alienated from the natural order and seeks relief among bungalows, caravan sites, ice-cream kiosks and deckchairs; but he is hardly aware that the Bank Holiday rush, the traffic jams and the ritual, largely invalidate his intentions. Even while attempting to briefly break down his alienation from 'nature', he is embedded in an even greater alienation; he is progressively even more disassociated from his fellows, from the community, and, more serious, from himself.

What he does not know, and what the corporate society for its own obvious reasons takes care he should not discover, is that the natural order is also within. The sense of alienation in our society results partly from the recognition of the fact that technology is not being used to create abundance, to produce adequate food and essential consumer-goods in such a way as to provide the maximum comfort and freedom (freedom both for and from the classical situations) to enable the greatest number to realize personally their own lives. Instead of rendering the desert fertile we construct greater engines of destruction; instead of banishing want we saturate our society with trivial gadgets and condition people to scrabble for prestige consumer-goods they neither really want nor need; instead of teaching our children and adolescents to think and act for themselves we try and impose pre-digested patterns on them, playing for the most part Academic power-games rather than creating a true learning and maturation environment; instead of developing machinery to increase leisure by doing away with toil we create needless work and bolster a

completely insane economic concept by deliberately manufacturing goods with a built-in obsolescence. Naturally, if goods were made with the full force of all our existing technical capacity; if we honoured the *Man in the White Suit*, if we distributed the 'ever-lasting razor-blade', if motorcars were built even half as well as the Victorian engineers constructed railway locomotives, if manufacture was to the highest specification feasible, if food and power production were rationalized, then toil, work in the emotionally unrewarding sense that almost 99 per cent of the population experience, would be dramatically reduced.

The same standard of living could theoretically be maintained in the industrial countries for a fraction of the currently expended labour, and surplus would soon raise the greater half to today's population of the planet, who are in actual want, to a standard of abundance. Of course, the existing power structure would collapse, the political situation based on deliberately contrived scarcity would crumble. The distinctions between the haves and the have-nots would evaporate, and privilege, whether of money or Party membership, would disappear. Those that would suffer from such a hypothetical but perfectly feasible situation, suffer let us note, not materially, for the equalization would be from the bottom upward, but merely suffer loss of privilege, loss of power) must effectively resist such 'reforms'. Certainly technology has produced, and is producing, a limited 'affluence' which has made the lives of the vast majority of people slightly less wretched than they were in the past; but there seems to be almost an unwritten political law which states that affluence is passed out from the haves to the have-nots at the minimum rate which keeps them content, if not from actually rebelling. And the increasing price that the individual have-not is obliged to pay for this 'minimum' welfare is a steady dimunition of independence, a continuing erosion of individuality.

'The argument', says Marcuse, 'that makes liberation conditional upon an even higher standard of living all too easily serves to justify the perpetuation of repression. The definition of

the standard of living in terms of automobiles, television sets, airplanes and tractors, is that of the performance principle itself. Beyond the rule of this principle the level of living would be measured by other criteria; the universal gratification of the basic needs, and the freedom from guilt and fear—internalized as well as externalized, instinctual as well as rational. "Real civilization does not lie in gas, nor in steam, nor in turntables, it lies in the reduction of the traces of original sin" (Baudelaire). This is the definition of progress beyond the rule of the performance principle.' [4]

It is, he tells us, specifically an 'inner' freedom that we are losing in corporate society, a freedom 'that designates the private space in which a man may become and remain "himself". Today this private space has been invaded and whittled down by the technological reality. Mass production and mass distribution claim the *entire* individual, and industrial psychology has long ceased to be confined to the factory'.

709.046 c

c.1

It is interesting to remember that Marx expected the proletarian
revolution to succeed precisely because it was the lowest rung on
the ladder. The old feudal system was overthrown by the aris-
tocracy, who in turn were supplanted by the bourgeoisie during
the French and American revolutions. It did not occur to him
that there would be a further class of the dispossessed yet one rung
below the proletariat; the exploited coloured races. 'The proletariat
has become the Third World', says Stokeley Carmichael, 'and
the bourgeoisie is white western society.' [1] It is clear at the present
moment that the initiative of the revolution has now passed into
the hands of the Third World; but one of the more obvious facets
of the student revolt is that the radical youth of Western society
is by and large identifying with this situation. The young have
'soul'; Guevera is a powerful ikon, his sensitive gaze with a
compassionate yet stern expression, reminiscent of a Medieval
Christ, gazes from the walls of a million student pads. The posters
prepared in The Village, Ste. Germain and Portobello Road are
true ikons of our time, fulfilling something of the role of the
Gothic and Slavic variety.

They are far from the official emblems of power, order or even
affection, like the ubiquitous Stalins, Kruschevs, Titos, Kennedys
and H.M.s by Annigoni, decorating cafe, post office and Embassy.
They are 'magical', even ritual objects. Their company is never of
the category suggested above. It is possible that they might share
wallspace with Lenin, but in a romanticized and avuncular version;
more likely their graphic neighbours would be Artaud and Genêt,
John Cage, perhaps Warhol. This is not a question of a political
figure being debased into Pop-art, something all too familiar, but
the recognition (indeed the celebration) of a symbolic and
magical image.

Whether it is specifically his personal historical experience or
not, the instinctual and romantic, as well as the politically
sophisticated, European and white American student recognizes
the inevitable flow, the imperatives of history. He identifies
perhaps more accurately than his elders the arena in which the

...ggle is currently being enacted. At specific moments of the ...nass-media reaction to the 'politics of youth' during the recent years, various individuals who belong to older generation groups, specifically those currently between 30 and 40, have protested their bohemian and radical background. Alan Brien, for instance, writing in the *Sunday Times*, tells us, claiming his own activism, that '... each generation tends to imagine that there are only two tracts in time, Now and Then. They recognize only two classes, Us and Them. ... There seems to be a need in each generation to date the expulsion from Eden, whether that is regarded as a fool's paradise or the homeland of the gods, some time before you could be blamed for it'. And he quotes a nice story, asking who it was who left Oxford, and in what year, declaring the university to be 'tedious, graceless and second-rate, asking, "what is there left to hope for, except a war or revolution?"—Answer: Evelyn Waugh in 1924'.[2]

Despite such a bizarre example, it is evident there exist older 'bohemian' rebels, who were then (and for that matter probably still are) representatives of what has been called 'the Other Tradition'. Certainly such individuals were in revolt against bourgeois society, and as artists many of them maintain platforms of 'opposition'. But the difference that Brien did not recognize is that they were individuals bucking the system. The political, indeed the historical situation, was totally different even ten years ago. In the '40s or '50s such people were *rebels* (the current writer imagines he was such); and in defining them as 'rebels' that is to say they were individualistic dissenters. Today it rather looks as if their descendants are becoming *revolutionaries*, for the latter possess, albeit in a confused and hopelessly naive manner, an ideology, and are members of a mutually identified and commonly recognized 'class'.

To say that today's dissident youth comprise a 'class' is not so far-fetched as it might immediately sound. Over the last fifteen years or more young people have developed an earning capacity and a clearly defined economic independence, so defined, in fact,

that whole industries such as fashion and popular musical entertainment are almost totally geared towards their needs. Moreover, in some countries the under 25's comprise almost half of the total population, and this is a progressively rising figure. They have a clear and defined identity, have developed a specific culture, one furthermore that is trans-national and truly contemporary, a dominant facet of the 'global village'. Is it far-fetched, therefore, to call them a 'class'? Let us apply a Marxist analogy.

It is perfectly obvious that the proletariat in Western society is no longer the revolutionary class. Not only have they declined the Marxist gambit to seize power, but they have shown themselves as being intrinsically reactionary. At this point let us remember that with the exception of one or two short-lived Syndicalist 'experiments', the proletariat never have seized power; the Russian revolution and every other European Communist revolution (with the arguable exception of Yugoslavia, which found itself in a unique situation) was essentially the result of a 'putsch'. The Left, particularly in the Anglo-Saxon countries, to a lesser extent in Germany and France, swiftly abandoned the Utopian aspirations of the late nineteenth century. Labour, and the Trades Unions, have made it lucidly clear over the years that their only ambition is merely to have a larger slice of the Capitalist cake. The European proletariat, with his grossly materialist viewpoint, has just about finally completed the pantomime transformation into petite bourgeois; it is not so staggering after all that London dockers should last year have marched in support of Enoch Powell's grotesque opinions.

Youth, on the other hand, are naturally in a state of rebellion. This, of course, is at its deepest roots a biological imperative. Adolescence is already in a state of rebellion against authority as personalizing the family, a normal and necessary weaning process, the social and psychological equivalent of physical weaning. As an aside, it is notable that psychiatrists have theorized at length on the effects of physical weaning, the importance of the maternal relationship and of the breast itself, but little work has been done

...a psychiatric rather than a sociological point of view) on
...is secondary weaning.

While in the bourgeois society of the past the family was a
comparatively stable unit, in the Megapolis of today, due to
social fragmentation, dispersal of work and education centres, it is
normal for the adolescent to leave home at the very earliest
moment possible, frequently severing contact with the family unit
altogether. The development of teen-age consciousness as a 'class'
is related to this; it is unclear, however, whether it is this that
encourages the young to leave the family, or whether the need to
leave the family, imposed by other social (and economic) pressures,
has led to the creation of group identity. It is a sort of chicken
and egg problem, albeit one with a feedback and snowball effect.

What is undeniable is that the solidarity and group-consciousness
of youth has led to a new political development. In the face of the
increasing bureaucratization and centralization of society, already
biologically conditioned into a rebellious stance, they began to
evolve their own political and quasi-political opposition to the
'machine'. There have of course been student demonstrations,
activism and violence in the past, even back into the nineteenth
century. These, however, rarely took place in the developed
countries; we used to read about them in the newspapers—
rioting in some obscure Balkan or Latin American republic.
These cases were different from those of today in that the students
were allied to, or being manipulated by, existing radical or
extremist political organizations. It is only in recent years that the
young have been politically active *on their own account*.

When Jimmy Porter cried out in the middle of the '50s that
there were no more 'good brave causes left' he (and his author)
had not then noticed that one was growing up around them.
The C.N.D. movement, though led by their elders, was fuelled
by the young, specifically in the case of the breakaway Committee
of 100, growing as it did out of intense and spontaneous dis-
cussions which took place in London's bohemian 'underground'
cafe 'The Partisan'. The young, disillusioned with the mess that

their elders had made of society, old enough to remember or to have just caught the tail end of the war, were frustrated and angry to realize that all the suffering appeared to have been for nothing, and that it was more than likely it would all start again; and furthermore, this time the destruction would be unthinkable, and very likely resulting in mass suicide for the whole human race.

Jeff Nuttall, in his excellent but highly personal survey of 'underground' society, *Bomb Culture*, maintains that the whole consciousness of youth, and specifically the bohemian, intellectual and artistic Underground, was a result of the Bomb, that the nuclear annunciation was a social watershed rather than a division of generations.

'V.E. Night', he says, 'took place in one world and V.J. Night in another. The world of the European victory was a brown, smelly, fallible, lovable place, an old-fashioned, earthy, stable place, a place in which there was considerable, sure and common ground between men on issue sof morality, where good was good and bad was bad, where loyalty to country, class, family and friends could be taken for granted, where no one felt the responsibility for public evils resting on their shoulders, where people felt that if things were wrong then history had ample time remaining in which they could be rectified, where evolution took place in the benevolent house of nature, where society took place in the benevolent house of evolution, where man lived his short life in the benevolent house of society. War had survived the war, exorcised the Bavarian poltergeist, struck a positive at the end of a long, hideous negative. We had found each other in our collective suffering and triumph. We had reconfirmed the ancient merits of honour, self-sacrifice, courage, will and companionship. The destruction was over. We knew the Devil and had killed him. The future yawned ahead for illimitable construction and if there was another war, we could survive again.

'The world of the Japanese victory was a world in which an evil had been precipitated whose scope was immeasurable, the act being, in itself, not an event, but a continuum, not an occasion

but the beginning of a condition. We knocked out the second enemy (by no means such a discernible villain as Hitler whom we could easily condemn through the sensational shock of the concentration camps and the obvious poisonous violence of his rhetoric) by alienating all those values we had confirmed in the first victory. We had espoused a continuum that negated (running parallel to) the continuum of society. We had espoused an evil as great as the Nazi genocide, we had espoused the instrument for the termination of our benevolent institution, society, and our certain identity, human. We had espoused a monstrous uncertainty both of future and of morality. If besides the "nazi gangsters", we were also wrong, who was ever right? If no one was right, what was right, and was right anyway relevant, and what could guide us through the terrifying freedom such a concept offered? Whatever the answer it had best be a good one for we could not rely on ourselves any more than the little yellow man or the evil hun. We had driven honour away a few short months after finding it. . . .

'The people who had passed puberty at the time of the bomb found that they were incapable of conceiving of life *without* a future. . . . The people who had not yet reached puberty at the time of the bomb were incapable of conceiving of life *with* a future. They might not have had any direct preoccupation with the bomb. This depended largely on their sophistication. But they never knew a sense of future. The hipster was there. Charlie Parker's records began to be distributed. The hipster became increasingly present in popular music and young people moved in his direction. They pretended too, but they did not enter the presence at all cheerfully. In fact they entered the presence reluctantly, in pain and confusion, in hostility which they increasingly showed. Dad was a liar. He lied about the war and he lied about sex. He lied about the bomb and he lied about the future. He lived his life on an elaborate system of pretence that had been going on for hundreds of years. The so-called "generation gap" started then and has been increasing ever since.'[3]

This is a very important point, particularly in its moral implications, and one that has not previously been brought forward with such cogency. But all the same Nutall makes too simple a case. The Bomb is part of the technological society, not the other way round; though it has obviously raised for the post-war generations unprecedented moral problems and saddled them with unprecedented social guilt. Other forces were at work, also aspects of the technological society. As Nuttall points out, the underground crystallized in 1963 but had been developing for almost a decade previously. By that date the first totally post-war generation had matured; true they grew up in the looming shadow of Hiroshima's mushroom cloud, but they also were the first generation to grow up with television and electronics, with mass-media, automation and modern communications. They were the first complete generation of McLuhan's 'audio-tactile' culture. They were the first generation to arrive to maturity, and discover the developing sense of their own group identity solidified, to find the cultural heroes and patterns already in existence. They were the first generation conditioned by the synthetic environment, economically independent; not merely free to move, but conditioned to be mobile by the new work-patterns of the 'global village', where, unlike the static industrial past, it was *expected* that employment would demand periodic shifts of venue, the willingness to move easily from city to city in the process of promotion.

These factors, of course, apply to the whole of 'pop' youth, the Carnaby-dressed (but conservative) labourer, as well as the dissident bohemian, Nuttall is only writing about the latter, and sees them, as it were, somewhat encapsulated. This would appear to be a mistake, for the Underground is clearly part of a larger pattern; one can say that it provides the *intelligentsia* for the whole group. That the relationship between the Underground and 'pop' youth as a whole is intrinsic is emphasized by the fact that the Underground 'bohemian' tendency crystallized during the early '6os. It is also emphasized by the fact that the Underground political consciousness, which was more or less Anarchist before

...moved in the direction of a revised Marxism,
one largely ... tskyist variety.

The importance of the C.N.D. cannot be overrated in this context. It was, however, also part of an older tradition, in some aspects a very old tradition indeed. The movement grew out of Peggy Duff's organization *Operation Gandhi*, a pacifist concept closely allied to classical Anarchism on the one hand, and Protestant evangelism on the other; a concept directly descended from a Utopian tradition. As we shall see later, this tradition is strongly Millenial in tone.

The Ban-the-Bomb movement moved away from its purely humanitarian, idealistic and Anarchist principles with the advent of the Committee of 100's activism, with civil disobedience in the place of Gandhian passive resistance, with provocation rather than demonstration. From the *Direct Action* of Donald Soper at the end of the '50s, through Pat Arrowsmith's first attempt to initiate industrial and strike action, to the spectacular cumulation of the *Spies for Peace* event, where secret information about Regional Centres of Government prepared for nuclear warfare was leaked to the public in 1963, the movement became more and more militant. From specific agitation against a government policy of developing and stockpiling nuclear weapons, action became inevitably directed to wider problems of Civil Liberties.

'Who are the real conspirators, us or them?' asks Pat Pottle, 'The Government uses secret police to break into offices, to steal papers, to open letters. Its agents search people in their homes in the early mornings. It taps telephones, sends spies to meetings, whitewashes its own brutality, and lies in court. . . . We say to the people; learn from your experience. As you become more effective, the Government will seek to destroy civil liberties. They bring in the troops. They talk of conspiracy. It is the Government itself which is an evil and criminal conspiracy.'[5] It is from this classical Anarchist position that we have the beginnings of a polarization process which is now becoming more and more obvious. Government is polarizing into increasing control and repression; a

steadily growing number of people, inevitably found among the younger generations, are moving into positions of revolt. Pottle and his colleagues, however, cannot be said to have *caused* the governmental machine to harden in the way that it has, they merely unmasked a process that was already in existence, they demonstrated by challenge the sham of liberal 'democratic' society.

As direct action grew more militant, so new political ideas were brought to bear in the changed political realities of post-war Europe. The offices of the *Universities and New Left Review* were located above The Partisan coffee-house, and it was this magazine with its editors, contributors and satellite theorists, mostly undergraduates at Oxford, who provided the impetus for a renascent 'new left'. Nuttall, in describing the genesis of the Underground, details the migration of 'hipster' ideas, mostly embodied in popular music and jazz, *from* the States to Europe. He also emphasizes that the political ideas travelled in the *opposite direction*, as did indeed the contingent theories of pop-culture as applied to the fine arts. The thinking of the English New Left of the mid-'50s led not only via Ban-the-Bomb to Tariq Ali, *Black Dwarf*, Hornsey and the Revolutionary Student Federations, but also fuelled a similar pattern in America, a pattern that developed from the direct action of the Freedom Riders, through sit-ins and Black Power, by 'riots' on the part of the police as well as of the Left, to the development of a new political consciousness centred by and large at Berkeley.

The Oxford Marxists were early theorists of a process, of course, not themselves the instigators. The spark, no doubt, was Kruschev's revelations at the Twentieth Party Congress in 1956 and the subsequent revolts in Poland and Hungary. This brought about reassessments throughout Europe, taking in the appearance (paralleling that of Oxford) of a new literary left; the English 'angry-young-men', Polish 'revisionists' and the French post-existentialism and *nouveau roman*. This led inexorably, via Cuba and the developing consciousness of the Third World, to a new

ne existing social as well as political order, to a
ion of what is implied in the ideas of relationships
human beings, what is implied in the notion of 'society'
what is implied in the ideas of 'freedom' and individual
esponsibility, to the development of a wide spectrum of op-
position to an outdated political machine, a spectrum ranging from
Western Maoism, through Syndicalist ideas to the separatist
'unilateralism' of the Black Panthers.

The basic thinking of the New Left is lucidly expressed in the
words of Paul Jacobs and Saul Landau in their book *The New
Radicals*. They are speaking of course specifically of the American
situation, but what they say goes not only for the new and
passionate conviction of a large section of American opinion, but
can also stand as a definition of the ideals of the radical young
throughout the world, as a description of the motivation behind
Hornsey and the Sorbonne, Rome, Madrid and Berlin, Prague,
Belgrade and the imprisoned Moscow poets.

'These young people', they say, 'believe that they must make
something happen, that they are part of a movement stirring just
below the surface of life hitherto accepted all over the world. . . .
The leit-motifs that dominate the Movement extend far beyond
politics. The Movement is more than anti-Vietnam marches,
civil rights demonstrations, and student sit-ins. To be in The
Movement is to search for a psychic community, in which one's
own identity can be defined, social and personal relationships
based on love can be established and can grow, unfettered by the
cramping pressure of the careers and life styles so characteristic of
America today.

'The Movement rejects the careers and life styles of the American
liberal too, for those in the Movement feel that modern American
Liberals have substituted empty rhetoric for significant content,
obscured the principles of justice by administrative bureaucracy,
sacrificed human values for efficiency, and hypocritically justified
a brutal attempt to establish American hegemony over the world
with sterile anti-Communism. The Movement sees the liberals

righteously proclaiming faith in American democracy from their comfortable suburbal homes or offices, while the United Air Force drops napalm on villages and poisons the rice paddies.

'So, those in The Movement see not only the openly authoritarian or totalistic society as an enemy but the administered, bureaucratic, dehumanized, rhetorical-liberal one as well. They reject liberal authority. They were stirred, momentarily, by President Kennedy's call for a commitment to freedom, but were so disappointed by his actions in Cuba and Vietnam that they turned on him with bitterness. And the Johnson Administration's foreign policy reinforces their view that America flouts, in action, the traditions of freedom and justifies the use of military instruments associated with the Nazis.

'The new Movement is also a revolt against the post-war "overdeveloped society", with its large bureaucracies in government, corporations, trade unions and universities. To those in The Movement the new technologies of automation and cybernation, with their computers and memory-bank machines, are instruments of alienation, depersonalizing human relations to a frightening degree. The brain machines and the translation of human qualities into holes punched into a card are viewed as devices that break down communication and destroy community in the interests of efficiency. Technology's emphasis on routine efficiency has created a set of values, rationalized by its supporters as representing "the facts of modern life". But The Movement sees these values as false, imposed on the whole society without "the consent of the governed". Even worse, the decision-making over which the governed no longer have control extends far beyond politics; in the technological order every aspect of the people's lives is under the control of administrators far removed from responsibility to the governed. And the elders of those in The Movement have exchanged their decision-making right for the comforts of American affluence. All that remains is nineteenth century rhetoric about democracy and freedom, and technology has drained the words of their content.'[5]

'I saw the best minds of my generation destroyed by madness, starving, hysterical, naked, dragging themselves through the negro streets at dawn looking for an angry fix',[1] cried out Allen Ginsberg, a prophetic voice calling out from the new and glitter-neon wilderness of the distant West. Here, in the mid-'50s was the authentic emergent voice of the new dissident confronted by the anonymous face of a gadget-orientated and materialist society. In California, as in Existentialist Paris and post-'Apocalyptic' Soho, the period immediately after the war saw a great surge in the corridors of Bohemia. The war had broken down the old order, and a new world was dawning; in England, Labour's star shone on a bright and just future, and bohemians and intellectuals planned the Millennium. After a very short time, however, the old sour realities came sweeping back. It was clear that nothing much was going to change after all. In disgust, the bohemians began without quite knowing it to prepare an 'alternative society'; the 'daddies' of the Underground were laying the roots of something that was to be quite different from the conventional sub-culture of dissent.

The less articulate, equally disillusioned, dropped deliberately out of society into aggressive and nihilistic stances. Ultimately that objectification of our collective social nightmare, the Hell's Angels appeared; Brando and Dean, rebels both wild and without a cause, focused a growing frustration. In England, what Charles Hamblett came to call 'Generation X' surfaced from the murky depths of deprivation and violence, deprivation of spiritual nourishment and violence impressed by the group on individual identity, and expressed themselves with bicycle chains and studded belts to the terror of the solid burghers of Clacton and Margate. Holden Caulfield, that perennial enduring his agonized *bildungs-roman* maturation, was transformed into the flip, aggressive and ultimately desperate *Absolute Beginner* of Colin MacInnes.

While London luxuriated in the high romantic pastures of Dylan Thomas and Paris canonized Juliet Greco as a priestess of

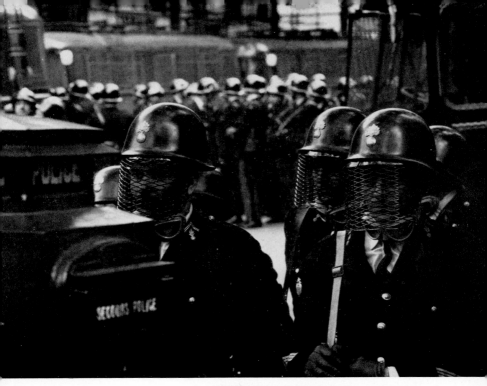

PARIS POLICEMEN

HORNSEY POSTER

'The Multiversity is not an
education centre, but a
highly efficient industry . . .'
(*p. 11*)

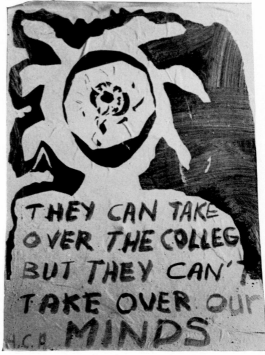

THEY CAN TAKE
OVER THE COLLEG
BUT THEY CAN'
TAKE OVER OUR
MINDS
H.C.O

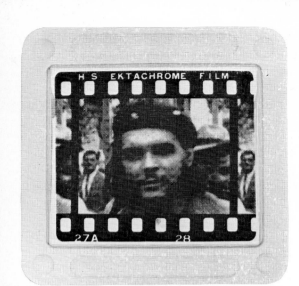

JOE TILSON

They are ikons, 'magical', even ritual objects. (*p. 25*)

L.S.E. POSTER FACTORY

... a new resistance to the existing social as well as political order ... (*p. 33*)

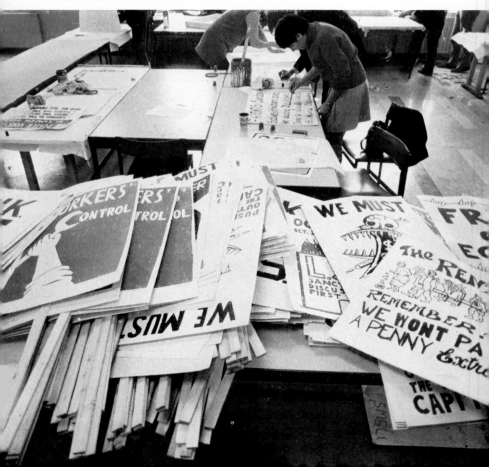

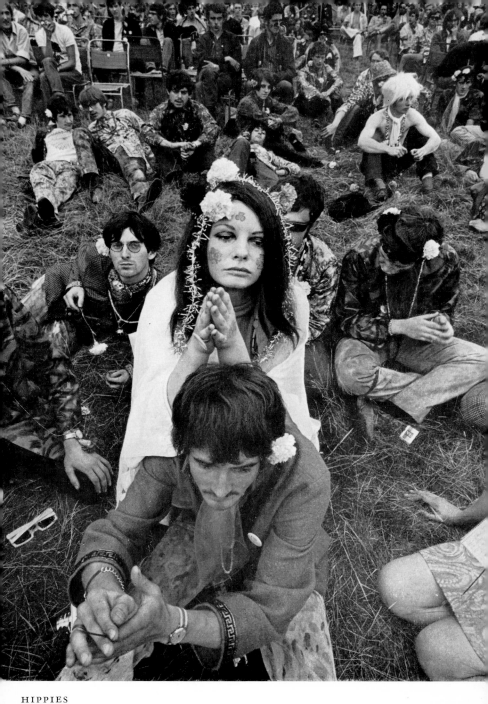

HIPPIES

. . . a clear and defined identity, [they] have developed a specific culture. (*p. 27*)

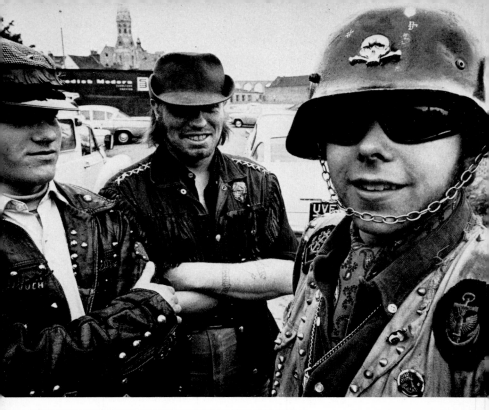

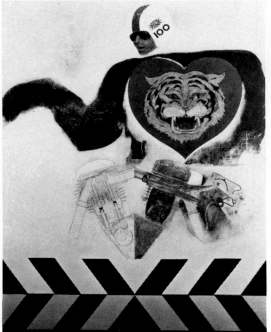

Above HELLS ANGELS
Below left PETER PHILLIPS
Below right DRAG CAR

The objectification of our
social nightmare . . . (*p. 36*)

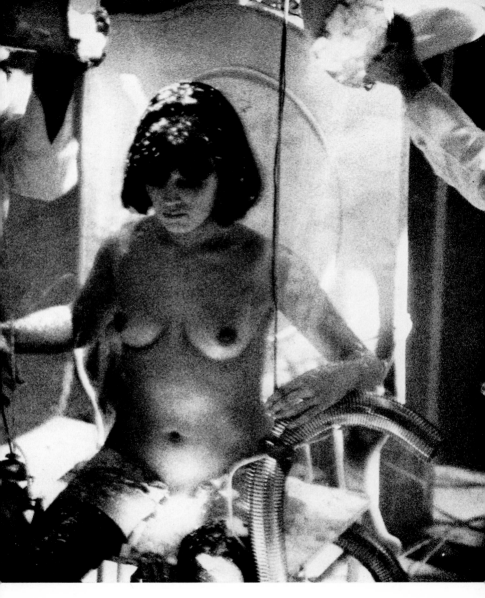

LEBEL

'The Happening is about man's displacement from order . . .' (*p. 55*)

Above RAUSCHENBERG

... the canvas as a sort of mirror ... (*p. 52*)

Centre LEBEL

Below TINGUELY

'... a true demonstration would at least have to be doubly absurd ...' (*p. 59*)

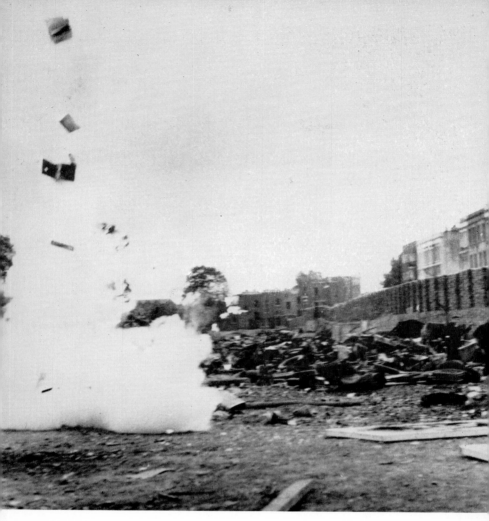

Above and right LATHAM

'. . . the idea of perpetual impermanence . . .' (*p.* 60)

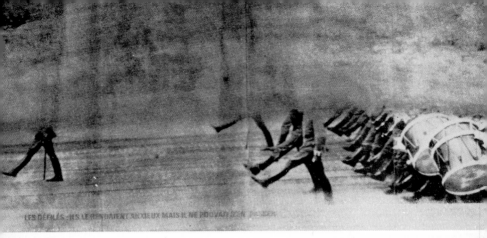

LES DÉFILÉS - ILS LE RENDAIENT ANXIEUX MAIS IL NE POUVAIT RIEN FAIRE

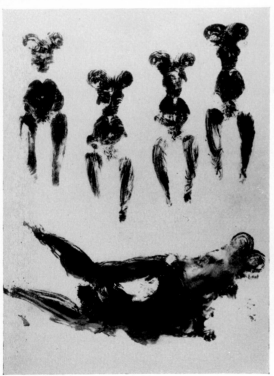

Above VOSTELL

The sense of the ambiguity of the human condition in society which gives rise to political action . . . (*p. 61*)

Below left YVES KLEIN

Right AUBERTIN

. . . the inability to observe more than the mark that action and experience leave behind their passage . . . (*p. 62*)

despair accompanied by Cocteauian booted and belted motor-cycle outriders, the California Beat scene found itself at a cultural cross road. Inhabiting what was undeniably the first achieved synthetic environment, the glittering littoral of movie dreams, superhighways and armament factories, they bridged the traditions of East and West. *On the Road* celebrated the old protestant and Utopian virtues, the sweeping landscape and the open frontier, but glossed the inner life with oriental quietism. Walden Pond was suffused with the unexpected light of Dharma.

The banners of Surrealist revolt were once more raised; the instincts were preferred before the enervating hand of rationalism. Pollock and the European Tachists threw themselves into auto-matism. What Breton stated more than thirty years previously was a rediscovered test. 'To reduce imagination to slavery' he wrote in the *First Surrealist Manifesto* of 1924, 'even if one's so-called happiness is at stake, means to violate all that one finds in one's inmost self of ultimate justice. Imagination alone tells me what *can* be.' Yet, as Dada led to Surrealism, political and social revolt led to aesthetic, the revival returned through history in the logical sequence. The automatism of Action Painting returned to a revived neo-Dada of Pop and *Nouvelle Realism*.

But this neo-Dada bridge led back also to certain voices of anarchist revolt, to the fierce and nagging individualism of Kenneth Patchen and Henry Miller, to the nihilism of Genet and Céline; it spanned not only the Dada mainstream, the dissent of Tzara, Heartfield and Janco, but also that eccentric and sinuous route which twists back through the thickets of rebellion, psychopathology and visionary idealism to a common fount of opposition that began with de Sade and the involuted logic of the mid-nineteenth century search for gestural identity.

The basic attitude of the Beats, of Ginsberg, Kerouac, Corso and Ferlinghetti, succoured, subsidized and published by the latter, was the celebration of an 'internal' reality, one that was if not more real than that outside, was more pressing and more valid because it was felt and lived totally by the individual; the 'Coney Island of

the mind'.[2] Though clearly influenced by contemporary events, the Beats did not acknowledge openly any debt to Paris: for to them that city represented Fitzgerald and Hemingway, those latter-day Jamesian exiles who endured an alcoholic and guilt-ridden purgatory at the springs of European culture in an attempt to discover an 'American' identity, who voyaged through a sort of hyperborean Grand Tour as a sort of circumscribed penance, an apprenticeship, even a prison sentence, the final resolution of which was to be the inevitable return from exile bearing merely the fruits of synthesis, an attempt at 'justification' for a new world culture. A justification, moreover, shot through with its own built in anomalies, an exile finally pointless, a return with gifts which crumbled to dross in transit. For these exiles never pene-trated the inner world of poetry, illumination and justice which the travellers sought; their pilgrimages ended up for the most part in despair, in suicide or the boozer's grave.

Though not acknowledging Paris, as we have pointed out, the Beats *were* the genuine American existentialists. They recorded and reacted like seismographs to the tremors of their actual time, and were perhaps the first American intellectuals able to speak abroad without the overtones of deprecatory qualifications, the ancient New England inferiority complex. Paradoxically, it was necessary for them to speak with a truly international voice in order to become the first American poets without obligations to European imperatives. In this, their position was similar to that of the painters a decade later. For the creative explosion of the New York school was certainly conditioned by Paris; Pollock, Kline, de Kooning, Hoffmann and Rothko were entirely for-mulated by European artistic values. The following generation of Rauchenberg and Johns, particularly the latter, were still funda-mentally *Ecole de Paris* painters, for them 'la belle matiere' was paramount. It remained for Warhol, Dine, Lichtenstein and their colleagues (Harold Rosenberg, Clement Greenberg and other pundits notwithstanding) to produce the first truly indigenous American school of painting, the first to raise a 'style' uniquely

voiced without either obeisance, qualifications or asides towards Europe.

As we have said, it is a paradox that the Beats (like the Pop artists) could produce an exclusively American idiom only at the same moment as they launched out upon an international platform. In this, Henry Miller was clearly their precursor. The sole exile of the pre-war period who did not return, prodigal, to despair and defeat. The dirty old man of the Tropics was transformed into the guru of Big Sur. Hysterical, confused and romantic, he mixed up aspirations of political, social and sexual libertarianism together with an eschatological mysticism into a large, messy, but oddly significant literary and verbal omelette. Loghorrea, fanaticism and mystical utopianism all stirred up in the same pot. The central preoccupations of Miller are those which we shall discover to be important in later pages; a certain political anarchism mixed together with Millenial ideas.

As we have already noted the migration of ideas leading to an emergent New Left was from Europe to the States, while the ideas leading to the 'underground' culture moved in the opposite direction. The idea of the 'hipster', what Norman Mailer has called the 'white negro', began to have an impact first in England then later throughout Europe during the 1950s. The original hipster, trapped in his North American ghetto could only express himself through music and dress; and it was from this point that a post-war spread of bop and zoot suits led via teddy-boys to mods, rockers and the mystical beads and flowers of recent years. (It is worth noting that the Beatles themselves started out as 'rockers', with duck-arse haircuts and leather jackets.) Fashion and popular music were not, however, merely the bearers of a new sub-culture, they were the very matrix in which this sub-culture was to grow. And while the wide mass of the young during the early '50s were responding to Bill Haley and Rock 'n Roll, a more intellectual élite reacted to 'modern' jazz, to Charlie Parker and his descendants, to Thelonious Monk, Charlie Mingus and John Coltrane.

The pre-war bohemian had been almost exclusively a middle-class phenomenon, as in general it was only the children of the bourgeoisie who has sufficient freedom to revolt in the first place. The larger mass of the working class, conditioned by rigid cultural factors as well as by the practical material need to leave school and start work at an early a date as possible, tended to keep the proletariat within a conformist framework—bearing in mind that in this specific context Labour agitation and Trades Union activity are also the 'conformist' opposition. During the period immediately after the war, as Hoggart has pointed out, the old working class culture began to evaporate in the face of mass media and the new communications setup as well as altered social conditions. Bohemia, from this point on, was no longer the prerogative of the privileged, for leisure, that prime condition for dissent, was becoming increasingly widespread. The '50s saw a social phenomenon that had never previously existed at any moment of the past, the appearance of a working-class bohemia. The Teds were the vanguard, the first thin wedge of an emergent social group that was soon to count within the body politic. The unshakable personal awareness of the *Absolute Beginner*, his sense of solidarity with his peers, his passionate if quirky insistence on justice and dignity, and above all, his total rejection of 'bank-clerk values' was to become something of an archetype.

The re-opening of travel immediately after the war contributed to the newly discovered solidarity of the young. Totally opposed in concept to the '30s German *vandervogel* with its sinister clannishness and boy scout ethics, large numbers of post-war youth, non-conformist and anarchic, took to wandering the roads of Europe. Distrusting the nationalism which they blamed for the recent war. A new generation of German, together with Dutch, English, Scandinavians and others, hitch-hiked endlessly down such arterial routes as the Hamburg-Frankfurt autostrasse or the Route Nationale Sept to set up camps and colonies on the beaches or in Youth Hostels in the Mediterranean sun. A free-masonry of the road was created, a bush-telegraph of information

laid down; someone last seen in Stockholm was just as likely to turn up in Prague or Tangier a few weeks later. Anticipating today's hippies, they settled in Cannes, Nice, Colloure, the islands of Ste. Marguérite and Levant; just ahead of an expanding tourist trade, however, which continually thrust them in their search for the inexpensive lotus further afield, to Malaga, Ibizza, Rhodes, and today to the ultimate of Katmandu.

The nomadic scene set a new seal of internationalism on a generation, for while the greater part of that generation stayed at home beginning to discover its identity through the eyes of Bill Haley and James Dean, the bums and the hitch-hikers formed from their beginning during the late '40s and early '50s a sort of intelligentsia able to articulate the emergent 'pop' youth. Political questions were central to the night-long discussions on the beaches of the Midi; 'Existentialism' was the label for a way of life that had something of the medieval troubadour about it. Plucking a guitar to a spectrum of folk-songs ranging from the Swedish Bellman to Isreali Horas or Leadbelly blues raised the price of a supper, a quick sketch cafe portrait the price of a bed; and like the wandering Medieval scholar, they shared the same 'spiritual home', the original *Quatier Latin*. Each long journey with rucksac and upraised thumb inevitably passed through the clearing-house of Ste. Germain, and found temporary rest in that bar called, perhaps without unconscious irony, Café Danton.

The ground, then, was already well laid in Europe by the time that message came across the water in that distinctive nasal monotone of Ginsberg's, surely the kindest and most gentle rebel ever; it was fertile for the appearance of such magazines as *Merlin* and *Points* in Paris, for the arrival of such writers as Alexander Trocchi and Gregory Corso, not to mention lesser figures like William Morris. The American Beat world, however, demonstrated one aspect unknown on the European scene, an extremely ambiguous relationship with the negro. 'The beatnik world of the '50s', writes Ralph J. Gleason, 'was an inter-racial world first and foremost. But an inter-racial world based on a white

assumption of black superiority.' And he contrasts the past with today, maintaining that '. . . the hippie world is quite different. The stereotype black stud of *The Dutchman* is discovering that the hippie chicks don't get upright when he tells them "you won't make it with me because you're prejudiced". This is changing too.'³

Leslie Fiedler, in an important book called *Waiting for the End* quotes Norman Mailer as saying 'in such places as Greenwich Village, a *ménage à trois* was completed—the bohemians and the juvenile delinquents came face-to-face with the Negro, and the hipster was a fact of American life.' Fiedler follows this by remarking that 'it seems at first reading as if he (Mailer) were merely talking about yet another sexless union of the races, in which, he tells us "marijuana was the wedding ring" and "it was the Negro who brought the cultural dowry", i.e., jazz, "the music of orgasm". But he is trying to tell us something else; about the child born at long last out of that union, about the hipster himself, rebel-without-a-cause, pseudo-psychopath, drug-addict and pursuer of danger; in short the White Negro.

'Here, then, finally is the justification of Thoreau's boast about the friendship he describes, "so almost bare and leafless, yet not blossoming nor fruitless"; the strange fruit not of the physical miscegenation so long feared by white suprematists, but of the innocent union of Huck and Jim on the raft. And here, indeed, may be the solution to our deepest guilts and starkest quandary (making possible, without further ado, even physical assimilation, to which not skin colour but cultural and psychological differences have always been the real impediments), the resolution we scarcely dared hope for in actual life, however often we imagined it in books. In light of this, it scarcely matters whether the Negro whom the hipster becomes in his imagination ever really existed at all; for it is with the projection of our rejected self which we have called "Negro" that we must be reconciled. Moreover, a new generation of Negroes is presently learning in Greenwich Village, or in Harvard College, to be what the hipster imagines it to be,

imitating its would-be imitators. It is the kindest joke our troubled white culture has played on them; and, one hopes, the last.'[4]

Fiedler, however, has pointed out that the hipster is part of an older tradition; that the 'hipster' in fact has been in existence almost as long as America itself. In speaking of the Negro writer James Baldwin he says that 'he (Baldwin) manages to establish living connections with a pastoral American archetype older than our cities. And if we could understand him, as we must, since he stands in the centre, if not in the vanguard, of Negro writing now, we must move back to the very beginnings of our literature and beyond, to a place where legends exist, though serious literature had not been invented. And to find that place, let us turn to Henry David Thoreau, who not merely imagined, like James Fennimore Cooper, the role of a white Indian, or lived it like Daniel Boone, but imagined *and* lived that role. The most illuminating of Thoreau's books, for our purposes, is his earliest— a very odd, very duplicitous, and hence very American work called *A Week on the Concord and Merrimack Rivers*. Pretending to be the day-by-day account of a vacation jaunt, a short excursion, it turns out to be an elegy for a lost love, a praise of friendship, and a compendium of a young man's reactions to his current reading— chiefly in Oriental philosophy. It contains also (and here it is of critical importance to us) the record of what certain seventeenth and eighteenth century encounters between white men and Indians had come to mean to the romantic imagination in the mid-nineteenth century. It represents, that is to say, the moment at which the meeting of the white race and the red in the North American continent was passing from history to myth.'[5]

The relevant passages in Thoreau's book which Fiedler examines are discussions of an incident from the chronicles of an early trapper one Alexander Henry, recounting an idyllic, but short-lived friendship with an Indian called Wawwatam, and a particularily violent and bloody occurrence in the life of an early woman settler, Hannah Dustan, who, captured, saw her child

murdered, finally managed to escape by killing her captors in their sleep and returned to 'civilization' with 'the still bleeding scalps of ten of the aborigines'. Fiedler regards these two stories as constituting a specific American version of the fall of man, 'an account of original sin in the New World . . . for, if the adventures of Hannah Dustan signify the loss of paradise, the idyll of Waw-watam describes for us the paradise lost. . . . It is clear, at any rate, that deep in the mind of America, if not actually below, at least on the lowest level of consciousness, there exist side by side a dream and a nightmare of race relations and that the two together constitute a legend of the American frontier, of the West (where the second race is the Indian), or of the South (where the second race is the Negro). In either case, it is the legend of a lost Eden, or in more secular terms, of a decline from a Golden Age to an age of Iron.'

The attempt to recreate Alexander Henry's idyllic existence as a 'savage' has been a constant thread in American culture. One sees it clearly in Hemingway, and it was the factor that so fascinated D. H. Lawrence, and Norman Mailer points out that these two 'imaginary Indians' were his intellectual antecedents. It is a thread that runs constantly through the Beat writers of the '50s, and today, in the face of a developing technological society it is being physically re-enacted by an increasingly large number of people. There is, paradoxically, while society is becoming more and more automated, a noticeable and increasing movement towards a reversion to 'tribal' social units. This is very clear in the hippie 'communities' that have been springing up in recent years. These seem, though, to be of two distinct types; one a conscious attempt to experiment with new social patterns in the 'global village', and the other a less conscious dropping out, a defence against the changing conditions of a technological environment. These two extremes are evident on the one hand with such experiments in group living as *Drop City*, *Libre* and *New Buffalo*, and the essentially tribal structures evident in such urban sub-cultures as teen-age gangs and organizations like the Hell's Angels.

It is notable that such American hippie communities as the three mentioned above, unlike those in London, Amsterdam or Berlin which are urban, are situated deliberately in Indian country. As Michael Wood, in an article in the London *Sunday Times*, recently pointed out, when discussing the siting of the *Libre* community, that 'their only requirements were that it should be "epic". It is epic; at 7,800 feet, a hillside of pine and aspen, of trees called *pinon* and *ponderosa*, with a vast sweeping view of the snow-covered rockies in front and behind, the steep Olympus-like wall of Mount Greenhorn. There are mountain lions about and the occasional bear.' This community, like others, takes on a romanticized view of the Indian that is directly related to Thoreau's; *New Buffalo*, for instance consists of a village of tepees scattered on a New Mexico hillside. As Michael Wood says, 'utopian experiments are, of course, a tradition in America—the country itself is one. In the nineteenth century there were the Shakers, the Mormons, the Icarians, there was Brook Farm, there was the Oneida Community, there was Robert Owen's *New Harmony* in Indiana—people and places dedicated to rather special forms of the pursuit of happiness. The new communities like most of the old ones are precarious, they fade, collapse, move on. But there is something different in the current movement. First of all, it *is* a movement.'[6]

This constantly growing underground is both getting so large and has such a detailed set of values in common that it can hardly any longer be regarded as a mere sub-culture. The growth of the Underground Press, for instance, during the last fifteen years, has now resulted in a world-wide network of information presupposing shared assumptions. *International Times* in England, the *Berkley Barb* or *East Village Other* in America, papers in Holland, Germany, Scandanavia and Japan all contain the same blend of Utopian fantasy, partly-digested Zen philosophy, science fiction, anarchist and libertarian ideas adding up to a common set of Millenial ideas. The American versions though seem rooted in the perennial idea of the White Indian. 'We are faced', as Michael

Wood puts it, 'with a splendid circular irony. As half the world scrambles towards the Doris Day dream of the American standard of living, Americans are leaving the ship, seeking out their Indians, learning from them, like pacifist pioneers bent on giving the West back to its old lords. And as we take medicine to the Congo, some Americans are busy forgetting all the hygiene they know.'[7]

The American tradition of dissent is a Utopian one based upon non-conformist religion. The Puritans in their frontier continually fissioned off into Utopian cults. In Europe, also, dissent, political as well as social owes its birth to the Reformation; 'The last root of all sectarianism', writes Werner Stark in his Study of the Sociology of Religion, 'lies in the alienation of some group from the inclusive society within which it has to carry on its life. It is a kind of protest movement, distinguished from other similar movements by the basic fact that it experiences and expresses its dissatisfactions and strivings in religious (rather than political or economic or generally secular) terms. The causes of alienation can be many, but hunger and humiliation easily come first. All through history, the lowest ranks of society have been the prime recruiting grounds of heresies and schisms. Marxists are, by and large, within their rights when they claim that sect movements are phenomena of an ongoing class struggle in societies within which the class conflict has not yet become conscious.'[8] The typical sect, he continues to point out, bears in itself, although it is disguised the typical form of the future party. The most obvious example of this is the development in Britain of the Labour Party out of Methodism, and as an aside this explains the striking difference between the Beat poets, suspended in the tradition we have just briefly discussed, and their English counterparts of the mid-'50s. Osborne, Amis, Wain, and the other Angries, as British working-class radicals, were firmly Labour, that is to say immersed in the Wesleyian Chapel tradition; and it is not surprising that they have demonstrated creeping conservatism in middle-age, swinging firmly to the right in recent years, for Labour does not offer a

radical programme. Of the whole group, possibly only Alan Sillitoe has been able to find a genuine Socialist basis for his writing.

Radical political movements have as their forbears radical religious movements; the deprived have always in the past first expressed their dissent in cults aiming to supplant the orthodoxy of the Church. The Church, however, particularly in Anglo-Saxon countries is less of a central social force, by and large Capitalist industrial society has become aetheist; and dissent has, since the nineteenth century progressively been channelled into direct political forms. The classical media for political dissent, however, have now become themselves monolithic, and revolt is increasingly against the erstwhile libertarian wing; as the radical parties become impervious to change, it must attempt to find methods of operating outside of the conventional political structure. But vast numbers of people, in a state, as it were, of suspended or incipient social rebellion, feel totally disillusioned with political alternatives. In rejecting political action, though, they clearly possess no vehicle in which to express dissent; and in order to discover one it would seem that they attempt to reverse the process described by Werner Stark, and go back from the political to the cultist. No longer Christian, however, they must invent their own religions. This assumption would appear to explain the quasi-mystical quality demonstrated by much of the Underground, the 'pot' imitations of Indian ritual *à la* Leary, Zen and meditation, mantras and the Maharishi, Tolkein and tantra, ritual and psychodrama.

In recent years the defining lines between the boundaries of various art forms have become more and more blurred. To a certain extent painting and sculpture have become enmeshed with each other, and with a great deal of work it is no longer possible to classify individual art objects; *environment* and *participation* are frequent critical catchwords. Poetry, also has become abstracted, relying often on visual patterns across the page while the boundaries between verbal and musical imagery are no longer as sharp as they used to be. Earlier poetry was of course always 'musical' in that it responded to the cadences and rhythms of the human voice, the sound patterns of 'concrete' poetry, however, owe their origins more to synthetic or accidentally discovered noise, the overheard sounds of city life, of traffic for example. *Avant-garde* music has learnt the collage techniques of the plastic arts, and the tape recorder has enabled it, as it were, to spill over into other disciplines. A similar pattern is very obvious in the theatre, from Brecht and Artaud onwards the drama is conditioning a new relationship between the stage and the audience.

This drift towards multi-media is most evident in the area known as Happenings, which as defined by Al Hansen, one of the originators of the idiom, are 'theatre pieces in the manner of collage, and that each action or situation or event that occurs within their framework is related in the same way as is each part of an Abstract Expressionist painting.'[1] Here the collage moves out of a purely static position conditioned by the assembling of objects; it now has the added dimension of time and event. Happenings as we now know them developed during the middle to the late '50s in America. There were, of course, earlier precedents; the provocative goings-on at the Cabaret Voltaire in Zurich from 1916 to 1919, where Hugo Ball, Tristan Tzara, Richard Huelsenbeck, Marcel Janco, Hans Arp and others anticipated much of what was to happen in the 1950s.

The orientation was different, however. Zurich Dada, and its parallel manifestations in New York, Barcelona, Cologne, Hanover, and Berlin was, in general, like that of Alfred Jarry

before them, an anarchic protest against bourgeois society exacerbated by a disillusionment and pessimism engendered by the war. Though the Futurists anticipated them in certain areas, particularly in typographical innovations and strident manifestoes, they were the first 'urban guerrillas', the prototypes of the Portobello Road anarchist who maintain a sort of social terrorism by aerosoling in large lettering on walls and hoardings such slogans as the one recently noticed in North Kensington; 'Crime is the Highest form of Sensuality'. This original Dada role of somewhat nihilistic provocation was deviated from by only a few individuals such as Duchamp and Picabia who searched for a philosophical basis and justification, and John Heartfield and his Berlin colleagues who transformed Dada into a political and polemic weapon in the climate of actual revolution in 1918 Germany.

Dada was on the whole orientated to literature; it was at the first major Dada evening that Hugo Ball is supposed to have 'invented' abstract phonetic poetry, a recitative consisting only of rhythmically uttered vowel and consonant sounds. Later Huelsenbeck, Tzara and Janco were to perform *poèms simultanés*, which in Ball's words are 'a contrapuntal recitative in which three or more voices speak, sing, whistle, etc., simultaneously, in such a way that the resulting combinations account for the total effect of the work, elegaic, funny or bizarre. The simultaneous poem is a powerful illustration of the fact that an organic work of art has a will of its own, and also illustrates the decisive role played by accompaniment. Noises (a drawn-out rrrr sustained for minutes on end, sudden crashes, sirens wailing) are existentially more powerful than the human voice.'[2]

As far as the visual arts were concerned the Dadaists were mainly concerned with promoting (at first, that is, in their comparatively provincial Swiss backwater) the already existing *avant-garde* of Paris and Munich; the early exhibitions they mounted consisted of works by the *Der Sturm* Group, and of one-man shows by Klee and Kandinsky. Though not in terms of the visual

arts, the latter was a considerable influence through his ideas of *Gesamtkunstwerke*, the 'total' work of art, embodying what up until then had been disparate disciplines. In Kandinsky's case, of course, the preoccupation was in the confrontation of music with painting. The actual use of the plastic arts was restricted in the Zurich events to the costumes and masks designed by Janco and to the adoption of Futurist typography. Hans Arp was the exception, developing the ideas of 'chance' already implicit in their theatrical events, and it was at this time that he made his first collages by tearing paper into random forms, letting them flutter to the ground and gumming them into the position into which they had fallen. Some of these were later developed into his characteristic wooden constructions. He also experimented with a sort of early assemblage, 'nailing pieces of wood . . . onto oblong box-like lids. He found some wooden rods, coloured variously by age and dirt, and set them side by side to produce their own kind of harmony'.[3]

Duchamp also, of course, was concerned with chance; his famous *Stoppages Etalon*, his own private units of measurement, were made in 1916. Questioning that one should accept the metric standard as unchanglingly and absolutely valid, regarding that bar of platinum kept under conditions of controlled temperature in the basement of the Bureau of Weights and Measurements in Paris as being somewhat 'arbitary', he produced with a careful and ironic seriousness 'a new form to the unit of length'. Taking a thread one metre in length, and dropping it onto a canvas from a height of one metre, he fixed it to the surface with varnish. This was repeated three times, and from these chance forms wooden 'rulers' were made, indicating with all the precision of surveyor's instruments the shapes discovered in this way.

Chance, perhaps, interested Duchamp in a rather unique way, as Calvin Tomkins has pointed out. He writes that Duchamp believed 'that chance is an expression of the subconscious personality. "Your chance is not the same as my chance", he has explained, "just as your throw of the dice will rarely be the same as

mine." When Duchamp and his sisters Yvonne and Magdeleine amused themselves in 1913 by drawing the notes of the musical scaled at random from a hat and then setting them down in the order drawn, the resulting composition, which they called *Musical Erratum*, was in Duchamp's mind a lighthearted expression of their own personal chance rather than a purely random creation.' [4]

This comment of Tomkins' is particularly interesting in that 'aleatory' music, to use the phrase coined by Boulez, has had the most profound influence on the visual arts, for there has been a feed-back situation between painting and the music of the *avant-garde*. It is at this point that the importance of John Cage must be stressed. Predecessors such as Varèse and Satie, of course have been associated with modern art. Varèse, for instance, developed from the interest in percussion music of the '20s, remembering that the Futurist Luigi Russolo called for an 'art of noise'; his *Ionization* of 1931 is an important work in this context. Satie, through his ironic inventions and deliberate subversion of accepted musical canon, is clearly related to Dada. Cage, much influenced by these two, and trained by Schönberg, was the first, however, to consistently explore elements of chance, and created the idiom now widely followed by such composers as Stockhausen, La Monte Young and Chiari.

It was in the early '50s, when writing music for the followers of Martha Graham, dancers like Merce Cunningham with whom he built up a life-long collaboration, and who was the first to take the composer seriously, that he stumbled upon the *I Ching*, the Chinese prophetic 'book of changes', where guidance is elicited from the chance configuration of thrown twigs or, traditionally, yarrow-stalks. Here the aleatory element joins with a concern about Oriental philosophy which was soon to become a dominant element in the *avant-garde* scene. For instance, one of Cage's best known techniques of composition was to use transparent sheets on which were inked 'lines, dots or biomorphic shapes; the lines and dots were understood to refer to the various aspects of sound

that would be used, and when the performer superimposed one sheet over another, the intersection of the lines and dots on one of the biomorphic shapes on another would give him the information he needed to "compose" the piece. Since Cage had no idea how the performer would superimpose one sheet over another, he could not foresee what would take place. Implicit in this whole process, he has explained, is the Buddhist belief that all things in the world are related and thus *relevant* to each other, so that no matter who used the transparencies or how he used them, each performance would be simply another aspect of the same (indeterminate) work.'[5]

A certain philosophic approach conditioned by Chinese magic and Zen Buddhism is also apparent in his use of 'silent' music, particularly in the much-discussed piece entitled 4′ 33″, a silent work for the piano where the performer sits for this length of time perfectly still at his instrument, except for solemnly closing the lid of the keyboard three times to mark the divisions between sections of the work. Here the 'music' consists entirely of random sounds filtering into the concert hall together with those contributed by the audience in the form of coughs, shuffles and other noises. Cage had once visited a totally sound-proof room in the physics laboratory of Harvard University, and was surprised not to find the dead and absolute silence that he had expected. Instead he heard two distinct and continuous sounds which he was told were noises made by his blood circulating and by the operation of his nervous system. He began to see music as something that was continually present, permanently in a flux with other aspects of perceptual experience, indeed he came to regard it only as part of a total experience, and that its expression in art must become something rather in the nature of theatre. 'Theatre', he once said 'takes place all the time wherever one is, and art simply facilitates persuading one that this is the case.'

In this he was close to the ideas of Robert Rauschenberg, who in his early 'field' paintings of 1952, saw the canvas as a sort of mirror which recorded aspects of the environment, a work in the

process of permanent creation by events taking place outside of the picture. 'I always thought', he said, 'of the white paintings as being not passive, but very—well, hypersensitive. So that one could look at them and almost see how many people were in the room by the shadows cast, or what time of day it was.'[6]

The meeting between Cage and Rauschenberg at Black Mountain College and their joint collaboration with Merce Cunningham, was to be very fruitful. Similar ideas to that of the composer were expressed by the painter when he made his much quoted statement, 'Painting relates to both art and life. Neither can be made. I try to act in the gap between the two.' Rauschenberg also wanted to step back into some sort of anonymity in the face of the picture itself, to take an opposite standpoint to that of the emotional self-expression of the Abstract Expressionists. He speaks of *collaboration* with his materials, 'I don't want a painting to be an expression of my personality . . . I'd really like to think that the artist could be just another kind of material in the picture . . . I don't want a picture to look like something it isn't. I want it to look like something it is. And I think a picture is more like the real world when it is made out of the real world.'[7]

This insistence on 'realism', like Cage's incorporation of actual pre-existing sounds, is perhaps not sufficiently emphasized in the average consideration of the art today. It is here that a distinction can be made between two separate trends. The direction we are considering at this moment, though technically enormously different, can be regarded as a descendant of much 'realist' art of the past. It is distinct from the parallel direction which is subjective and 'idealist' in nature. Frequently works from one category are confused with works from the other as the result of similar technical aspects or superficial qualities. A lot of pop art, for instance is clearly 'idealist', while some hard-edge is 'realist'; the question revolves around intentions, and is basically the dichotomy between existence and essence which we shall discuss in the next chapter.

The collaboration between Cage, Rauschenberg and Merce

Cunningham led to a series of 'theatre' pieces dependent on random events during 1953 and 1954. The term Happening had not then been coined, this was to wait another four years when circumstances brought a particularly talented group of young artists together in one of Cage's classes at the New School for Social Research in New York. Al Hansen, Dick Higgins, Allen Kaprow and George Brecht were all enrolled, and they also brought in friends such as George Segal, Jim Dine and Larry Poons. These young artists developed the idea of the collage event in various directions, exploring audience participation and 'total' theatre.

'The Happening is about man's displacement from order', writes Al Hansen. By this he clearly intends a social comment, even a political one; one imagines that the 'order' spoken of here is thought of as being some sort of utopian condition, and the 'displacement' a fall from grace engendered by the alienation of the individual in a bourgeois and Corporate society. 'I realized', he has also written, 'that nationalism, with its unwieldy, unrealistic morals and hypocritical values, was crumbling. In its rise from the Renaissance, nationalism carefully took art out of life and made it the establishment's private property. Now there are neo-Dada, found objects assemblage, collage, happenings, *musique concrète* sound collages—all are life things, life events becoming art, putting art back into life . . . we thrive on crisis, corruption, the revolutions are piling up on each other. From the poorest individual unit of this great pachinko game called democracy to the largest G.M.-like corporate entities, all is for private profit rather than for the good of everybody. The rich get richer, and the poor get poorer. The incredible thing is that so many poor people are content! This is probably the worst charge that can be made against education. . . . Human misery stems from the great sense of alienation from the natural order of the universe. Happenings, and indeed all other art, operate best in terms of an awareness of this natural order. This one-ness called in Zen *satori*. The casual mind considers the typical Zen hip parable as a nonsense joke. Rather than a rejection of reason, it is really a trip through the central processes of reason.'[1]

Hansen is firmly linking the practice of art with a radical social and political platform; this is not an attitude that is unique to this one artist, but is a commonly-held platform through the whole area of Happenings. Art is here considered as something which not only has a 'presence' inseparable from life, but also as a social activity operating directly onto the environment in a programmed manner. More than the polemic, which merely advocated change, it is intended to be the instrument of change itself. The loosely plotted 'total' theatre, the event constructed like a collage in

various dimensions, provoking the audience into participation, frequently has a cathartic effect. The thinking behind Happening theory does not only take in political elements from the New Left as one might expect it to do, but also picks up aspects of recent developments in psychiatry. Hansen, himself, points out that occasionally performers get over-emotionally involved, and in his book he draws parallels between Happenings and Gestalt or Group Therapy as well as the dynamics of crowds.

This element of 'psychodrama' is in itself an illustration of an inclusive multi-media approach, for there are certain 'existentialist' psychologists such as Ronald Laing whose teaching and practice seem to bridge into the same root areas as Happenings, and whose works are widely read by artists and other members of the Underground. It is perhaps this link with Existential Psychology, that departure of recent years which regards mental illness as constituting a disturbance of *Being*, of the individual as divided against himself rather than alienated from society and his fellows, which gives us a pointer to the fundamental difference between the original Dada manifestations and the Happenings of the 1950s and onwards.

We have already noted that one of these appears to be 'idealist', and the other 'realist'. Modern philosophy, and specifically Existentialism, distinguishes between two metaphysical principles, Essence and Existence. 'The Essence of a man in what he *is*, that is to say a living organism with certain human characteristics. When we speak of an object's essence we are referring to the characteristic it shares with all objects of a similar kind. These constitute its universal characteristics, and when we are talking of the universal characteristics of a man, we are referring to the characteristics which he has in common with all humanity. In addition to these universal characteristics, he possesses also certain individual features by means of which we distinguish him from other human beings. But as Paul Fontguré has pointed out in his small volume on Existentialism, Essence does not necessarily carry with it the assurance that such things are actualized—that

they exist. *Existence is, in fact, that which actualizes Essence* "Our use of language clearly reveals this distinction of the two metaphysical principles in things. When I say 'I am a man', 'I am' affirms Existence; 'man' designates Essence." . . . The problem which the existentialist is attempting to solve, and which he does solve in a certain way, is the following problem: when a man is in question, to which of the two principles should primacy be given, to his Essence or to his Existence? Up until the nineteenth century, philosophers never doubted the primacy of Essence and this being so we can call them Essentialist philosophers. What distinguishes the Existentialist from the Essentialist philosopher is that the former always accords primacy to *existence*.'[2]

It is not necessary in this essay to go deeply into the problems of Existentialism, save for commenting that from its inception with the Phenomenology of Husserl onwards its development has paralleled that of the modern movement in art, an important point which we shall return to later; the foregoing definition by Kenneth Walker quoted from his book *Diagnosis of Man* is sufficient for our present purpose. If we consider this distinction between Essence and Existence we can throw a clearer light on the apparently confusing situation of the plastic arts at the present time.

From the statements of Cage, Rauschenberg and Hansen, it is perfectly clear that a body of work has developed over the last fifteen years or so that 'accords primacy to *existence*'. Following Rauschenberg, and to a lesser extent Jasper Johns, neo-Dada assemblage and 'event' art became a dominant movement in the States. Of course, America did not hold the monopoly for this development; a group of European artists known as *Cobra* mounted some events in the late '40s, and during the '50s the *Situationist* and *Léttriste* movements also mounted early proto-Happenings. The *Situationists*, who still exist as an active force, are a loose grouping of intellectuals and artists of an extreme Marxist persuasion, while the *Léttristes* have long been concerned with concrete and sound poetry. The activities of the *College of Pataphysics*, a post-Surrealist joke-serious organization, heavily com-

committed to a particular form of Gallic irony and drawing its inspiration from Alfred Jarry, can also be said to have been active in this area. These groups were by and large descendants of the actual Dada tradition of the '20s, but, as in America, a change of intention became evident during the middle '50s, and the Happening as a definite existentialist act became evident. Paralleling the appearance of Hansen, Kaprow, Oldenburg and their colleagues in New York, various individuals began to stage events in Europe; Gustav Metzger, and John Latham, in England, Yves Klein, Tinguely and Jean-Jaques Lebel in France, Wolf Vostell in Germany, Boudnik and Knizak in Prague, Enrico Baj and Sergio Dangelo in Italy.

It must not be thought that the European events were at first under the direct influence of New York, though this was to be the situation later on. The two centres of development were more or less separate until their meeting round about 1958 during which year Hansen, Kaprow and others met up in John Cage's classroom, and Pierre Restany formed the first theory for the group of New Realists in Paris, consisting of Yves Klein, Arman, Martial Raysse, César, Tinguely, Hains, Daniel Spoerri, Villeglé and Dufrêne. Like Rauschenberg the Europeans were concerned with working out of 'the real world', but also they have been more concerned with ideas about change and movement; kinetic art, originating with Gabo and Maholy Nagy. The influence of Oriental mysticism and Zen are less obvious as one would expect, on the Continent, and the direct acknowledgement to Existentialism more overt than in the American version. 'Maybe it is possible', Jean Tinguely has said, 'to make things that are so close to life that they exist as simply and as changeably and permanently as a cat jumping, or a child playing, or a truck going by outside, and if so I would very much like to make them. Life *is* play, movement, continual change. Only the fear of death makes us want to stop life, to "fix" it impossibly for ever. The moment life is fixed, it is no longer true; it is dead, and therefore uninteresting.'[3]

It is from such a premise that Tinguely has made his 'impossible'

machines, which are less works of art than symbols for a certain attitude of mind. Frank Popper has spoken of this, 'Tinguely gradually accumulated the elements of his vocabulary. First he made the discovery of the "machine" which for him is a being that incarnates human *intelligence*. Other aspects which impressed him were the sculptural beauty of these constructions and their *movement*, the metamorphosis of the machine developing into a more comprehensive dynamism in the spectacle. Literary notions such as Gide's *acte gratuite* and the interpretation of the myth of Sisyphus by Camus could be added. But Tinguely wanted to go further. For him a true demonstration would at least have to be doubly absurd, before reaching the *summit of absurdity* by its own logic. So he conceived machines which would work for nothing (*pour les pommes*, Tinguely says) and secondly these machines would have to *destroy themselves*. In this way Tinguely avoided the pitfall of demonstrating in protest against an existing—and therefore already acceptable—situation, in which the symbolism would be no more than photographic. In fact Tinguely managed to make his demonstration a mirror of the absurdity and the necessity of the social and psychological situation, but also the absurdity of this absurdity—thereby giving a lead towards constructive ideas and manifestations of truth and liberty.'[4]

The remarkable English artist Gustav Metzger, who has long been concerned with the elements of change and movement, and who was probably the first artist to use the phrase 'auto-destructive art', parallels the aesthetic of Tinguely. Through the idiom of his plastic and nylon structures disintegrated by acid, he expresses a fiercely radical attitude to permanence. 'Auto-destructive art', he writes, 'is a public art. It has connections with the ritual of the past. It should be placed where it can be seen by masses of people, in the open air or inside buildings . . . by providing a socially sanctioned outlet for destructive ideas and impulses, auto-destructive art can become a valuable instrument of mass psychotherapy, in societies where the suppression of aggressive drives is a major factor in the collapse of social balance.'[5]

We can see on the evidence of Tinguely, Metzger, Latham, etc., with their constructions and assemblages of junk, art existentially concerned with the idea of impermanence, with the ambiguity of human and social relationships. That values are impermanent and that part of the artist's function is anarchic, was of course already pointed out by the Dadaists. Jasia Reichardt notes what is essentially a political re-orientation. 'The great difference', she writes, 'between the gesture of auto-destructive art and Dada is that, whereas the exponents of Dada were mainly nihilistic in their intentions, those behind auto-destructive art are to demonstrate with a similar method—the idea of perpetual impermanence. It is really a protest. A protest against adjustment in an unjust society, a protest against standardization of values, against rigid canons of taste.'[6]

Metzger's belief that art can be, indeed must be, a political action, is implicit in his behaviour. We have already noted the importance of the Committee of 100 in the development of the New Left. Metzger was central to this activity; in fact it was he who coined the name for the movement as he was at that time studying the art and politics of the Renaissance, and he drew a parallel with the historical Guelph 'Council of 100'. And as far as the role of his own art activities are concerned he has written elsewhere, 'Auto-destructive art is a comprehensive theory for action in the field of the plastic arts in the post war world period. The action is not limited to theory of art and the production of art works. It includes social action. Auto-destructive art is committed to a left wing revolutionary position in politics, and to a struggle against future wars.'[7]

This idea of art as 'committed to a left-wing revolutionary position in politics', is perhaps the one genuine Socialist art that is possible at this time. Socialist Realism has long since drowned in its tractors and blond proletarian heroes, foundered because it has refused to recognize the aesthetic imperatives of history while recognizing the social ones. Even at its best, the Mexican muralists for example, it tends towards an inflated bombast divorced from

the individual human condition. In all cases it has fixed its aim on the abstract ideal, on the Essence and not the Existence. Tinguely's self-destroying machines, on the other hand, being concerned with Existence, are able to take a committed political platform which works *precisely* because of their aesthetic content. 'If the works of the smallest dimension,' writes Georges Boudaille, in respect of this artist, 'can be considered as collection objects, sometimes amusing and often tragic, their value arises more from what they want to suggest than from what they are intrinsically. The proof lies in the distain of the *matière* and the technique with which he executes his work. His machines are condemned to destroy themselves, just as our civilization bears within itself the germs of its death. To share his anxiety, the anguish of our civilization in the face of its menacing danger seems to me to be the aim of Tinguely's entire work; he has composed (August 1962) a new spectacle for N.B.C. Television in the Nevada desert, the birth-place of the atom bomb.'[8]

The sense of ambiguity of the human condition in society which gives rise to political action is not merely concerned with the individual's relationship with his environment. It begins to question the nature and permanence of that environment itself. In considering the idea of the ambiguity of matter, which would be the logical progression, we are led directly into the territory touched upon by such artists as Yves Klein, Arman, Manzoni, and, particularly Fontana, and collide headlong with the *Principle of Indeterminacy*, perhaps the most far-reaching and influential single idea of our epoch. Heisenberg discovered in 1927 that, within certain dimensions of time and space smaller than a specific range, it became no longer possible to make observations. The actual presence, the speed and direction of an electron, he discovered, could not be observed—for the act of observing, itself, introduced other factors which played upon the object observed and altered its behaviour. Since direct observation could only be effected through the use of light or some other band of the electro-magnetic spectrum, and the introduction of a wave

complex must interfere with the electro-magnetic behaviour of the electron itself, matter (and by extension reality) cannot, at this level, be observed. Its attributes may only be deduced by the traces it leaves in its passage through time and space. 'To pry into the secrets of this world', says Banesh Hoffman, 'we must make experiments. But experiment is a clumsy instrument, afflicted with a fatal indeterminacy which destroys casuality'.[9]

Here the ultimate objective solidity of the universe, and the individual human being's capacity to apprehend it personally, concepts which have been axiomatic throughout history since the Renaissance, begin to become fluid. Reality which has always previously been subject to actual experimental test and observation, becomes ambiguous. 'The Universe', maintains James Jeans, 'begins to look more like a great thought than a great machine, the old dualism of mind and matter seems likely to disappear . . . in our time matter has become spiritualized and the spiritual materialized.'

The very *Principle of Indeterminacy* was endemic to the work of Klein, Manzoni and Fontana during the '50s. These artists seemed to be aware of the inability to observe more than the *mark* that action and experience left behind their passage, and they set out to record these imprints. Klein's theatrical stunts of apparent publicity in covering nude models with oil paint, and then rolling them across a canvas, were less frivolous than they might immediately appear; and his act of making a picture by means of strapping a wet, freshly-primed, canvas to the roof of his car and driving from Paris to the Riviera in a thunderstorm, in order to record an imprint of the actually existant natural forces, was a logical result of certain philosophical implications of that time. If reality cannot be observed through the medium of our senses, he seems to say, the traditional idea of the artist as interpreter is obsolete. What, therefore, can he do? He can record evidence, certainly—but this is what the scientist does with his gifts of organization and empiricism. What can the artist do with his gifts of intuition and apathy? Ah! He can *choose* what to record; and in

so doing, create the reality of his choice. And as for observation, he can observe his own perceptions rather than the blank face of objective reality, and in this last development the artist takes up the post-Sartrean approach to Existentialism, particularly as it is exemplified by Merleau-Ponty in his *Phenomenology of Perception*.

We shall speak later of Kinetic and Op art, but at this point it is worth commenting that in these areas it is perception itself that is the subject matter of the art-work, and that work of this nature is concerned with Existence not with Essence. It might seem a paradox for a moment to state that work by Rauschenberg, Fontana and Vasarely spring from allied roots, but they all have as their central subject matter the three-way perceptual relationship between artist, spectator and object, and it is by and large this process of perception that is the 'content' of the work. These are not, as we have seen, stylistic questions, for though by and large work descended from Cubsim and Constructivism confront the spectator as 'integrated' objects, often referring with symbolism to values outside of themselves, one cannot make of this an absolute rule. In the same way, work descended from the Romanticist-Dada-Surrealist stream does not necessarily fit into the sort of network category we have been discussing; a lot of Pop art is clearly concerned with representational symbolism, and therefore has at its point of departure Essence rather than Existence.

To return briefly to the 'phenomenological' artists, who for some reason have always been particularly strong in Italy, greatly influenced by the *Spazializmo* of Fontana, one notes Castellani, Bonalumi and Simetti, but it is probably Manzoni, who died five years ago at the age of 30 who was outstanding. The idea of 'the evidence of the presence', the trace and mark, was central to this very talented artist who poured out a constant stream of disturbing and paradoxical objects with almost a Duchampian presence. Similar ideas of 'surface' and spatial ambiguities are also central to the German artists of the *Zero* Group, to which Klein and Tinguely also belonged, Mack, Uecker and Piene, and their

followers the Dutch *Nul* Group of Henk Peeters, Schoonhoven and others; as are they also to the work of the Israeli artist Hoenich, who creates artworks out of the random configurations of sun, light and wind in the desert. Behind them all stands the figure of Fontana, whose obsession with the holes, marks, rents and tears that tools (representing, perhaps objective matter, the true subject material of the painting) makes on the surface, has provided a fertile direction for the younger artists to work in.

8 'It serves us right if we are given only what we ask for: the motley wrappings rather than the concrete core'

Herbert Read, writing just after the war, commented on the intimate relationship between Existentialism and modern art. He quotes Picasso's famous dictum; 'The important thing in art is not to seek, but to find', and he goes on to say that this statement might be given 'as the motto of the whole movement. The artists projected themselves into the future, into the unknown, not knowing what they would find, relying on the concrete evidence of their senses to find a way to the genuine work of art. It might be here remarked that this attitude was anything but idealistic—it was, in fact, very much the attitude now defended by Jean Paul Sartre, on the philosophical and political plane, as existentialist. Sartre's philosophy is said to derive from Heidegger's philosophy, but to a considerable extent I believe it to be a philosophical synthesis based on the practical activity of modern art. It is not without significance that it is precisely in Paris, where the revolutionary attitude in art has prevailed so long, that this new philosophy has arisen.'[1]

From the point at which Read was talking, referring on the whole to Parisian Tachism, the intellectual adventure of our epoch has been in its essentials a voyage, phenomenologists to the fore, into that ambiguous half-territory between the subject and the object, between *me* as an autonomous identity and *that out there*, that which is palpably *not me*. In optical or kinetic art, since the aesthetic effect is the result of an interaction and takes place retinally, it is clearly apparent that the 'art' itself exists separate from the circumscribed and objectively perceived *thing*. The phenonema, the experience even, is not to be found either within our own subjective, condensed and walled-in selves. It would seem to occur in some unidentified location between these two separate states of actuality. It would seem to be a process; to be, not a fact, but rather an event. Created by the tensions between the subject and the object, the me and the not-me. It is suspended in a cats-cradle of perceptual forces out of phase with, or just to one side of, our habitual grasp of linear space and time. It has been suggested that art of this sort is in no-place. It does not

concern itself with the before or the after. It may even be possible to see duration and location as 'effects' of art, rather than the other way round.

'Matter' painting, what Michel Tapié called *art autre*, sometimes superficially appears to be merely recording objective visual data perceived in terms of traditional realism, arriving at a sort of vastly expanded detail of a directly perceived object. And, as such, the work occasionally gives the viewer the impression of being an enlarged fragment of a traditional painting. What an artist such as Burri or Tapiès is doing, though, is objectifying reality in an existential manner rather than simply recording it. It is the *Other* that in his subject matter, that alien, unyielding matter which confronts man, and which isolates him, defining his existence. That matter was not as solid as it appeared to the sense-data did not disqualify its objective presence; the minute particle has location after all. However, new ideas have recently been put forward by the physicists—it looks now as if matter cannot be regarded as being located in space and time after all, but that space and time are attributes of matter.

To quote Banesh Hoffman's exposition of this idea, '. . . the air pressure in our automobile tyres is but the statistical effect of a ceaseless bombardment by tireless air molecules. A single molecule has neither temperature nor pressure in any ordinary sense of the terms. Ordinary temperature and pressure are crowd effects. When we try to examine them too closely, by observing an individual molecule, they simply vanish away. Take a smooth flow of water. It too vanishes away when we examine a single water molecule. It is no more than a potent myth created out of the myriad motions of water molecules in enormous numbers. So too it may well be with space and time themselves, though this is something far more difficult to imagine even tentatively. As the individual water molecules lack the everyday qualities of temperature, pressure and fluidity, a single letter of the alphabet lack the quality of poetry, so perhaps may the fundamental particles of the universe individually lack the quality of existing in space and time;

the very space and time which the particles themselves, in the enormous aggregate, falsely present to us as entities so preeminently fundamental we can hardly conceive of any existence at all without them. See how it all fits in now. The quantum paradoxes are of our own making, for we have tried to follow the motions of individual particles through space and time, while all along these individual particles have no existence in space and time. It is space and time that exist through the particles. An individual particle is not in two places at once. It is in no place at all.' [2]

Can this idea of regarding space and time as a statistical 'crowd effect' of matter be behind the images of interpenetration and exchangeability of mass and movement in recent painting and sculpture? Is the sequential, semantic element allied to a disintegration or ambiguity of surface in much contemporary art the result of an intuitive grasp of such new thinking about the nature of the physical universe?

Hard-edge painting, one-art systems, reductionist and other groupings that fall under the general heading of Minimal art occupy a position diametrically opposed to the work we have been discussing. Where the 'phenomenal' direction in painting and sculpture is concerned primarily with the perceptual experience itself, the aesthetic event resulting from the confrontation between spectator and object, the formal mode is concerned with the absolute presence of the object as an autonomous identity. Where the first is concerned with Existence, the second is in the older tradition of Essence. There is a fundamental Platonic quality evident in all purist or geometric abstraction. The re-assessment of space implicit in Cubism was quickly seized upon by the Russian Constructivists and Suprematists, as well as by the Dutch De Stijl Group. Analytical and other post-Cubist styles basically developed from the search for absolute objectivity. The 'classical' line was to 'capture' reality, as opposed to the 'romantic' line followed by the Expressionists which was to discover emotive symbols for it. In both cases, of course, it was the language of *form* that was the vehicle for the two processes.

Constructivism, in general, is however, finally less interested in a subject matter which is actually existing, than in one which is *ideal*. There is here a method of transcendence, of heightening the perceived and objectively real. This Platonic element is noted intermittently from the architecture and sculpture of the Mediterranean Classical world, through the Renaissance mainstream onwards, in Piero della Francesca, Poussin and Ingres; a continuous tradition reaching up to date. The mathematical perfection of relationship symbolizing an 'ideal' reality behind appearances clearly has its relevance in our technological age. The Futurists were excited by the machine as we know, but clearly in a romantic and deliberately anti-Platonic manner. The machine was for them a symbol of speed, of violence, aggression and destruction. Marinnetti wrote in 1909, announcing '. . . a new beauty . . . a roaring motorcar, which runs like a machinegun, is more beautiful than the *Winged Victory of Samothrace*'.[3] The Russian Constructivists and Suprematists developed out of Parisian Cubism, taking it to the next logical stage of development by exploring the possibilities of collage. But they also welded two apparently opposing tendencies together, incorporating the emotionalism of the Futurists with the formalism of the Cubists. In the *Realistic Manifesto* of 1920, the year of the first big Constructivist exhibition, the idea of Archipenko and Boccioni that it was movement rather than volume which was of the prime importance in art was restated.

With this confrontation between Futurism and the Platonic tradition, the *Winged Victory of Samothrace* was, as it were, rehabilitated, but with a new dimension—one could say that she was now automated. A very complete awareness of the Platonic ideal can be found in the thinking of the Dutch De Stijl Group, whose activities paralleled the developments in Moscow. As their first manifesto of 1918 has it, '. . . the new art has brought forward what the new consciousness of time contains: a balance between the universal and the individual. . . . The new consciousness is prepared to realize the internal life as well as the external life.'

Writing on the occasion of a recent exhibition in London, a historical reassessment of the Group, Bernard Gay remarks, 'Cubism, which led Mondriaan to neo-Plasticism, was a fundamental source. For Mondriaan, absolute abstraction was the logical development of Cubist experiments. His direction was that which he claimed the Cubists were unprepared to follow. . . . The members of De Stijl saw in a machine perfection and uniformity of which the hand of man could not be capable. They saw society organized in a more and more abstract way; the blueprint became its symbol. In the mechanistic world, a building is personally finished with the drawings. Like music, which is complete when the score is complete, the building existed as a work of art before it had been built. Such thoughts led the artists of De Stijl to the belief that the personal performance in a painting, for example, was of no relevance. It was the general universal concept that was more important—universal harmony. Within such ideas and concepts, one can see how easily all the arts can be embraced; had to be embraced, to create a universal harmony of equally significant parts.'[4]

We may regard Essence as being the result of considering the art object as a self-contained symbol pointing towards a more ideal condition. This is a condition that was fundamentally 'spiritual' in nature between the Renaissance and Cubism, and one that was largely 'social' since then; for the Constructivists thought in terms of architecture, regarding art as a way of manipulating the environment. This was quite evident in the Russian period before 1924, when the theory was directly related to the revolutionary idealism of early communism. Essence, we may also note, has been the source of the conventional art-historical approach through the years since Roger Fry and Heinrich Wöfflin evolved the concepts of 'significant form'. Indeed this is still the official art-historical line that is in evidence today, the one insistently presented in art institutions, art colleges and schools. Gene Swenson has pointed this out in his extremely important essay *The Other Tradition*, 'Very few critics and historians', he says, 'almost no Americans, outside

the "literary" establishment view the history of twentieth century art as anything but the development and evolution of significant form . . . Dada and Surrealism in the minds of most historians is a diversionary tactic, healthy only insofar as it illuminates the "main" tradition.'[5] This fact, as he emphasizes, makes for some difficulty and confusion in the consideration of works which lie outside of the 'main' tradition, which are in the area that I have defined of as being concerned with Existence, and for which he has coined the term 'The Other Tradition'.

Pierre Rouve raises much the same question by approaching the problem from a different direction. 'Criticism has sadly lagged behind the evolution of art', he says, 'particularly in countries chained to empirical descriptions of paintings but alien to the metaphysical core of painting. And above all—of abstract painting (domain of the invisible reverberation of the visible). But metaphysics is still a dirty word for many ears stuffed with nineteenth century Positivist cotton-wool. To talk about a visual configuration as a "revelation of its being" is to incur the wrath of those who still maintain that perception is the end and not merely the tool of visual communication. If we exclude this spiritual self-revelation of the work of art from our considerations, how are we to draw a line between skin-deep beautifications and profound inner density? If we cast aside all ontology, we are left with mere technology. We have no choice but to discuss acrylic dyes, sweet colours, swivelling quadrants and strong textures. Out Texts remain weak; we slide on the surface forcing the artists to keep us company. We toss about famous names, but we treat them as purveyors of ready-to-paint forms and not as teachers of spiritual disciplines that have generated those forms. Instead of searching for significant essences, we indulge in parasitic descriptions of meaningless appearances. Our philosophical illiteracy and our linguistic banality have made of us dismal defenders of shallow decoration, paladins of expressive dumbness, knights of wallpaper aesthetics. It serves us right if we are given only what we ask for; the motley wrappings rather than the concealed core.'[6]

Formalism today, particularly in sculpture, seems to be taking on eclectic characteristics. The very meaningful dicta of Mies van der Rohe 'less is more' can so easily degenerate into mannerism. Recently we have had in England a plethora of open air sculpture exhibitions. In the City of London, in Coventry, Bristol, Southampton, Liverpool and in other cities large reductionist sculptures have been pitched against the pavements, buildings and traffic of the urban environment with positively mixed effect. Sculpture conceived ideally for the negative and aseptic interior spaces of galleries often cannot hold their own in terms of presence and monumentality against street furniture. At one such exhibition this present writer came away realizing how 'beautiful' a G.P.O. pillar-box was. Along with the reduction of content can also come a concomitant reduction of aesthetic demands in terms of judgement. And in this way one can sometimes arrive at a 'psychedelic' state in which all objects possess equal meaning, particularly when one is 'turned-on' by objects without discrimination.

This is partly due, no doubt, to the 'sameness' of so much contemporary minimal sculpture, to preoccupations with related and frequently banal spatial problems. A work by one artist will be concerned with painted sheet metal plates that are straight and angular, one by another that are curved and sinuous. In both cases the formal problems are almost identical, edges drawn in space and defining movement, the end results being stylistically almost indistinguishable. It is quite a common experience, when considering a catalogue or a photo-spread in an art magazine covering one of these open-air group sculpture exhibitions, to have the feeling that, though the show is concerned with the work of many artists, one is looking at an article about a one-man show. This sort of 'sameness', this anonymity of authors, is a mark of mannerism.

The American critic Peter Hutchinson has defined the development of neo-Mannerism in contemporary work, noting its appearance in the use of cliché, acid colour, drama and 'high technique' in certain post-hard-edge and Op works. 'Contemporary

Mannerist work', he remarks, 'sometimes gets so extreme in its use of acid colour, exaggeration of shape and in its drama that it appears hysterical. Indeed in today's reaction against Romanticism, against Freudian explanation, against purist logic, these artists see themselves as useless members in a society where everybody is useless. Where art was once the only useless thing, now everything has lost meaning. If the artist himself feels that he is losing meaning, no wonder he reacts with hysteria. He does super works with the directionless energy of a hysteric—and the result is often hysteria's attendant paralysis. The coldness, the lack of motion, the acidity of colour, the lack of detail (expression), are Mannerist symptoms felt before in other centuries in times of mounting disbelief. Bronzino's frozen gestures are pure paralysis. The only hope is that this non-human contemporary view will break out into horizons broader than hitherto, views not seen entirely from the human scope. It would be a true Mannerist convention that works done despairingly, that desperately parody, should turn out to be truly significant.'[7]

It would, however, seem difficult to hold out much hope for the optimism of Hutchinson's final sentence. Mannerism itself, as the historical mode, was essentially a retreat from social realities. Though the style produced many masterpieces, it was an aristocratic or 'courtly' art produced in isolation from the realities of a violently shifting social and political situation, the product of escapism in the face of the plague and the collapse of a specific social order, in the face of the social proto-revolution of the reformation, of the violence of the Hussites and the thunderings of Wycliffe and Luther. As Simon Watson Taylor has it, 'The Princely courts of Europe during the sixteenth century might be considered the "forcing houses" of Mannerism. In an era plagued by political upheaval and social unrest, these courts were artificial paradises, the private worlds of princes and prelates who were above the law and above the laws of morality applying to the common people. Within the castle walls, sheltered by gardens filled with *trompe-l'oeil* perspectives, grottoes, hydraulically

operated automatons and statues of giants and monsters, the court artists were free, indeed encouraged, to create a profane art which sometimes reflected the unprincipled, eccentric, licentious way of life surrounding them, but was in any way characterized by an originality and individuality in which their imagination was allowed full rein.'[8]

A certain quality of what one might call conceptual flabbiness in much of today's sculpture is probably the result of 'instant' image making, developing ideas that are fundamentally graphic (a lot of minimal sculpture has grown from painting), and blowing up maquettes without any true understanding of the problems of scale and the nature of materials. Clearly what may look effective in a small cardboard maquette does not necessarily work in heavy-gauge metal, and very often the image is developed directly from a small sketch on the drawing board. Some sculptors in this area, however, have arrived at a minimal statement from a position of complexity, reducing the image gradually over a period of years, refining their vocabulary and syntax through a long organic process of research and experiment.

It is interesting to consider one such artist for a moment. The English sculptor Brian Wall has developed to his present position over a period of about fifteen years. The work he is presently engaged upon is the strictly logical linear descendant of the painted wooden constructions he made in St. Ives during the middle '50s. These early works prefigured what has been Wall's constant concern, the articulation and *description* of space by linear means. At a time when sculpture in England was almost exclusively concerned with volume and mass he was already exploring different ways of tackling this problem. The expressionist sculptors of the '50s, working in that post-Moore idiom described by Herbert Read as 'the geometry of fear', were concerned with object and presence. The emerging neo-Constructivist sculptors of that period were concerned with subject and relationship. We use the term neo-Constructivist, for Wall has (as has also an older sculptor, Robert Adams) developed essentially from a tradition

whose mark was stamped on English art by the sojurn of Gabo and Mondriaan in this country during the '40s. They both stayed and worked for a time at St. Ives at the instigation of Ben Nicholson, and it is logical that one of the strongest pockets of their influence should have been in the West Country. Artists such as Anthony Hill, Gillian Wise, Kenneth and Mary Martin mark one line of development in this tradition, Wall and Adams another.

The more recent appearance of hard-edge and minimal, though partly feeding from the same source, at one remove as it were, by way of Anthony Caro, has its roots in a tradition more strictly concerned with painting. The theory leading to the present school of minimal sculpture can be found embedded in the Bauhaus. The group of artists who were launched with such élan at the 1965 *New Generation* exhibition, David Annesley, Michael Bolus, Phillip King, William Tucker, Isaac Witkin and others show on one hand a development from the educational ideas of Basic Design propounded by Hudson, Thubron and Pasmore, Bauhaus second remove; on the other hand they have been directly influenced by American work, primarily painters such as Ad Reinhardt and Barnett Newman and secondarily sculptors like Don Judd and Bob Morris. This, of course, is Bauhaus second remove again, for behind these American artists lurk the presence of teachers such as Herbert Bayer, Albers, Gropius, and Moholy-Nagy who have directly carried on the traditions of Mies in the States. This train of influence moves round full circle, yet all lines seem to lead back to Moscow and the Netherlands. For the influence of Constructivism, Suprematism and De Stijl was crucial and formative on the Bauhaus, and this influence (via Gabo) was almost direct upon Brian Wall and Robert Adams, while for many of their colleagues it has been filtered through the Bauhaus.

9 *'Anything really new is repulsive, because it is abnormal and unreasonable'*

It would be a mistake to analyse the Existence-Essence problem by stating that the first is the dominant aspect of the Romantic-Dada-Surrealist tradition, while the second is the dominant aspect of the remainder. The Classical-Renaissance-Cubist line, as we have seen, can be so defined. Expressionism, however, is a third 'tradition' that may fall into either camp; and a great deal of it is existential in nature.

It seems reasonable to imagine that the creation of an abstract work of art is a subjective matter. In Abstract Expressionism, for instance, the artist's emotional condition is 'fixed' upon the canvas in much the same way that an image is fixed upon a photographic plate. Clearly the artist's attitude to, and relationship with, objective reality is conditioned by what he sees and experiences. However, in such a case the work is invariably the result of a conflict between the old subjective-objective business.

Let us for a moment consider the COBRA group of painters. One mistake often made in regard to these artists is to see them in this light, to regard them as part of the gestural tradition of Action painting and to concede that the main point of difference is their use of figurative imagery instead of the organic and material-dominated forms usually associated with the movement. A different mis-reading is to see this group as part of a primitive-magical tradition, creating a sort of childlike and disturbing iconography of neurosis. COBRA was an international grouping formed in 1947, taking its name from the home cities of its participants: Copenhagen, Brussels, Amsterdam. Like many groups, especially those formed during a period of public indifference to art, it soon collapsed from internal wrangles; its effective life was a matter of only three years or so. However, what it did produce was a common style, one that has entered fully into the sensibility and consciousness of our time. It is true that the work of some individual members has since deteriorated into a formula, recent paintings by Appel and Corneille, for instance, have none of the condensed passion that was previously evident.

For some reason the Scandinavian wing has remained firmly attached to the original conceptions; Lindström, Henning-Pedersen and, above all, Asger Jorn, have consistently explored a visual language that will retain permanent relevance. This would seem to be due to a basic attitude towards sense experience. 'The signification of something', says Jorn, 'lies in its presence here and now. I don't care what it has been or what it will become. It is the experience of things that matter, the confrontation with things.'[1]

This attitude is fundamentally the Phenomenological idea of *Being*, the idea that things exist in their own right. It is a totally non-Cartesian point of view, no longer a question of subject investing object with identity. 'The biggest danger for art is that it should become a conceptual art. For me the liberty made possible by the Dadaists and Surrealists was that they could suddenly look at everything outside of its function.' We tend to regard an object, a table for instance, as being inert, as being an abstraction, until we invest it with identity by granting it a function, by thinking of it as a thing to put other things upon. It would rarely seem to exist outside of its role. What Jorn would wish to do is to confront objects in their naked and total presence, stripped of all preconceptions and associations.

'Anything really new is repulsive', he says, 'because it is abnormal and unreasonable,' and by this we may take him to mean that it is because it has no function, because such a thing would lie outside of our conceptual world where objects *have a use*. When we see objects in terms of their function, we are projecting upon them; in extreme cases they become symbols and represent the same thing to different people within the same culture. Pop art, for instance, operates upon the premise that certain forms and images are common currency. The various forms of Existentialist philosophy have been aware for a long time of the conflict between the external world conditioned by subjectivity and the awareness that reality is a concrete thing 'somewhere out there'.

The final invalidation of Abstract Expressionism lay in the fact that the visual experience was purely a projection of a subjective frame of mind. As a result of this there was absolutely no point of judgement; everyone's private experience was as valid as anyone else's. Self-expression pure and simple, is mere egoism, the assertion of one's personality over his fellows. Ultimately it becomes a social (or rather anti-social) act. Though Jorn's technical method of painting is not related to the gestural, it stems from the same root—the automatism of the Surrealists. His first one-man show was in 1938, and he must have been aware of the activity in Paris and elsewhere at the time. However, he felt that he was not able to develop along the lines laid down by Surrealism; it was necessary to find some sort of different but related route. Surrealism, as a movement, had a restricted life because it was too committed to a pre-conceived programme. It had, by definition, to suscribe to a sort of party-line of Freudianism. However, Surrealism proper is a frame of mind; it is the direct heir of nineteenth-century Romanticism, and aspects of it remain with us today as a continuing tradition—not as a school, but as an attitude.

It would be too pat a formula to say that post-Freudian Surrealism has become Jungian, but there may be some element of truth in this. With the average critic's incorrigible habit of categorizing, one speaks today of neo-Dada, Nouveau Réalisme, Fantastic Art, Magic Realism, Funk and Psychedelic painting, yet the development of Romantic painting over the last thirty years has yet to be examined. When this is done, it may well be seen that COBRA first initiated the breakaway from the orthodoxy of Breton. Jorn, however, decisively parts company from automatism as represented in Tachism. 'The interesting thing for me', he says, 'is the concept of "action" painting. But this should be something more than the use of mere gesture. When a Latin, Baj for instance, talks about gesture, all he arrives at is rhetoric. For this reason I don't like to use the word "gesture" since it implies a typical Latin element of chance.' Automatism, for Jorn,

is a way of bypassing the conceptual consciousness and arriving at a deeper and more instinctual level of perception, a way of reaching a point where there is an identity between intention and action rather than between preconception and action. In order to render the objective world naked one must also strip oneself naked.

Colin Wilson, writing about the philosopher Husserl, has said 'he showed me that my consciousness was not as static as I thought, and that the poker-faced world is not the real world at all, but a world of symbols. The world seems to be wearing a mask, and my mind seemed to confront it helplessly; then I discover that my consciousness is a cheat, a double-agent. It carefully fixed the mask on reality, then pretended to know nothing about it.'[2] This is clearly an experience that Jorn has undergone; in his own words, '. . . the symbol as image is always an image of something that is not there. The difference is between sign and symbol. The former materializes. The material character of a thing becomes important.'

It is exactly this material character of objective reality that is important to him, the physical and the actual presence of things divested of ideas. In this he is close to Dubuffet, and speaks of his affinity to him and to the ideas of *La Compagnie de l'art Brut*. An eye that can succeed in gazing upon the tangible world without filtering sense experience through a deforming screen of language and concept is bound to arrive at a quality of vision that can only be described as innocent. But to draw a parallel between this and the analogous vision of a naive or primitive artist is a great mistake. The naive personality sees the world invested with wonder because he views it in a pre-logical manner; his is the visual language of childhood grasped with senses that for one reason or another have not been distorted by concepts. Nevertheless, this itself is a code of sorts; objects are perceived in terms of conventional hieroglyphs that are logical within the system. Such a method finally is symbolic, the proof of this is the remarkable similarity between the work of a small child, a retarded adult, a schizophrenic and a member of a primitive society.

The work of a sophisticated artist such as Jorn, on the other hand, is an entirely different matter. The sense of wonder is not the lucid astonishment of a child confronted with a bright, extraordinary thing. It is a grasp of the uniqueness of every separate object, the confrontation of an individual with an absolute and total presence.

The history of art has been, until recent years, a series of attempts to objectify the *real*, a series of more and more complex depictions of the visible aspect of reality. From the moment when the Greek philosophers called art 'an imitation of nature', through the Renaissance, and via the obsessive naturalism of the pre-Raphaelites, painting has striven towards more accurately recording what we actually see. What we do see, though, as Gombrich has pointed out, is not what we *expect* to see. Discounting any preconceived knowledge as to the shape, form and texture of an object, the image perceived is shifting and ambiguous —and it has been remarked before that the Impressionists were perhaps the most 'realist' painters ever.

In our times, however, this current seems to have been by and large reversed. The Cubists briefly returned to the object itself. The shape of a Braque guitar, for instance, was no longer the actual shape that the artist saw—it now involved sculptural and symbolic form. It became a schema, a hieroglyph for that object. We identify it because it triggers off our knowledge about guitars; and the final image is in the mind and not on the canvas. This visual shorthand is also basic to primitive art and to all image-making outside of the Renaissance mainstream; it is found today particularly in advertising and mass-media. In the feedback process of figuration in recent years, many artists, specifically those working in Pop areas, use a system of schema. The image is conceived in terms of concepts and classes, not in terms of a particular object.

It is this approach to the 'Other Tradition', as the critical alternative to the concept of significant form, that may be the cause of some difficulty in coming to terms with the work of an

artist who is concerned with the particular, with the actual unique and concrete object in front of him. To say that such an artist's work runs counter to fashion is too simple a conclusion, it begs several questions. The three-thousand-year-old attempt to come to terms with the concrete objective world is not a process that suddenly ended with the post-Impressionists, though there are indeed few enough artists seriously following this pre-occupation at the moment.

Also, the current interest in schema, the idea of the canvas as a message-carrying device can quite often be seen only as fashion inasmuch as it is related to certain changes in public attitudes as to what a picture is or should be. Communication theory, after all, even if only hazily grasped, is a very real part of our present view of the environment. In this context let us consider for a moment the Italian artist Ennio Morlotti. He is a 'figurative' artist who might have found himself hanging awkwardly, as do today many other 'realist' painters, between two opposed attitudes. Perhaps his single minded retreat into a private confrontation with the object has saved him from this.

Born in 1910, Morlotti matured under the heavy atmosphere of academic *Novocento* painting. Italy throughout the period between the wars, could not have been said to have had a fruitful climate for the indigenous artist; the discoveries and passions of modern art seem to have passed her by. It is true that, at the beginning of the century, the Futurists blazed up briefly with their dramatic contribution to the parallel and international revolution that was at that moment being presented from Paris. But Futurism was an art for export only, and there was no comparative importation into Italy of ideas from France. The most creative artists of the period, De Chirico, Modigliani, and Severini, belonged more to the Ecole de Paris than to Italy herself, and were firmly ensconced on the banks of the Seine. There were of course various central influences at work but operating at a distance in time. A group of Roman artists rebelled against the *Novocento*, ceding influence to Van Gogh, Soutine and other Central European Expressionists;

at the same time the Group *Six* of Turin followed Matisse, while the Milanese Group *Chiaristi* worked under the combined shadows of Dufy and Utrillo.

It was not until 1939 that the first Europeanizing movement *Corrente* burst upon the scene, and it was with this group that Morlotti first exhibited. Douglas Cooper remarks about this participation that 'on the evidence (of the painting exhibited) it is difficult to see how he could then have been thought of as a figure of the *avant-garde*.'[3] Paintings from this period were landscapes of an atmospheric and expressionistic character; in a way they are reminiscent of the work of Bomberg painted about the same time, and like Bomberg they revealed the same weaknesses. The images have a curious, almost arbitrary character, and despite the energy of the paint they remain essentially decorative. There is at this date none of the passionate involvement with the seen object that is revealed in later work.

By 1946, Morlotti had become caught up with the Paris-orientated Group *Fronte Nuovo delle Arte*, a very loose association of *avant-garde* artists of almost every persuasion. With the collapse of Italian Fascism, the gates were opened to the floods of the international cultural mainstream, and the *Fronte Nuovo*, exuberant and chaotic, was to become the hotbed from which grew the great Italian art explosion of the following decade. For a period of some six years it looked almost as if Morlotti might settle into a niche as a minor and derivative artist of the *avant-garde*. For him, as for many of his contemporaries, Picasso loomed on the horizon as a giant, and for a long period Morlotti abandoned landscape in favour of fragmented and expressionist figure studies, executed somewhat in the manner of the flattened Cubism of the 'Master's' Antibes period.

In 1953, though, almost with the suddenness of the blow of conversion, and certainly with its single-mindedness, he abandoned the *avant-garde*, he abandoned the figure, abandoned urban life, retreating into the countryside of Lombardy, he returned abruptly to his own roots and to a world that he could entirely

contain in personal and direct experience. What event, physical or psychological, was the cause of this sudden realignment is not clear; but the evidence of the work testifies to a sudden deflection, or rather *reflection*, because at that point he began an obsessive examination of the tangible world as he experienced it. Deliberately restricting his vocabulary of images to a minimum; landscape, foliage, flowers, and occasionally the human figure—but the human figure depersonalized. Douglas Cooper, in enumerating the artist's subject matter, describes this as 'the human animal' and it is precisely this objective quality implied in Cooper's phrase that was to become more and more the artist's concern.

Morlotti is, in a sense, a regional painter, in that his experience —his love if you like—has been condensed to an awareness of a small corner of his native Lombardy. One occasionally hears his work described as 'pastoral', but this term implies an idealization, a justification, of the landscape. Certainly he is a 'nature' painter, but as Cooper has pointed out, he is not as in the English tradition a weather-conscious artist and he '. . . virtually does away with a sense of space and obliges us to feel our way visually like an insect round and round the jungle buried in what he has called *le penombre di questa mia dolcissima terra* . . . and it is characteristic of Morlotti, who is wholly under the ban of nature, that when he turns his attention to the human figure, he sees neither a paragon of beauty nor a seductive animal, nor even a mass of warm and palpitating flesh, but some half-formed blindly struggling primeval grub whose natural habitat must lie in the depths of his own familiar undergrowth.'[4]

This, of course, is one view; but it is also a projection. The whole point about Morlotti is that he is reacting visually to 'things' (and people are also objects in a world of objects) without projecting upon them in any way. The 'paragon of beauty' and the 'seductive animal' are clearly concepts imposed upon the objective world. They are not aspects of reality, but are, on the contrary, ideas that exist in the head. But the 'primeval grub' is also an idea in the head. Objective reality is anonymous, and it would not seem that

Morlotti is reading a particular human figure as a 'primeval grub'. He is reading it simply as an object, a thing in front of him. To apply a poetic syntax to his images is to confuse the issue. What Morlotti does is to attempt to strip 'ideas' from 'things', and to reveal the latter in their condensed and naked presence.

Here, paint does not merely carry an image of exterior reality, it is not a complex of signs and signals which together make up a statement about a perceived experience, it has become something beyond this, an analogue, an equivalent for the thing itself. The seen world is certainly real, but the painting is also real. It obeys its own laws, it has its own continuum of space and time, and it does not depend in any way upon the subjective. The vast majority of paintings contain a 'message' about a visual experience, but the message in paintings by such artists as Morlotti is more in the nature of a signal. It simply states that it exists. It is this quality of *presence* which is so dominant in the work. Reality is here grasped rather more than is usual in painting, somewhat in the manner that it is apprehended by the sculptor, as a total object. The image and the symbol become synonymous. We have just said concerning Asger Jorn that an eye that can succeed in gazing upon the tangible world without filtering sense experience through a deforming screen of language is bound to arrive at a quality of vision that can only be described as innocent. In the case of Morlotti and similar 'expressionist' painters we could sub-stitute the word 'passionate' for 'innocent'; it is possible that under certain circumstances the two words could mean sub-stantially the same thing.

Moving from the particular to the general, one is aware that the possible facets in a work of art that can carry a creative charge are manifold. The 'mana' of a painting may be imagic as in Alan Davie, or allusive as in Picasso; it can be mystical and symbolic like in the mandalas of Albers and Reinhardt, or hallucinatory like Magritte. But in order to relate individual works or trends one must find a common denominator with the aid of which comparison can be made. There are, of course, purely *perceptual* elements such as line, colour, tone, rhythm, density, volume, mass, movement, contrast; but space is the only *conceptual* element that is common to all painting and sculpture. It is intrinsically bound within the presence of any art-work, if not the essential ingredient of its structure.

During the Renaissance something strange and unexpected appeared to have happened. One might imagine that over a comparatively short period of time man's comprehension and conception of space was altered. It seemed as if he had discovered another dimension within which it was possible to relate his perceptions. One could say that prior to a certain date, European man's basic scheme of perception was two dimensional or orthogonal. Clearly he could judge and act objectively within three dimensions, but he chose to represent (which suggests that he thought and perceived) in two dimensions. This is not to say that orthogonal representation was a result of technical insufficiency, but was rather a certain attitude of mind to reality.

Discussing this last point in his book *Art and Visual Perception*, Rudolph Arnheim says: 'The Egyptians—as well as the Babylonians, early Greeks and Etruscans, who used a similar style of representation—were commonly thought to have avoided foreshortening because it was too difficult. This argument has been disposed of by Shaefer who has shown that the side view of the human shoulder occurs in a few examples as early as the Sixth Dynasty but continues to remain an exception throughout the history of Egyptian art. He cites two examples of reliefs that show workmen chiselling or towing a stone statue; the shoulders of the

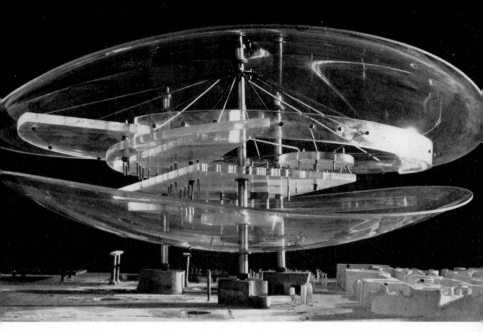

CONSTANT

'. . . the building existed as a work of art before it had been built.' (*p. 69*)

BRIDGET RILEY

The phenomena . . . would seem to occur in some unidentified location between two separate states of actuality . . . (*p. 65*)

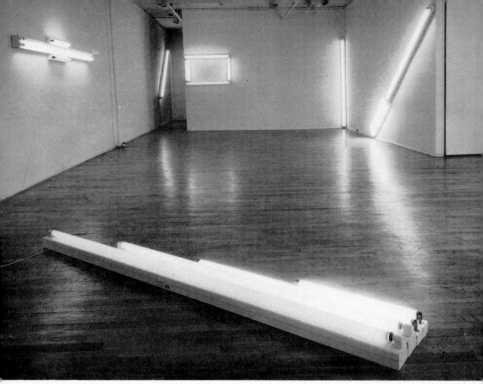

Above DAN FLAVIN
Below left PHILIP KING
Right DON JUDD
'. . . the coldness, the lack of
motion, the acidity of
colour . . . are Mannerist
symptoms . . .' (*p. 72*)

MORLOTTI

... an obsessive examination
of the tangible world ...
(*p. 82*)

ABORIGINAL BARK
PAINTING

Primitive art developed from
a clear necessity, a very real
tool for manipulating the
environment. (*p. 100*)

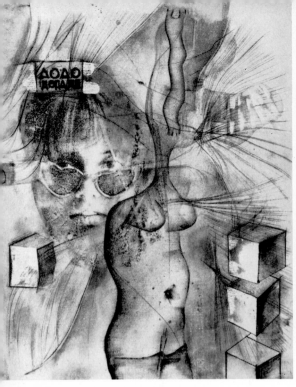

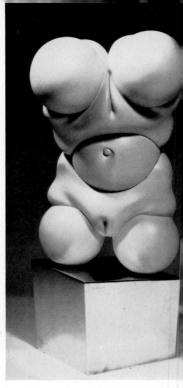

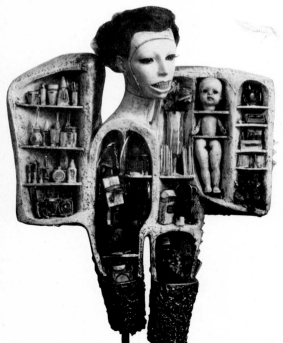

Above left KUJAWSKY

Above right BELLMER

Below ŠTEPÁN

'. . . the objects seen in dreams should be manufactured and put on sale . . .' (*p. 110*)

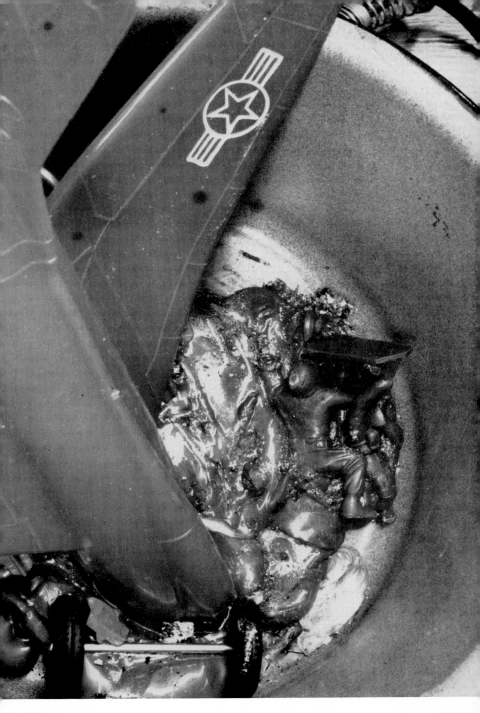

VOSTELL
. . . it is also a moral parable. (*p. 120*)

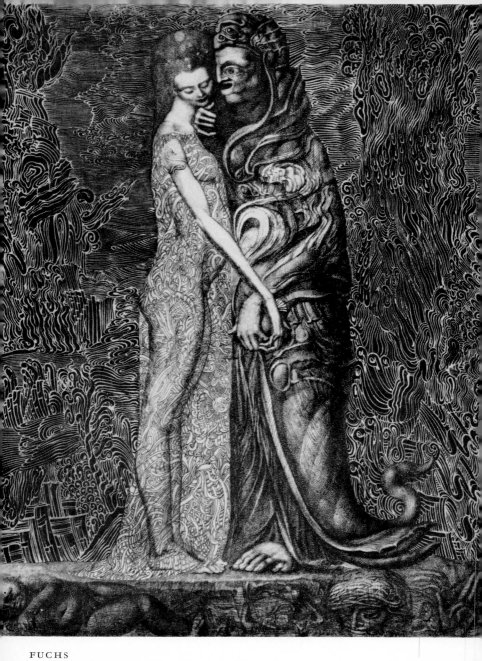

FUCHS

. . . imagery that is usually overtly mystical . . . (*p. 123*)

HORNSEY LIGHT PROJECTION

. . . expand and attenuate the visual sense . . (*p. 122*)

MICHAUX

. . . particular alterations of vision and consciousness brought on by chemical means. (*p. 121*)

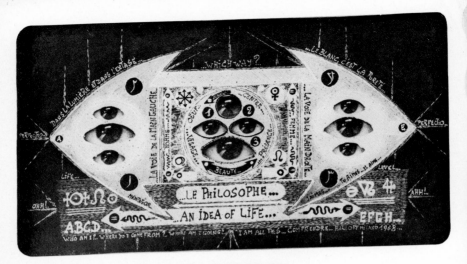

HARLOFF
TANTRA PAINTING

. . . a fantasist immersed in
the gnostic tradition.
(*p. 131–132*)

living men are given in the conventional front view, but the statue shows the perspectively correct side view. Thus, in order to express lifeless rigidity, the Egyptians had recourse to a procedure that, in the opinion of the average nineteenth-century art teacher, created the much more life-like effect. In addition Shaefer points out that, for the purpose of carving a sphinx, elevations were drawn on the side of the rectangular block as early as 1500 B.C., and probably earlier. Naturally perspective drawing was required for these elevations. Therefore it is evident that the Egyptians used the method of orthogonal projection, not because they had no choice, but because they preferred it.'[1]

To say, however, that it was 'because they preferred it' implies that representation by orthogonal projection was a mere matter of taste. A culture that had at its command the technical ability to produce a perspectually central projection (demonstrated by the elevation drawings for sculpture), but chose not to use it, elicits the question: Why were artistic representations for many thousands of years in terms of two dimensions then suddenly around the year 1400 in terms of three? It would seem that, for certain reasons, there was a radical change in the very structure of perception. This change was such that concepts of objective reality and the symbology of subjective reality could only be valid in terms of the idea of recession: that man's deepest feelings about the universe as well as his more immediate feelings to objective trivialities could no longer be expressed in schematic or diagrammatic terms.

William Irvins suggests that central perspective was discovered as a direct result of the invention of wood-block printing; that the mechanical principle of reproduction gave rise to the idea of reproducing an exact copy of the visual appearance of reality. From the Renaissance until just recently, our purely visual perceptions have been of a three dimensional order. During the thirteenth century man had divided the two ideas of *perception* and *diagram*, and the concept of recession into the canvas had enabled him to visualize further into the complex of the essentially abstract idea of relative values. One might postulate that we are

G

now breaking away from relating the ideas of *perception* and *model*. All extension of our perceptual faculties are in the nature of an increasingly more complicated series of relative relationships.

The very small baby, for instance, can be said to judge one-dimensionally; he is the totality of the universe. His mother is, for a time being, a 'thing' which responds to a given stimulus. Being all-powerful, the baby has merely to demand in order to be fed and dried. At this time sensations are supreme and perceptions yet to be discovered. Before long, however, he starts on a mutual feedback process of emotional and perceptual exploration, the act of learning. At the same time he is progressively adjusting to an objective environment and beginning to make judgements of space and distance, of weight and texture, of the difference between solid and liquid, hardness and softness. He learns to perceive by relating different experience and sensations. New data on the objective universe must result in an increasing complexity of perception.

That the human animal is binocular, and has always been able to judge distances in his objective environment is one thing, but *visualization*, the inner equivalent of objective perceptual judgement, is another. Is it possible that before circa 1300 Western man was capable of *visualizing* only in terms of a limited orthogonal referential system, a sort of interior 'flatland' of the popular relativists? Giotto was one of the first artists to give exploratory expression to a different concept of space, and his experience was inextricably bound up with the beginning of that sudden reassessment of values, that intellectual and conceptual ferment we call the Renaissance.

The Renaissance, of course, was not primarily a watershed in art-history, despite the usual educational approach to that period in Italy between the thirteenth and fifteenth centuries. It would seem to be quite extraordinary how in the average 'art-appreciation' course, whether at a 'popular' level or in the Complementary Studies Departments of Art Colleges, the Renaissance is treated as a divergence of aesthetic style divorced

from the larger social panorama. We have already noted that the invention of perspective *may* have contributed an added perceptual tool. To pose the question as to whether a technical advance resulting in an added way of manipulating the environment also enhances the available vocabulary of perception is to raise an intriguing and curiously nagging problem. It is one, however, as are most problems concerning perception, that is dependent upon subjective evidence, and therefore a question we shall never be able to answer definitively.

This is a problem analogous to that other perplexing problem of the colour sense of the Ancient Greeks. We know from the available evidence that artists at one time only used four colours; black, white, red and yellow. There were technical reasons for this. In a Bronze Age culture the available hues and dyes were obviously limited. However, Homer insistently and oddly speaks of the 'wine-dark' sea, of laurels that are 'white' and a sky that has no colour at all, unless it is stormy and dramatic when it then becomes uncompromisingly 'black'.

Are we to infer from this, that given the artists' necessarily limited palette, there were no concepts for colours that could not be produced artificially? That, in fact, since they were culturally 'unidentified', these colours simply were not seen, that in a sense they did not exist?—Objectively, of course, laurels *were* brownish-green, and the sea blue, in the sense that we understand these colours, but were these qualities noted? It is a curious speculation to wonder whether the Ithacans lived in a world rather like pre-technicolour movies. We know, of course, from anthropologists, that primitives have to 'learn' to read a photographic image, that the isolated bushman for instance cannot identify a two-dimensional image until he has been taught a certain set of conventions, since his orientation, unlike that of modern man, is not exclusively visual, but is largely tactile not to mention olfactory. One point worth raising here is that linguistic philosophy insists that the 'naming' of objects is a process that consists of more than merely identifying them, it also confers presence upon them. Oscar

Wilde also, in an apparent flip epigram, remarked that nature imitates life, but of course this had also been noted not only by Saint Beuve and Goethe, but also by their classical Greek forerunners.

If one is to conclude that technical innovation as well as expanding the control of an environment by any specified group also adds to the language of perception itself, this does not merely give us a better understanding of the Renaissance; it also adds toward un understanding of our current predicament. For the Renaissance was primarily a social revolution; following earlier attempts in the Hanseatic and Flemish cities, it was the first effective breakout from feudalism to an early capitalism. The development of Florence as a merchant power engendered a particular sort of republicanism that was in its early days under pressure and attack from its neighbours. The rediscovery of the ancient world was necessitated by the pressing need to find archetypes that could bolster the defensive civic identity. It was only after the act of claiming precursors in pre-Imperial and Republican Rome, that the riches of the forgotten classical culture painfully revealed themselves by accident into the murky light of the middle ages, and quite obviously the resurrection of Platonic idealism not to mention pagan hedonism was a potent weapon against the forces of the Vatican States and the conservative Church in general. It seems sad to admit that the 'cultural' benefits were an unexpected bonus.

All the same this was something that could have been called, in the sense that we might today use the term, a 'historical process'. It is odd how the human race seems to extend its consciousness by means of a series of sudden and unexpected, indeed, almost inexplicable leaps; it is almost as if the group consciousness evolves in a manner analogous to that of a biological organism. Certain concepts and ideas are adequate for a great length of time, then suddenly there is a breakthrough into another and totally different system of references. Our conception of the environment alters overnight, and this appears to happen in a violent and unexpected

manner. The new discoveries, the additional data which give us a more viable and enhanced control of our environment, and explanation of the universe, is far from being merely the logical extension of information already possessed. A breakthrough is not the continuation of an additive process of the accumulation of information; but is as the word implies, an unexpected and total emergence into previously unknown fields of information that are not implied by information already held.

Perhaps for no other reason than the pressures of survival (a sort of group survival, psychic and social rather than personal and physical) there is a sudden losing of our mental tails, a sudden loss of psychological gills. Man thinks, feels, senses in a fundamentally different manner after such an evolutionary jump than he did before. The primitive man in his cave was *totally alien* to his successor of a few years crouched by his fire in the cold night air. So also with the shaped flint for a tool. So with the wheel. So with the purely physical-mechanical machinery of levers and pulleys conceived in the Renaissance of which our modern combustion engine is but an extension. And so, finally, with the age into which we have all been so recently plunged; the age of nuclear ambiguity, of electronics, of solid-state physics and the quantum, of the maser and the laser, of D.N.A. and cybernetics, this age that marks its crucial date at the moment when the symbols $E = MC^2$ were first written. For we, though perhaps too close to appreciate the fact clearly are living at the hub of one of those few moments in history when consciousness suddenly arcs over from one set of conceptual ideas to another; when overnight our whole relationship to the universe must be adjusted, when our intrinsic feelings about reality are uprooted for another series of notions, when the pressures of conflicting ideas plunges us all into a morass of doubt and when, at the same time, vast new possibilities of the human spirit are opened up before us, provided we are able to grasp them.

11 'The world consists of "to-whom-it-may-concern" messages. . .'

We live in a world of objects; indeed we are ourselves objects in a universe of objects. The actual physical volume of our bodies occupies space in just the same way as does any inanimate thing, and in a purely physical sense we are each of us individual components in a network of spatial relationships. We are usually so conscious of our subjectivity that we forget our own status as objects in an environment though we frequently treat out fellows as such without fully realizing it; but, when they, or society at large does the same thing to us we are rightly indignant. Man of course is more than an object, and most human suffering results from his sense of a lack of power when he is so treated. All the same, our actual physical presence, our dimensions and volume in space condition us. We also are of the order of things. We are imprisoned inside the skins of our own bodies. The artist, particularly in recent years is aware of this, his images are projected in terms of the human scale. A lot of contemporary art is concerned with the idea of *environment*, with scaling an image in terms of the dimensions of the spectator; but more of this later.

As we have seen, Existentialism permits us to regard ourselves as being part of a network of continually shifting relationships. This is not, though, a network composed of simple one to one relationships between 'me' and any given 'other', but a network in a permanent flux of movement. It is conditioned by the linear dimension of time and the relative dimension of movement. Any present complex, this one here and now, is at a given moment attached to and dependent upon an already solidified past complex while at the same time standing upon a threshold and prefiguring innumerable alternative future complexes.

At a casual glance it might seem that our mobility sets us apart from the universe of non-organic things. Is it not a fact for us, conscious, sentient, kinetic objects that we are, that 'relationship' is a continuous process of change in time, while for inanimate nature it is a static spatial configuration? No, we recognize, this is a too near-sighted view. Our knowledge of the physical structure of matter no longer permits us to regard it as static and

immutable. It is a question of dimension. On one scale objects may appear to be static within a small and restricted area of time. On a different scale, over a larger area of time, chemical change sets in; beyond the immediate and present moment objects change and decay. In the domain of space, of dimension, the universe regarded at a sub-molecular level becomes a roaring, buzzing, chaos of apparently random energy.

If the body is an object, so also are its component parts, the innumerable cells that make up the flesh, fluid and nervous tissue. Certainly these are blind in terms of consciousness, yet they are programmed each to their function. Together they mysteriously achieve more than the sum of their parts; in the aggregate they arrive at the desire for survival, will, volition, consciousness. Similarly, a complex of energies gains in sum the added dimension of presence. Like building blocks which add together in complexity, a network of energy made up of individual charged particles, are in turn components of atoms and molecules. They 'programme' a chemical element, and they finally assume form in our tangible, perceptual world. They become an object that has identity. They become a chair, a table, a tree, a rock, whatever.

It is clear that, without diverting into any Berkleyean argument, that the 'presence' of an object is conditional upon it being perceived, indeed in the case of organic objects its very form and colour are factors relating to the qualities of being perceived and recognized. All animals and plants from the most primitive upwards are continually emitting signals in order that they might identify themselves. Nature in fact is a constant babble of signals emitted throughout all the wavelengths of light and sound. The shape and colour of a plant is a signal broadcast to the specific species of insect without whose co-operation it would not be able to reproduce itself. The form, the colour and the noises made by all living creatures are directed towards identifying themselves and communicating with members of the opposite sex of their kind. Evolution has seen to it that this broadcast signal is received and understood only by the organism to which it is directed. All

organisms including, indeed especially, man, are bathed in a 'white noise' of radiation and vibration, but each has different methods of filtering out irrelevant information. If this were not done, all life would be swamped: blinded and deafened by a thundering cacophany of signals.

Man alone has seen fit to take note of signals which do not have immediate relevance to his survival and well being. His curiosity causes him to take note of and identify signals not intended for him. He wonders about the irrelevant sense-data with which he is bombarded, but to do this, he has first had to learn to bypass his perceptual filters. Man has often been defined by such a phrase as the 'tool-making animal', one could perhaps call him with even more pertinence 'the filter-bypassing animal', for all his science and technology is based upon this extraneous information categorizing process. Yet behind categorizing lies the act of perception, the deliberate attempt to identify and understand his environment of signals so that he could render them meaningful. It is from this part of the process that art has sprung.

If one regards organic nature as broadcasting identifying signals, we can also see how man-made objects are constructed in such a way as they do the same thing. The form of an artefact defines its function. When we look at an artefact, it is usually its shape which first tells us to what use it is intended that it should be put. Discounting deliberately ambiguous and eccentric objects such as the early television set camouflaged as a sideboard, or a telephone hidden in a tea cosy, functional identity is broadcast as a signal composed of such attributes as shape, colour, texture, etc.

A signal, however, unless it is interpreted, is mere noise. Just as a foreign language which we do not understand has no meaning for us, so objects, unless they are identified, 'named' as it were, into an environmental complex, are merely abstract shapes. A very small child has to learn to identify objects much in the same way as the adult learns a foreign language. At first there is a period of conscious 'translation', but rapidly we learn to recognize the word, the sound, the shape, and the signal itself eventually

suffices for a total grasp and comprehension of the stimulus. But something seems to have happened to the signal during this process. It appears to have become transformed into something else. The signal, or complex of signals, has now become a *symbol*. This is not, although, a fundamental transformation; the symbol can be regarded as an extension of the signal.

All the same symbols are human creations. They never existed in the world before man made them, and, like tools, they were invented for a specific purpose. Symbols comprise the mechanism by which man transforms the biological and geographical world of signals into a world of meaning and value. The anonymous space filled with things and sensations in which man finds himself is rendered into environment.

It would seem that the concepts with which we identify the objects in our environment are verbal in nature. The process of comprehending an object through the symbolic process appears to be associated with the development of language. The abstract idea 'tree' cannot be disassociated from the word 'tree', and it is possible that the development of a structure of symbolic ideas used for categorizing our environment and the development of language itself were synonymous. One way of regarding symbols is to see them as specifically invented for the purposes of communication; however, communication here is not only to be regarded as the conscious and deliberate imparting of information, an essentially two-way process, but also the one-way communication of a conscious intelligence in relationship to matter. Communication implies not only the broadcasting of messages, but also the receipt and interpretation of them. A message, indeed, only becomes information upon interpretation, and it is information (which has ultimately developed from the fundamental signal) that renders the world meaningful and understandable.

Symbols are often thought of as being physical images of abstract ideas, in that they are sometimes hieroglyphs, analogues for a set of concepts or attitudes. Such images as the cross, the

swastika or the red star are examples of a visual and emotional communication shorthand that has developed out of a social complex. They are examples of an active and contractual process which involve tacit agreements between different individuals in a group. Symbols of this nature are concerned with behaviour, attitudes and beliefs, as are also symbolic narratives such as myths and legends, the social purpose of which are the indoctrination, particularly of children, into the conventions and *mores* of the group.

Through a developing process of experience, on a personal level during education in childhood, and on a group level during the maturation of society, a specific family of images or forms becomes associated with an idea. As we have stated, the shape or colour of an object, of an artefact as well as an organic object, is first perceived as a signal. It is the process of perception that intercepts and translates these signals and identifies the object. This is achieved by comparing the signals with a generalized idea that we already have in our minds, an idea which is an abstraction from previous experience and encounters with similar objects in the past.

A form that is declared by signals to be round and hollow impinges upon the idea of 'pot' that we retain in our minds; form declares the function of the object by meshing with the abstract mental symbol, and specific detail defines it further as bowl, cream-jug or jam-jar. Symbol response is here acting at the fundamental level of identification and classification. To activate the secondary level of symbol response the identification process must be complete and the image recognized under specific conditions. A hammer and sickle, for instance, depicted on a street poster or flag deploys a whole series of ideas surrounding the political concept of Communism, while the same image presented in a different environment and in a different configuration does not carry such symbolic overtones. At the most the latter may provide speculative information; perhaps a farm worker and a carpenter have downed tools together to share a drink. Similarly,

the image of a pot presented in a certain configuration might evoke the idea of the Holy Grail or the Jungian archetype of the feminine principle; in a different configuration it is baldly and simply a jar, a bottle or jug.

In organic nature, as we have seen, signals are a vital aspect of the survival process. The colour and perfume of plants, the plumage and song of birds, ensure the reproductive cycle; sound, colour and form also operate in a defensive or aggressive situation. All living organisms intercept signals from their environment, very often in unusual sense combinations. Lorus and Margery Milne, in their book *The Senses of Animals and Men*, examine 'the five senses and a few more', and they describe how various creatures interpret biological signals coded to touch and vibration, temperature and pressure, high-frequency echoes, electricity, magnetism and gravity as well as the more familiar sight, scent and sound. It seems, however, that only man has the capacity to elevate the signal to the level of symbol, though many creatures are able, through a learning and associative process, to develop a 'vocabulary' of signs.[1]

Norbert Weiner once described the world as consisting of a myriad of 'to whom-it-may-concern messages'; for man, these messages are either 'neuter' or they are identified through the manipulation of symbols. Intelligence, itself, has been described as the capacity for symbol recognition and response, and language of course is a structure of symbols, a way of codifying reality. It is clear that symbol response is an active transactional process, established by a 'knower' with the known or the to be known.

There is, however, a third quality with which objects can be invested in a communications matrix, and that is the quality of sign. Where the signal identifies, and where the symbol acts as an orientation and communication mechanism, the sign operates as a carrier of specific and circumscribed information. Certain abnormal aspects of a patient's condition, for instance, are signs by which the doctor diagnoses the illness. The 'red sky in the morning' is a sign by which the shepherd takes warning, the

diving gannets and other sea birds are a sign, a 'mark' in nautical terms, which indicates to the offshore fisherman where to shoot his nets.

The word sign is confusing, however, as it is generally used in the context of traffic 'signs', advertising, announcements, and street furniture. In most cases these are, in fact, symbols; making use by and large of a hieroglyphic alphabet in order to impart specific instructions. As we have seen, the symbol is a construct, a convention that has been created within a social context; it is something which each of us has learnt, have apprehended and have come to react instinctively to as a result of instruction, as a result of having a convention taught to us by those older or better informed than we.

Signs, on the other hand, do not spring from this social context. They are information indicators which are of such an order that we can have learnt them ourselves from private experience. Animals, as we have said, are capable of developing a 'vocabulary' of signs, and the most obvious example is the Pavlovian dog salivating to the sound of a bell which he has learnt by repeated experience indicates food, this sound has become a sign which informs him that food is imminent. In a sense any trained animal or pet which reacts to commands of one sort or another is reacting to signs; it does not of course 'understand' the human language, but has learnt through a process of reward or deprivation that certain sounds, tones of voice or gestures indicates the expectation of a specific reaction on its part. Man as well reacts to signs as anyone who has been in a situation of sustained danger well knows. For instance those who experienced the air raids in London and elsewhere during the last war will probably still have an instinctive response today if they unexpectedly hear a siren. Most likely they will experience immediate muscular tension, heightened blood pressure and a release of adrenalin before identifying the noise and realizing that it merely connotes a tea break in the neighbouring factory. For the workers (for whom this sound is familiar) it is a sign conveying different information,

and they may be expected to have an immediate and overpowering desire for a cigarette.

Ernst Cassirer has made the distinction, 'signals and symbols belong to two different universes of discourse; a signal is part of the physical world of being: a symbol is part of the human world of meaning. Signals are operators; symbols are designators.' [2] Signals are part of the environment, symbols are a mechanism through which we attempt to comprehend the environment, they constitute a machinery by which certain configurations are made analogues for the natural order of mysteries that man finds himself immersed in and which make the environment meaningful in terms of the basic concepts and assumptions of a culture.

The distinction between signal, symbol and sign are extremely important here, for they are (especially the first two) endemic to the whole question of the visual arts. A painting or a piece of sculpture identifies itself, of course, by means of signals. Its very material, canvas, paint, frame, pedestal, bronze, etc., condition us to a certain frame of mind, to a circumscribed area of judgement. Though it is premature at this point to go into the question as to what constitutes a work of art, it is worth pointing out the importance of the context in which such signals are intercepted. An apparent configuration of junk on a bomb-site becomes a Tinguely when placed in a museum; and, more specifically revealing, a certain porcelain urinal, despite Duchamp's avowed intention, became 'art' when presented for exhibition at the New York Society of Independant Artists in 1917.

One imagines that the simplest and most primitive forms of verbal (or for that matter, gestural) communication were concerned with fundamental biological needs. Early man's vocabulary of ideas must have been limited to such concepts as 'food is found here', or 'it is dangerous to go that way'. Through the mechanism of such messages, individuals were beginning to place themselves in a state of relationship with their environment by means of symbols; with gestures and sounds, not necessarily more than grunts, representing the abstract ideas of food or danger. It is clear that by 'naming' directly certain biological needs and urgencies some control is gained over an unknown, and therefore hostile, environment. In speculating that it was such a process which took place when man first began consciously to act on his surroundings, we see that primitive speech was a 'tool', the mental equivalent of a rock grasped as a weapon to ensure better chances in the struggle for survival.

Once this process has begun, the environment, previously neutral, begins to be peopled by ideas. Indeed, one might say that, strictly speaking, the environment did not previously exist; since before ideas were impressed upon it, before some sort of perceptual order was invested into it, the environment was only a mere 'place' of blind biological conflict. But perceptual awareness, once it starts to be articulated, results also in a more complex relationship with the environment; when naming and controlling the environment, the perceiver also alters himself. Along with the development of language and the first primitive symbolic vocabulary, there must also have developed the awareness of subjectivity, a process that can be observed by anyone during the maturation of a child. The construction of a symbolic framework and an increasing awareness of a subject-object dichotomy are clearly parallel.

Primitive man at a totally pre-logical phase was completely immersed in the world he inhabited, he would not have been aware of any exact distinction between himself and anything other than himself. It is almost possible to say that the invention of

language constitutes the archetypal Fall, the act of verbalization creating the split from one-ness, from unity. For, paradoxically, the attempt to control the environment, itself divorces the environment from us. Man becomes at that moment a subject in a world of objects, and once this process has developed to a certain point, the environment becomes totally hostile. It becomes the Other, that-which-is-not-me.

At this stage it is no longer merely sufficient to 'name', and therefore control, events and objects directly related to biological needs. Everything in the environment, whether of immediate relevance or not, must be slotted into some sort of pattern. This imperative is fulfilled by the eventual appearance of some sort of cosmology, and anything that cannot be interpreted in terms of this, anything that is not explained or 'understood' within the logic of the specific system, is obscurely threatening. It is necessary to assimilate the unknown in order to disarm it, to have power over it. It is possible to come to terms even with devils and ghosts, while the uncomprehended, the alien, remains unsupportable. The primitive religions of totems and fetishes are the symbolic language of this sort of control. One might say that this is a symbolic language of the second order; the first is aimed at coping merely with the object, the second at coping with the object and subject in conflict. This is still, of course, an act of communication; true, no longer one between individual man in relationship to something outside of himself, but between Man, a whole society, and his total environment, both inner and outer.

'Man became man through tools', Ernst Fischer has pointed out. 'He made, or produced, himself by making or producing tools.' And he describes a process of 'making alike', where the accidentally discovered stone which is used as a 'found' tool is later deliberately copied. 'Man made a second tool to resemble the first and by so doing produced a new, equally useful and equally valuable tool. Thus "making alike" grants man a *power over objects*. . . . If you imitate an animal, make yourself look and sound like that animal, you can attract it and stalk it more closely, and

the prey falls more easily into your hands. Here again, resemblance is a weapon of power, of magic . . . similarity is universally significant, and pre-historic man—who had by now acquired practice in comparing, choosing and copying tools—began to attach enormous significance to *all* similarity.'[1]

Primitive art developed as a clear necessity, a very real tool for manipulating the environment. But the word 'art' here is misleading, for what we usually mean by this term is a quality we have impressed upon certain objects by taking up a specific attitude about them. 'Art', indeed, as we shall see, is the product only of a highly sophisticated society. Appearing first, briefly, in the Mediterranean Classical world, it was not finalized into a social phenomenon until the Renaissance. As far as our present argument is concerned we shall have to use the word to indicate two separate functions, though clear distinctions will be made in terms of context. Unfortunately we are in the habit of using the same word in reference to both the relatively primitive manipulation of environment through symbolic means and the more sophisticated impulse to aesthetic pleasure and social prestige. A great deal of confusion has arisen from this fact, as there need not be a logical development from one aesthetic level to another; indeed, the two can co-exist side by side, and clear distinctions are not often made.

Just as the development from a stone-age society to a complex technological and corporate one does not follow an overall linear pattern, just as primitive tribal structures survive today, not only in isolated corners of the globe but also in 'pockets' underground as it were, as 'regressions', in our large cities, so also a great deal of contemporary art is still geared to the relatively primitive process of instinctively attempting to dominate the environment by symbolic and magical means, by the creation of totems and fetishes.

The earliest known paintings by man, the cave-paintings of the Upper Paleolithic period belonging to the so-called Franco-Cantabrian tradition of South Spain and Northern France, works

dating from between 15,000 and 20,000 years ago, are generally accepted as being magical in nature and intent. It was considered that the act of depicting hunters killing their quarry acted as a ritual surrogate ('making alike'), ensuring the successful outcome of an actual hunting expedition. The ritual element seems certain, for, as Leonhard Adam[2] has pointed out, in certain caves the painted animals are scarred with marks suggesting that arrows have been shot at them. This, of course is a continuing process, and similar procedures can be noted today in the aboriginal *Bark* paintings of Australia, particularly those of Arnhem Land depicting fishing expeditions. The notion that to depict something is to gain power over it is a very deep-seated one, and we are all familiar with stories of the reluctance of primitive people to having their photographs taken. This is often encountered in primitive areas, but vestigial remains of this archetypal fear are frequently encountered in the midst of our complex urban society.

Environment, however, is not merely a physical space in which one discovers location, it is also, as it were, a psychic space. Primitive man makes a club or stone axe to meet his specified needs as a weapon; this soon becomes a symbol of his power and strength, it becomes a *mace*, and it now begins to tell us something of both his inner and his outer worlds. The power of the king, the leader, the priest, often interchangeable roles in primitive society, is over the invisible world as much as over the visible one. The regalia and the ritual, the effigy and the totem, are aspects of the symbolic vocabulary for this control over the inner environment, an environment peopled by ideas rather than things, ideas concerning natural and supernatural forces, the veiled, the mysterious, the abstract.

When we come later to examine the social role of art, the way in which it operates within a society, we shall see that it is effective by and large through an extension of this fundamental mechanism. Art was exclusively symbolic throughout the Middle Ages, and to emphasize this one only has to consider for a moment the function of heraldic devices (or for that matter, contemporary

flags, national symbols and political emblems) which are essentially extensions of the stone-club-becoming-a-mace. Medieval, Byzantine and Gothic art similarly tended to objectify social and cultural attitudes. The timeless and hieratic posture of the Christ Pantocrator also implied the structure, the rank and the majesty of Byzantium's Imperial throne. The eternal order and stasis of heaven was also a wishful synonym for the permanent structure of power on earth.

It was not until the Renaissance that the first hints of a shift in this pattern became evident. The apparently most obvious facet of the Renaissance was an attempt to revive values of the Classical world, learning and humanism long since lost. Yet this is intrinsically bound up with what were essentially political developments within the social structure. The republicanism of Florence, an extraordinary, abrupt and almost inexplicable break with tradition, the first concerted attempt to provide an alternative to the feudal pattern, was certainly illustrated and fuelled by the re-discovery of Classical works of art and literary texts. Nevertheless, the inspiration was largely provided by an imaginary and utopian past. The great creative burst of Renaissance painting and sculpture shifted the symbolic language away from the feudal iconography of the Medieval Church, and impressed it upon a secular visual syntax of a utopian past merging with an idealized present. Indeed, previous to this point in history, any distinction between sacred and secular was largely meaningless. The point of interest here, and one which we shall examine in detail later, is the fact that *art* as we have come to understand it, a largely social activity as opposed to a magical one, made its appearance through a utopian situation. This is a pairing of ideas which we shall discover to be of continual relevance in art-history since the Renaissance, and of specific relevance today.

A corollary to this point is the fact that the appearance of secular symbolism was finally the expression of a political development, an evolutionary step in the maturation of society as an organism. This new re-assessment of values helped to strip off some of the veils

of a particular symbolism no longer operating and obscuring objective reality; a world that had been almost totally inner-directed now began to become outer-directed, and for the first time since the Classical world man was able to attempt to observe the natural world objectively. The scientific method of observation which had made its first appearance in Periclean Athens was reborn. This more immediate and personal awareness of the physical world is emphasized in the stylistic developments of Renaissance painting; the invention of perspective, the increasing ability to depict form and volume as tangible presences, were the first steps in a struggle towards achieving an absolute naturalism in art, a process which is not merely parallel to, or representative of, an increasing technological control over the environment, but is inextricably wedded to it.

Indeed an increasing objectification of the visible world took place from the fourteenth century to the end of the nineteenth century, from Giotto to Holman Hunt. Yet the modern revolution in art was also a revolution of absolute naturalism; as Professor Gombrich has pointed out, the Impressionists had in fact taken this process one stage further. In the search for absolute object-ivity, in the attempt to pin down the observed world, their lucid and shimmering visions were more true to the physically visual and actual experience, to what the eye actually observed of the world, than the most detailed naturalism. This desire to record the objective world dispassionately, to capture essence rather than existence, is a fundamentally Platonic attitude; and this tradition, so central to the utopianism of the Renaissance, is still very much an active principle. It might for a moment seem a paradox to state that non-Cubist abstractionism, the absolute objectivity of Malevitch, Lissitzky, de Stijl and others is a direct descendant of nineteenth-century realism, of the Nazarenes and Pre-Raphaelites, but it is only one if we insist on viewing Cubism as a fundamental break with tradition, as a sudden re-alignment of aesthetic direction to which point one traces the genesis of modern art.

This, of course, is too simple a view; nevertheless it is often held that Cubism was entirely due to a sudden and dramatic conversion, that it sprang Athena-like from the heads of Picasso, Braque and Derain, and that its sole progenitor was Picasso's interest in African masks, expressed in the *Demoiselle d' Avignon*. But things just don't happen in such a simple way. When a style appears with this sort of authority one is sure that this is because there is already a need for it in society, that it has been trying for some time to break through the skin of sensibility.

The development of Parisian Cubism has been thoroughly documented, but the Cubism of Picasso and his colleagues, though it developed fastest and reached the highest peaks, can no longer be seen to be the unique and sole parent. Quite apart from Futurism with which Cubism shared one important source, the now well-known Czech School appeared almost immediately afterwards, and although there was an undoubted and dominant influence, the Prague painters' plunge into the new aesthetic was too sudden for it to be explained as the result only of direct Paris influence. It seems in retrospect that the ground was well prepared. Edvard Munch's woodcuts at the turn of the century have a 'fragmentary' quality of recession, a quality that is subtly different from the orthogonal perspective he had been using some years previously. This possibility might be due to his use as early as the mid-1890s of the necessarily flattened perspective of wood-plank grain in a sort of early *frottage* effect. Picasso, himself, with some of the Blue Period etchings several years before Cubism, often seems to prefigure the style. Though in linear terms these have superficial links with the 'modern style', the disposition of the forms in space clearly suggest that a breakthrough is brewing.

While Picasso logically pre-figures his own development, the example of Munch is particularly interesting in relationship to the Czech Cubists, for Munch was undoubtedly the seminal influence on modern art in Prague. His big exhibition there in 1905, as Miroslav Lamač[3] points out, acted as a catalyst on the young

artists who were groping for identification and for roots. While the older artists of that period by and large explored Impressionism without any great success, a middle group turned to the decorative 'modern style' and produced the extraordinary fantasies of Mucha, the sculpture of Bohumil Kafka and Jan Stursa, the architecture of Jan Kotera, and the work of the most consistently interesting painter of Central European *Secession*, Jan Preisler, as well as the early paintings of František Kupka. The young *avant-garde*, under the influence of Munch explored a sort of Expressionism which demonstrated elements of *art nouveau* but which at the same time pre-figured many of the spatial problems of Cubism, arriving at a style that Lamač calls 'Cubo-expressionism'. This is particularly evident in the work of Emil Filla and Bohumil Kubišta, so they were well prepared to react to the Parisian variety when they were exposed to it. One might suggest that if Cubism had not existed it would have been necessary to invent it, and the Prague artists might well have done that.

It is interesting to mention at this point that not only in Cubism can the stylistic roots of *art-nouveau* be found, but also in formal abstractionism. The most obvious example is the Orphism of Kupka whose work bridges the styles, but this development is also clear in such artists as the Scottish designer Charles Rennie Mackintosh and the artists of the de Stijl Group, notably van Doesburg and van der Leck. Clearly, although stylistic continuity and development is evident, some extraneous force was operating. The 'modern movement' in art cannot be placed exactly on or around the year 1908, modernism in literature, for instance, began much earlier than it did in painting, but a series of apparently unrelated events took place during the first decade of the century. In 1900 Max Plank published his Quantum theory, Sigmund Freud the *Interpretation of Dreams*, Edmund Husserl his *Logical Investigations*, wireless and gramophones were invented. In the next few years Einstein announced the special theory of relativity, Henry Ford 'brought out his Model T and sealed the fate of an urban aesthetic thousands of years old', the Wrights

achieved the first powered flight, and Niels Bohr formulated his theory of atomic structure.

Parallel with these events, Thomas Mann, Maxim Gorki, Rainer Maria Rilke, James Joyce and Marcel Proust broke with past traditions, Schoenberg invented atonal music, Frank Lloyd Wright and Adolf Loos changed the nature of architecture, the Fauve painters 'proclaimed their contempt for realistic colour', Cubism explored new concepts of pictorial space and Kandinsky painted the first purely abstract work. It is clear that the events of 'modernism' in art are related to these breakthroughs in theoretical science and technology. 'I would say', states Nuam Gabo, 'that the philosophic events and the events in science at the beginning of this century have definitely made a crucial impact on the mentality of my generation. Whether any of us knew exactly what was going on in science or not, does not really matter. The fact was that it was in the air, and the artist, with his sensitiveness, acts like a sponge.'

As far as the visual arts were concerned the new philosophy developing from Husserl into Existentialism and the discoveries of the physicists acted as the basic source for the *avant garde*, the first providing new ideas about the nature of relationship, and the second altering the artists' conception of space. Later in our argument we will examine this question in more detail, suffice for the moment to state that it was essentially the scientific breakthrough leading to the technological society in which we now live that enabled the development of the specific sensibility we call 'modern art'. Rather, it was one of two historical events which caused this sudden shift.

The second event which could be called a 'geographical' one, though it stems from the first, has had such an overpowering impact in the nature of society that it qualifies to be considered separately. This, of course, is the discovery of the 'Third World' which we have already discussed. Modern communications, stemming from the period of the Industrial Revolution and the development of railways, opened up the possibility of wide

cultural interaction of style. For the first time since its inception, Western culture began in the nineteenth century to loose its Euro-centric point of view, a process that today is all but complete. Where in the past a Western artist developed within a specific cultural continuum, planted his sensibility firmly in a circumscribed tradition, that basically of the Graeco-Roman Mediterranean, today he can feed his imagination on the total visual repository of history, on oriental, tribal and prehistoric art.

The opening up of the Orient in the nineteenth century showed the first evidence of this in European painting; the importance of Japanese wood block prints to such artists as Whistler and Van Gogh is well known, and the oriental methods of defining space by linear means is central to *art nouveau*. At this point it is interesting to note a certain conservatism in the manner in which the art of other cultures penetrated that of the West. Gauguin, influenced at Pont Aven and through his contacts with Van Gogh by Japanese art, nevertheless did not react as one might have expected to the primitive Melanesian art when working in Tahiti. His style then, barring a broadening of technique and greater brilliance of colour, a straightforward development of increasing creative power, was basically that of his Breton period; and it remained for Derain and Picasso to discover the plastic possibilities of primitive and tribal sculpture. We can see now that it was the particular influence exerted by the African carvings first 'discovered' by Derain that identifies Parisian Cubism as 'Cubism', defining it from Futurism, the Moscow Schools of Constructivism and Suprematism, *Die Blaue Reiter*, and other 'schools' reacting to new ideas about the nature of space, time and matter.

In general, one cannot argue a division or opposition, as one frequently encounters, between Cubism and its descendants and Constructivism and its descendants. It is a fallacy to place these in a Romantic-Classical dichotomy, one resulting from a superficial view of what might be called the 'lyrical' content of individual pictures, a type of judgement made on a 'warm' or 'cool' basis, of discussing a work in terms of its emotionalism or restraint. But, as

we shall see, the Romantic-Classical dichotomy is still a pertinent issue. It is an issue, however, related to the type of communication image used and to one of two separate and distinct ways of viewing the world; not so much an immediate question of style, indeed one sometimes cannot easily place a particular work into either category from this point of view. The distinction lies rather in intent than appearance.

Earlier we have stated that a great deal of formal abstraction is the contemporary descendant of absolute realism; by this we mean that just as was that of Impressionists, or for that matter the Pre-Raphaelites, this type of work is striving towards objective reality. Though not necessarily using a language of imagery concerning the visible tangible world of experience, and not necessarily presenting analogues for that world as does 'figurative' painting, it is nevertheless concerned with the *real* world. The logical descendant of the Renaissance, it however, unlike its predecessors, does not attempt to 'depict'; for the lessons of science and psychology have made it clear to us how ambiguous objective reality is. Matter is no longer solid and immutable, indeed today it seems not 'even to be composed of waves and particles, of wavicles, but rather of bundles of abstract events, possibly discontinuous and finally unknowable'.

The psychologists have long since demonstrated that what occurs on the retina of the eye does not necessarily have any relationship to what exists outside. Formal art today does not so much try to depict, but is an attempt to 'be'. The work of art here does not refer to any realities outside of itself; it is discrete, self-enclosed, obeying only its own laws. It becomes, in short, the object, rather than a depiction of it—reality itself. In terms of our earlier distinctions, it is attempting to achieve the status of 'signal'.

In general, work of this nature is grounded in the ideas of science, and it frequently emphasizes this by making use of the techniques and the 'appearance' of technology. In opposition, the 'Other Tradition' is grounded in the philosophical ideas of

Existentialism, and instead of identifying with the 'signal' it tends towards the 'symbol'. Equally based in the cultural breakthrough at the beginning of the century, but in psychology and anthropology rather than physics, it is nevertheless more atavistic in nature. Where the first is concerned with perception, the second is concerned with instinct. Where the first has an aesthetic role, the second has a magical one. Where the first operated by presenting us with signals, the second does so by confronting us with symbols.

'The painter is the bearer of a kind of singular and tragic grace, the grace of the Unconditional'

As long ago as 1924 André Breton suggested that 'objects seen in dreams should be manufactured and put on sale'. It is clear that this advice has been taken to heart and widely applied, particularly during the last decade or so. Yet Breton meant something much more than merely using the Freudian imagery of dreams as source or subject material for art. Writing twelve years later about his earlier statement he said that he conceived the object's '. . . assumption of concrete form—outrageous though they might turn out to be—as a means much more than as an end. I certainly hoped that by their quality they would cause a slump in the esteem attached to the objects that infest the so-called real world by virtue of their often dubious "conventional" utility'. A slump, I thought, was just the thing to set *inventive powers* free, and the latter—though the most we can hope to know of dreams is limited—might well be fired by the sight of dream-engendered objects, by true desires in concrete form. Yet the end I had in mind went far beyond creating objects of this sort; it was nothing less, in fact, than to externalize the very act of dreaming, to translate it into concrete form.'[1]

To translate desire itself into 'concrete form' is to manipulate the nature of matter, rather than to interpret it or record it. Here the object becomes 'total', reality is embodied in it rather than represented or interpreted by it. It is a similar process to that described by Gombrich when he tells us that in the world of the child there is no clear distinction between reality and appearance. A table turned upside-down *is* a spaceship, a bowl *is* a crash-helmet. 'There is no rigid distinction between the phantom and reality, truth and falsehood, at least not where human purpose and human action come into their own.'[2]

From the point at the Renaissance that art began to lose its thaumaturgical role and concern itself with the objective world of things and social values, with what Breton in the same article refers to as '. . . the mad beast known as convention . . . the hateful reign of commonsense (which) is founded on the world of concrete objects', both image and object were incorporated in the

same work. The image, inextricably welded with the physical object, the painting or sculpture itself, referred, however, to values outside of the object; it 'talked about' ideas that were both central and limited to the cultural assumptions of the particular social group who supported and patronized 'fine art'. Dali was aware of this, '. . . only the violence', he said, 'and the destruction of your hardened dream can resist the hideous mechanical civilization that is your enemy'. It is for this reason, in recognition of its persistently radical stand in the face of art considered as the mask of a society, that Surrealism can be considered 'revolutionary' in the political sense, and explains the affiliation between that movement and Marxism.

Under the twin impact of Freud and Heidigger, first Dada, then Surrealism began to split the two ideas of image and object, began to re-invest the object with its lost 'presence', its autonomy. With Dali's 'critical paranoia' the image and the object are in direct conflict, the soft watch presenting an insolvable dichotomy. With Duchamp's 'readymades' the process of partition is complete. Dada, however, in the person of Duchamp was ironic and intellectual ('I wanted', he said, 'to put painting once again at the service of the mind.'), while in the persons of Tzara, Huelsenbeck, Richter and Janco, it was anarchist and nihilistic, and in the person of Heartfield it was frankly political.

Surrealism, which appeared for a moment to supercede Dada, actually helped to transform it, leaving with it a residue of the eschatological and magical preoccupations so central to the movement. As Patrick Waldberg points out, 'Imagination, folly, dream, surrender to the dark forces of the unconscious and recourse to the marvellous are here opposed, and preferred to all that arises from necessity, from a logical order, from the reasonable . . . Surrealism proclaims irresponsibility, asserting that man must escape from the control of reason as well as from the imperatives of a moral order. Thus, while declaring himself a non-conformist, he brings his essential prejudices to bear on those states of surrender amongst the first of which is found the dream

and, along with it, that state of vision advocated by Rimbaud ("... one must be a seer, make oneself a seer"). There is, too, the state of the medium, whose hand is no more than the instrument for transmitting a message, sent not from the spiritual hereafter, but from the actual self hidden by consciousness.'[3]

The importance of the post-Dada attitude to 'the object' lies in the juxtaposition of this romantic and 'magical' approach with the altered perspective which results, as we have seen, from developments in philosophy. The American critic, Dore Ashton, commented in a very important article published in 1963, '... the change in man's relationship to objects is really a change in man relationship to the cosmos—it is a philosophical change. We can no longer remain at the classical distance from objects. Science has swept away the notion of an objective universe and with it objects. Heisenberg states, on the basis of his scientific experiments, that man confronts himself alone. The subject-object dialectic has been abolished.'[4]

Sculptural form is not normally isolated from its surroundings, that is to say that it exists on its own terms not that of the environment's particular reality. It may certainly act as a catalyst on the environment and activate the surrounding space—this clearly is the intention of minimal and reductionist structures—but by the very fact that it exists *as an object*, is present on different terms and relates in a different language, it must clearly be separate, be imposed upon the environment. The assemblages of 'junk' sculptors, for example, try to integrate this disassociation by a unification of detail rather than of totality. A Cesar or Chamberlain sculpture is, after all, the same object as the vehicles that drive past it.

The Surrealist, indeed the Dadaist, achieves the same effect by wrenching the object out of context. Duchamp's readymades are clearly of this category; '... whether or not Mr. Mutt fabricated the "Fountain" with his own hands is not important. He has *chosen* it. He has taken an ordinary element of existence and disposed of it in such a way that the utilitarian significance

disappears under the new title and the new point of view—he has created a new thought for the object.' In a sense this 'dis-establishing' of the object, this process described by Dore Ashton as the object being '. . . stripped of associations; furniture is condemned to be furniture', depends from a nineteenth-century anxiety about the proliferation of machine-made objects. The reaction of the time resulted in the Arts and Crafts Movement, in William Morris' idea of the 'artisan'. Here was an escape from industry which was first to take refuge in medieval fantasy then later in the overwhelmingly baroque of Secession and *art-nouveau*. The problem of the artist's adjustment to the machine-made object, and by extension to technology itself, was still untackled at the beginning of this century; and this was the crucial problem facing the modern movement.

It was first tentatively approached through Cubism, with the invention of collage and the incorporation of 'real' objects into the painting, a process which, as Appolinaire points out, was '. . . adding no picturesque element to the *truth* of the objects (for) the objects had already been impregnated with humanity for a long time'. This reassessment of the object's role in art was probably taken further by the appearance of still-life sculpture; Boccioni's famous *Development of a Bottle*, or Picasso's *Absinthe Glass*, to say nothing of his subsequent abstract assemblies of odd pieces of wood.

The 'moderns' reacted by finding two apparently diametrically opposed solutions to the problem. On the one hand there was the solution of using machine-made objects, indeed machines them-selves, accepting them totally with all the implications of a technological society and subordinating them to the private vision of the artist; this was the direction accepted by the various groups working in the constructivist mode. On the other hand, there was the solution of stripping the object of all associations, or of juxtaposing it in such a way that it gained a new and gratuitous set of associations; this was the direction accepted by the Dadaists, Surrealists, and the 'other tradition' in general.

Perhaps where the neo-Dada situation which has developed from the middle '50s diverges most obviously from it's '20s and '30s predecessors is that the machine-made has long since been thought of as anything but a threat. It is now incorporated completely into art, which is perhaps the beginning of its total incorporation into life; after all, most of us today, those in cities anyway, are well on the way to living in a completely synthetic environment. The object and the syntax used to express it have become united. To put it another way, in the words of Christopher Finch; '. . . from these beginnings (at Rauschenberg and Cage)— and they were not entirely isolated; Chirico's dream flotsam and mannequins, Cornell's boxes, the Surrealist Object, were all concerned with the same thing—a new mood of exploration has arisen. Artists, like skuba-divers, don their masks (of meta-irony) to explore the offshore regions of that warm ocean which is at once a language and a physical world.'[5]

The Dadaists opposed the 'industrial' object (seeing perhaps with disillusionment a parallel between technology and brutality, the senseless violence of the 1914-18 war) by the weapon of irony: they refused to take it seriously. The Surrealists, following them, rehabilitated the object, but in a new dimension—those seen in dreams were brought struggling and wriggling into the hard quotidian light. The object was invested by them with the extra dimension of imagination, of what Stapane Lupasco talks about in his concept of *Les Trois Matiéres*. The 'third matter' is essentially that of the imagination. 'The events of the soul', he says, 'are neither real in the sense of actuality, nor unreal in the sense of pure virtuality. The space-time psyche is placed in suspense and removed from irreversible external time . . . the abstract artist, outside of his states of veritable trance, fleeting or sustained, loves life in all its forms . . . today's artist is fascinated by the psychic: he senses bubbling up inside him the fundamental contradiction, the antagonism which is the creator of the essence of Energy, the source of all things . . . the psychic system alone, by means of its deep tumults and conflicts, filters—and quenches its thirst with—

affectivity. And the painter known as abstract, servant of these tragic forces, tries to make abstraction of pure psychism. He is the bearer of a kind of singular and tragic grace, the grace of the Unconditional.' [6]

Although Lupasco was speaking in general of 'painting', and one would imagine more specifically of Tachism, it is this very quality of the 'Unconditional' with which the object becomes invested when it is transformed into art. Rauschenberg's goat or real glass of water and spoon are not shock objects, they are not even ironic comments, but are objects transformed by the imagination, transcended indeed, and placed on a different level of reality. An ordinary goat would be confronted by us, it would be object to our subject; Rauschenberg's goat *confronts us*, reducing us also to the status of object (or transcending both into subject, depending which way you look at it). As Dore Ashton said, the 'subject-object dialectic has been abolished'.

This shift, of course, has effected the individual existentially; one result is to emphasize a sense of insecurity. We are today in a more or less permanent state of anxiety in our immediate environment, and we echo Michaux's nightmare of being surrounded by hostile objects, or Ionesco's fantasy where wardrobes or other pieces of furniture multiply as if by spontaneous fission and gradually fill up the stage. One way to counter this anxiety is to attempt to once more 'domesticate' the object by turning it into a cult object or even a fetish.

As Henry Stone comments, in his study of the motorcycle as a cult object; 'An object made by man for a definite utilitarian purpose can involve his emotions and thoughts until the object transcends its practical use and takes on qualities of meaning not originally associated with its intended function.' Like the caveman's club becoming a 'mace', a symbol of power, motorcycles, drag-cars, uniforms and the 'gear' of underground 'tribal' groups and gangs, are objects which assume a fetishistic role. 'Motorcycles are machines', he tells us, 'man-made, controlled by men, and expressions of human skill and mastery of tool-making.

Like the caveman's axe the motorcycle is made by men who wanted to form a tool that directly, most efficiently, and with no wasted time, effort, or material did that for which it was intended. The user of such a tool can go into his environment, and meet it masterfully; the tool is an extension of himself, amplifying but not replacing his own strength. An example of this can be found in the way men once waged war. When a samurai drew his sword and strode into battle he was not turning the job of fighting over to his sword; *he* did the fighting, and the sword, the result of many centuries of refinement for its task, was an extension of his own power. Now we look on the samurai sword as a beautiful object, its simplicity and the perfection of its curve somehow expressing the quintessence of a sword's quality. We forget that it was a very real and brutal tool that hacked with extreme efficiency into men's flesh, serving the strength and skill of a trained killer. Now wars are fought by machines: the pilot of a jet bomber, does not see himself as a killer, but as an extension of his machine, the possessor of certain skills that are needed to assist the metal monster in its job of killing. As the guided missile replaces the bomber, even that element of contact is lost and we suddenly find ourselves afraid that the machine itself autonomously will bring destruction upon us—we are not really sure we are its master. The removal from personal responsibility for our modern forms of killing is symptomatic of something general in our world . . . in our present cultural environment the machine has come to protect us from exposure to the feelings and meanings of our day-to-day existence.'[7]

Stone sees the cause of this as being mainly social, '. . . I believe that all these men (motorcycle fans) to some degree feel choked by the "plastic reality" of their world. As they move about and play their roles in life they feel themselves as unreal, in some way out of touch with the reality of natural and physical sensation; they feel that our culture somehow suppresses the energy and potency of their individuality. It is this the motorcycle helps them overcome.' It would seem that this social alienation is also

the existential one. To be divorced from one's environment is also to feel divorced from matter, which objects represent; and the motorcycle, being the sort of machine that the rider has an almost symbiotic relationship with, raises the object out of this inert state.

Though it may well only be a contributary factor in such areas, the existential need to 'manipulate' the object is clear in the visual arts. A great many fine-art objects are clearly magical and fetishistic in nature. Many examples of this spring immediately to mind; the famous fur tea-cup and saucer of Meret Oppenheim is an obvious early example, and closer to date we note the pin-encrusted furniture, books and boxes of Lucas Samaras, the 'accumulations' of Arman, the reliquaries of Bernard Requichot, the sadistic constructions of Kurt Steinvert, the static violent charades of Edward Keinholtz. Of course not all neo-Dada is concerned with this 'magical' aspect; Dine, for instance appears to lay the object bare in a bald and blunt a manner as possible, Oldenburg to make analogues by transforming the material and the scale, Christo to 'create' the object by the act of hiding it behind shrouds and wrappings, Daniel Spoerri to 'fix' it, pinning down the temporary and elusive configuration. While Tinguely is concerned less with object itself than with the duration and nature of time, Yves Klein, even further divorced, searches for metaphysical abstracts, with for example his concept of Klein Blue, the 'Colour of the Universe.'

The fetishistic, however, is very obvious. It is almost as if the Cubists re-discovered the *style* of primitive art, while the 'other tradition' has re-discovered its *purpose*. The single object is 'magical' in that it is propitiatory; the recurring theme of violence deflects from the artist and the community the growing threat of real violence. We have seen that Happenings are cathartic and ritualistic in their manner, and that the painting or sculpture had to become an 'event' that was experienced. The three-way dialogic situation between the artist, the spectator, and the object is not an isolated phenomenon, or a matter of simple aesthetics, but is on

the one hand part of our total experience, both psychologically and socially, and on the other an objectification of our individual inner experience. We have, as Ronald Laing has pointed out 'largely lost touch with our inner world in gaining control of our outer world. We have become strangers to our own experience, we are alienated from ourselves'. Laing's whole thinking as a psychologist is centred around a process of what he calls 'mystification' whereby the human individual is 'socialized' at childhood out of his own true spontaneous personality. This act of conditioning people's behaviour patterns by imposing masks and attitudes upon them results, he maintains, from an act of violence masquerading as love.

It seems likely that it needs a reciprocal act of violence to free a person from his masks. As John Cage has remarked, 'the anarchistic situation frees people to be either noble *or* evil', it allows them to re-discover themselves, to experience and to act as separate individuals. A few years ago an exhibition entitled *Violence in Contemporary Art*, part of a three-month long symposium on Violence was held at the I.C.A. in London. On this occasion, Roland Penrose wrote: 'The bogey of violence is particularly horrifying and intolerable to us when we meet it in cold blood. The arts, however, avoid its brutal impact by their appeal to the emotions, they warm us to its presence, turning terror into enjoyment and cruelty into compassion. We participate in the act of violence without suffering its evil consequences. Art, in fact, allows us, as do certain rituals, to satisfy our Olympian yearning to stimulate the forces of nature. Its non-violent power has a therapeutic and catalystic influence.'[8]

Penrose here has touched upon the three facts of violence in modern art; compassion to the human condition, the fundamental importance of ritual leading to catharsis, and the attempt to re-discover real experience blanketed by the conventions of society. All Happenings, Events, Décollage, crushed motor cars and junk assemblage, auto-destructive and disposable art are attempts to come to terms with these problems, attempts to strip society of

dangerous preconceptions and to return its members the freedom to act and to choose as individuals.

We live in a world where we have to come to terms with and accept public violence. Vietnam is, after all, half a planet away. The crashed car claims anonymous victims and not neighbours. Death, when it does occur close to us, no longer has any ritual; it is packaged, aseptic, distant—discreet undertakers protect us from reality. We are invited daily by the machinery of advertising to live in a manner conditioned by fantasies of violence; James Bond and Modesty Blaise obviously, but more insidiously, Boysie Oakes, George Smiley and Illya Kuryakin haunt our daydreams.

The Sado-masochistic fantasy of the spy thriller is not all that far from the Utopian dream. Norman Cohn, in his book *The Pursuit of the Millenium*, has told us all about that. He has made clear the parallels between the millenial tradition and the worst excesses of political hysteria. If only we can act in such a manner, if only we follow such a leader, if only we can get rid of the scapegoats, then it will be possible to enter the Promised Land. Of course we all wish for a better world in a half-hearted way, yet oddly our collective contemporary fantasy is an upside-down utopia. The bomb lurking above us seems to be something that we are half in love with, and which makes an 'uneasy peace' possible.

During an earlier age, the act of painting was a moral act only occasionally and more often a personal event, a personal voyage towards individual salvation. The classical psychodrama of the Graeco-Roman world has long been debased into the Catholic confessional. It is true that certain Romantic artists arrived at a sort of documentary protest; Daumier, Millet, Goya, celebrated and lamented the human condition; their rage at injustice still moves us. But the whole point of course is that to rage at the injustice of the system is not enough. We cannot stand back and condemn *the others*; we ourselves are also involved and responsible —the injustice against which we protest is within each one of us.

Today, however, whole areas of the *avant-garde* live and act in such a way that their art is not a separate compartmentalized thing. Their art is concerned, as all art should be, with reality. But reality, our reality, also includes the Bomb, Rhodesia, Vietnam, Chicago and Freedom Marchers. The most striking aspect of the artists who organize Happenings and Events is their political and social involvement. For instance, when not long ago a group of Dutch *provos*, politically active left-wing intellectuals, visited England it was quite logical that their host should have been the auto-destructive artist Gustav Metzger.

We have among us a new generation of intellectual dissidents; the beatniks of yesteryear have grown up and the hard core have turned into serious artists. Of course they always were serious, but they can no longer be easily dismissed. While many erstwhile rebels have accepted the conventions of society as a result of the art success boom, others have remained aloof, evolving an art form that is total experience, one that questions values, that provokes spontaneous reactions. It operates in exactly the opposite ratio to the art of Bond Street, the Faubourg Ste. Honore and Madison Avenue, which ultimately offers a consumer product designed to confirm society in its prejudices.

When Vostell fractures and destroys an image as a result of his technique of *décollage*, when Spoerri captures a transient and perishable situation like a breakfast table—a *topography of chance*, when Hansen or Lebel mount a Happening—a 'collage of situations and events occurring over a space in time', they are urging our sensibilities beyond the mere aesthetic into a total experience, and they are soliciting a total response.

When Tinguely sets up his machines to destroy themselves or each other, when César squashes a shiny new automobile in a hydraulic press, when Metzger's structures change form and disintegrate under the effects of acids before our eyes, when Latham's elaborate towers of books burn and crumble, we are presented with more than a visual experience. It is also a moral parable.

'Green. Did I see it? Too fugitively seen. I know that there is green, that there is going to be green, that there is an expectation of green, and that there is green frantically straining towards existence, a green that couldn't be greener. It does not exist, and there is any amount of it (!) . . . Here it comes! It has emerged. Completely. I am honeycombed with alveoli of green. Greens like bright dots on the back of a beetle. It is the zone in me that emits green. I am wrapped in green, immured. I end in green. . . . A large plaque fairly circular and as though elastic. A spasm causes it successively and almost imperceptibly to contract, then to expand again. It is also elastically pink. Pink, then not pink, then pink, then not pink, or barely pink, then very pink. Pink spreads. Innumerable pink bulbs appear. Pink spreads more and more. I generate it, I sparkle with it. I am sprouting pink. I suffocate with pinkness, with pinkening. The pecking of this pink disturbs me, is odious—Cessation. Thank heaven! . . .'[1]

From Henri Michaux's book *The Miserable Miracle*, a study of the effects of the drug Mescalin, it is perfectly clear that the hallucinogen drugs have a profound effect on the visual sensibility; indeed the name 'hallucinogen' speaks for itself. Michaux in France was writing in the middle '50s, at about the same time that Aldous Huxley was exploring the 'antipodes of the mind' in America; despite the special interest at that period, these two, of course, were far from the first to consider the particular alterations of vision and consciousness brought on by chemical means. Havelock Ellis' *Note on the Phenomena of Mescal Intoxication* appeared in *The Lancet* as long ago as 1897. '. . . I would see thick glorious fields of jewels, solitary or clustered, sometimes brilliant and sparkling, sometimes with a dull rich glow. They would spring up into flower-like shapes beneath my gaze, and seem to turn into gorgeous butterfly forms and endless fields of glistening, irridescent, fibrous wings of wonderful insects; while sometimes I seemed to be gazing into a vast hollow revolving vessel on whose polished surface the hues were swiftly changing.'

Havelock Ellis' experience was direct from Peyote, the Mexican cactus, while later experiences have resulted on the whole from synthetic products resulting from the accidental discovery by two Swiss chemists, Stoll and Hoffman of what came to be known as L.S.D. in 1938. This essay does not give us the occasion to go into the sociological questions of drugs, addictions and minority drug sub-culture. We will merely at this stage note the fact that the bohemian drug sub-culture, a synthetic social grouping, membership of which as a compensatory factor is an important facet of addiction, and the Underground mesh at certain points. These points of congruence are most notable when one examines different aspects of perception. Jazz and 'soul' music is an obvious case—it is well known that the cannabis family of drugs expand and attenuate the aural sense. L.S.D. and associated hallucinogens such as mescalin, psilocybin, peyote, and morning-glory similarly expand and attenuate the visual sense. As a result, many artists have experimented with these drugs, and the impact of their sensations has been noticeable on the whole field of art in recent years.

The visual drug-induced experiences are so characteristic that these exploratory artists have in fact launched a distinct 'school' of contemporary art. For a specific *style* has become strongly defined in recent years; it clearly is a style, and not a common experience due to chemical distortion, since a great many artists, perhaps now the majority, working in this idiom are innocent of any stimul-ation. As a style, furthermore, it is the only one that can be said to specifically have developed from the Underground, since Happenings, neo-Dada, etc., are too wide to be defined as styles, being rather fundamental methods of approach, states of mind, which in themselves contain stylistic groups and categories. Not only the provenance, but its continuing development within the Underground, of Psychedelic art is evident in the Underground press, in posters and the dress habits of contemporary bohemia. These qualities have, of course, long since spread to the wider group of Pop 'youth', and from there are possibly producing the

ground for the first genuine popular style of decoration since 'Art Deco' of the '30s and '40s.

The qualities most evident in Psychedelic art are swirling forms, ambiguous spatial configurations, and highly differentiated acid colours where the work is abstract, and obsessive detail, often with a curious unifying effect where objects perceived in the far distance are portrayed with the same clarity and detail as those in the foreground, together with imagery that usually is overtly mystical if it is not intuitively archetypal when the work is figurative. 'Praeternatural light and colour are common to all visionary experiences', remarks Aldous Huxley. 'And along with light and colour there goes, in every case, a recognition of heightened significance. The self-luminous object which we see in the mind's antipodes possess a meaning, and this meaning is, in some sort, as intense as their colour. Significance here is identical with being; for at the mind's antipodes objects do not stand for anything but themselves. The images which appear at the nearer reaches of the collective subconscious have meaning in relation to the basic facts of human experience; but here, at the limits of the visionary world, we are confronted by facts which, like the facts of external nature, are independent of man, both individually and collectively, and exist in their own right. And their meaning consists precisely in this, that they are intensely themselves, and being themselves, manifestations of the essential givenness, the non-human otherness of the universe.'[2]

Huxley's examination of the psychedelic experience and his equation of it with mystical and visionary states is well known. In his book *Heaven and Hell* from which the above quotation is taken, he draws parallels between the typical jewelled landscapes, towering cities, heroic figures and fabulous animals induced by the mescalin experience, and both the descriptions of Paradise, the Isles of the Blest, the Garden of Hesperides and similar heavens or fairylands of religion and folklore, and their depiction in the visual arts. The 'transporting' effect of jewellery, he maintains, of medieval stained-glass, of frescoes and candles in church

interiors, of ritual and incense, are references and memories of the occasionally glimpsed vision of paradise.

'There are in nature', he tells us, 'certain scenes, certain classes of objects, certain materials, possessed of the power to transport the beholder's mind . . . out of the everyday Here and towards the Other World of Vision. Similarly, in the realm of art, we find certain works, even certain classes of works, in which the same transforming power is manifest. These vision-inducing works may be executed in vision-inducing materials, such as glass, metal, gems or gem-like pigments. In other cases their power is due to the fact that they render in some peculiarly expressive way some transporting scene or object. The best vision-inducing art is produced by men who have themselves had the visionary experience; but it is also possible for any reasonably good artist, simply by following an approved recipe, to create works which shall have at least some transporting power. Of all the vision-inducing arts that which depends most completely on its raw materials is, of course, the art of the goldsmith and jeweller. Polished metals and precious stones are so intrinsically transporting that even a Victorian, even an Art Nouveau jewel is a thing of power. And when to this natural magic of glinting metal and self-luminous stone is added the other magic of noble forms and colours artfully blended, we find ourselves in the presence of a genuine talisman. Religious art has always and everywhere made use of these vision-inducing materials. The shrine of gold, the chryselephantine statue, the jewelled symbol or image, the glittering furniture of the altar—we find these things in contemporary Europe or in Ancient Egypt, in India and China, as among the Greeks, the Incas, the Aztecs.'[3]

This numinous element is very clear in the art of the middle ages, as is indeed its eschatological subject matter. The imagery of the visual arts from the pre-Gothic, the Byzantine and the Romanesque, in fact all Western art between the Roman and Levantine fourth century and the Renaissance was completely geared to the iconography of the Christian Church. The whole

tradition was exclusively didactic, and it was not so much that the Church was 'the only patron', but that the feudal world was totally coloured by the actual *living* presence of Heaven and Hell; the very existence of the 'other world' was the idological core upon which society was constructed.

Chiliastic thinking was absolutely central to the medieval mind; this present world was due to pass away inevitably and perhaps imminently, into the greater realities of reward or damnation. It is notable that the most hallucinatory eschatological visions in art, those of Bosch, Breughel and Grünewald were painted in Northern Europe at a time of religous upheaval. As Werner Stark puts it '. . . in the '20s of the sixteenth century the territories now known as Germany were in a state of complete unrest. It was clear that the old feudal order of things was on its way out. It was not so clear what would take its place. The mood was millenial; anything seemed possible.'[4]

During the period of change from the middle-ages to the Renaissance Chiliastic movements swept one after another across the face of Europe. By and large they were the product of developing protestantism, a specific religous radicalism which, as we have noted, pre-figures political radicalism. In a pre-socialist situation the political was inevitably entangled with the eschatological. As Norman Cohn tells us: 'Between the close of the eleventh century and the first half of the sixteenth it repeatedly happened in Europe that the desire of the poor to improve the material conditions of their lives became transfused with phantasies of a new Paradise on earth, a world purged of suffering and sin, a Kingdom of the Saints'.[5]

However, as Cohn argues, this eschatology is still operative in the political movements of the modern world; indeed his book *The Pursuit of the Millenium* has an examination of this as its main theme, and its subtitle is *Revolution and Messianism in Medieval and Reformation Europe and its bearings on modern totalitarian movements.* 'The Middle Ages', he writes, 'had inherited from Antiquity . . . an eschatology, or body of doctrine concerning the final state of

the world, which was Chiliastic in the most general sense of the term—meaning that it foretold a Millenium, not necessarily limited to a thousand years and indeed not necessarily limited at all, in which the world would be inhabited by a humanity at once perfectly good and perfectly happy.'[6] He goes on to show how the middle ages took the prophecies quite literally, and how they acted upon them from the date when the fiercely aesthetic movement known as Montanism spread throughout Asia Minor, Africa and the Mediterranean about 156 A.D.

For a long time these preoccupations remained on the periphery of the European consciousness. This was so until the end of the eleventh century from which date there spread throughout Europe a whole series of popular revolts of a Chiliastic nature. These mass movements headed by 'prophets' and hesiachs of one sort or another swept across both the European continent and the European sensibility in a series of waves. The Sybilline and Johannine prophesies deeply affected political attitudes; for medieval people the 'stupendous drama of the Last Days was not a phantasy about some remote and indefinite future but a prophecy which was infalliable and which at almost any given moment was felt to be on the point of fulfilment.'[7]

The element of salvation is here of a special kind; it is not the salvation of unique souls who will be reconciled in the world to come, but the Heavenly City is to appear on *this* earth and the 'chosen people' will dwell in joy and plenty, while the unbelievers, including all orthodox Christians, will utterly perish. Natural catastrophies such as earthquakes, plagues, and above all the Black Death, were seen as omens ushering in the final Armageddon.

The Flagellants, the Beguines, the Pastoureaux, and the whole sequence of popular Crusades, amounted to a Messianic frenzy that became part of the total European consciousness, and one which, as Professor Cohn shows, has disastrously manifested itself in our time. 'The Nazi fantasy of a world-wide Jewish conspiracy of destruction stands at only one remove from medieval demonology. Curiously enough, the fantasy came to

Germany from Russia; and in Russia relations between Jew and Gentile remained right down to the twentieth century very much as it had been in medieval Europe, and so did popular Gentile beliefs about Jews.'[8] The Millenial idea, however, need not be restricted to the Aryan apocalypse, we have noted that there are elements of a gentler version in the hippie communities springing up in the desert, and anyone familiar with the Underground Press will have noted a specific mixture of magic, esoteric lore and mysticism.

The hallucinogen drugs, of course, do create a climate for mystical cultism as well as for the individual voyage of psychic exploration. Timothy Leary in America, from working on serious research in psychology, has become a sort of high priest of a 'revived' Amerindian religion. In England, also the status of R. D. Laing seems to have subtly altered in recent years, from the point of view of many young people who seem to want him to be a guru as well as a culture hero. There is, of course, a sort of 'scientific' utopianism separate and distinct from the cultist one, and we shall examine it further in a little while; suffice to mention here that there is an element of near Chiliastic thinking which appears from time to time in the writings of Marshall McLuhan and Buckminster Fuller which parallels that of Timothy Leary and Ronald Laing.

Returning to Psychedelic art it has often been noted that the effect of the hallucinogenic drug is a sort of induced schizophrenia, and there is occasionally a marked similarity between the drawings of disturbed patients and those produced by an artist such as Michaux under the influence of drugs. Few Psychedelic pictures are painted when actually under the influence of the drug because of a certain disintegration of technical control. Work done at a later date, however, attempting to recapture elements of the visions quite often result in images that are superficially similar to that of schizophrenics; particularly in those drawings which are of a specific decorative nature. A Dutch psychiatrist, J. H. Plokker, speaks of these in that '. . . it is typical of them that they fill the

whole sheet so that no open sections remain. Innumerable, often very different ornaments worked out in detail cover the whole paper, so that Prinzhorn speaks of an "exuberant opulence". The excessive filling of the surface with minute motifs is indeed very striking. . . . Nothing more can be fitted in, they are filled to saturation point. Geometrical figures, flourishes, spirals, strokes or dots, flower and plant motifs, anatomical shapes, figures, letters, etc., are used as a filling.'[9] Plokker suggests that this over-filling represents a 'horror vacui' and E. Minkowski connects the phenomena with the 'tendency of the sufferer from schizophrenia to fill up time completely'.

As with all the drawings of the mentally disturbed, there is a strong magical element, '. . . it is virtually always impossible with these ornamentally decorative sheets to obtain a reasonable interpretation or commentary from the patient. Either he gives no explanation at all or one which is completely unintelligible and appears irrevelant. There was a patient who gave us an explanation of his decorative drawing: 'that is the zodiac'. This answer can be taken as an arbitrary thought of the moment, but perhaps also gives the secret meaning, the magic significance of the work. The man was, in fact, suffering from megalomania and imagined himself to be the creator and supporter of the universe. It is consequently not impossible that he considered himself able to fix the order of the universe or able to influence world hppenings by means of this drawing, as if it were a powerful magic formula. Such a typically magic train of thought occurs regularly in sufferers from schizophrenia. Bearing in mind, however, that the patient would not or could not provide any further commentary, this remains purely a supposition. It may certainly be assumed that many elements in the decorative sheets have a magic significance and power for the patient.'[10]

It is interesting at this point to briefly notice the further similarity between psychedelic, schizophrenic and Tantric art. The latter has been a comparatively recent 'discovery' in the art centres of Europe and America, and is related to more familiar

kinds of Indian and Tibetan art. It is a secret and esoteric art, which explains why it has remained comparatively undiscovered, ostensibly only for the eyes of the initiated, and is largely analogous to European alchemical images, concerned as were the latter with symbolizing a cosmology. The mandala-like shapes, the images of snakes and ladders representing phenonema and experience, are closely related to images intuitively discovered in either controlled or involuntary hallucinations.

15 'I am ruled by external circumstances which appear to offer little scope for freedom. The freedom of imagination is available to me through the medium of art'

The human animal may be considered in many ways as living in two places at once. He is both a unique organism, a single and separate private individual, a whole universe trapped within his own skin, and at the same time a unit in the larger organism of society with the reactions and sensitivities of a personality in relationship with others. He lives simultaneously within two environments, inhabits at the same time two different sorts of space. He is part of a network of relationships with the people and things that surround him and he is also the chief protagonist of his interior world. In art one finds the same split that is evident in the unique individual. It is either inner- or outer-directed, though it may sometimes be both at the same time. The mainstream by and large seems to favour the outer-orientated, it caters in the main for the collective fantasies of the group, rather than those of the individual. It would seem that the current trends which have caught the popular imagination, Pop, Op and Environment, objectify the fantasies of society at large rather than those of the solitary person. This is by no means a new thing. There is a good case for drawing a parallel between certain contemporary painting and 'picturesque' painting of the past—between bandits in land-scape and cans of soup.

There are certain artists who though clearly part of the 'other tradition' can be seen to form a sort of sub-group within the larger group. They can be recognized by a sort of common imagery, post-Freudian, post-Surrealist, magical and esoteric; to a great extent their ideas seem to have derived from the psychology of Jung. Among the giants of modern art, Klee stands somewhere at the background of this line of artists, and Dubuffet is found at one side, a sort of lateral uncle. Magic and religion play a central part to the images that obsess these artists. Alan Davie is a very good example; in one sense, he is fundamentally a gestural painter—and it must be remembered that he was exhibiting works that are consistent with his most recent painting as long ago as 1948, that is to say, at the moment when theories of action and gestural involvement were being hotly debated in Paris and New

York. Considering the state of English painting at that time, enmeshed in the picturemaking of the neo-Romantics, continually shoulder-glancing backwards to Samuel Palmer, it is not strange that Davie held his first exhibitions and laid the foundations for his reputation in Italy.

The statement that he is a gestural painter, however, must be qualified. Unlike the 'action' painters who used the gesture in a manner restricted to dynamics which record the artists 'presence' as both an object and a force, Davie used the gesture as a means of bridging the world of the substantial with that of the insubstantial. His actual involvement with paint—the splash, splatter and scribble—is a means of objectifying the immaterial.

Reality is manifold; and for Davie what is important is not the perceived reality of objective sense impressions, the tangible space in which we all attempt to orientate ourselves. He is concerned with the revealed and the metaphysical; not the actual and present, but the transcendent and absent, not the environmental and material, but the immanent and magical. His awareness of reality is finally an awareness of a spiritual condition rather than of an actual place. It is represented in concrete images, however, for the painting itself is after all a specified object and a defined location. His images are close to the images of traditional mysticism. They are also incidentally close to the images of psychotherapy and those that populate the games and drawings of young children.

Davie is groping towards a spiritual attitude, a point of view of faith; his is a visual framework that is concerned with an ideal rather than with a cultural or currently presented system of reality. This is done, however, within his own private frame of reference. He is a man trying to speak of matters that are hidden, and furthermore he is attempting to speak entirely on his own resources. Perhaps his work can be seen as acts of propitiation of one kind or another.

Guy Harloff on the other hand is an artist who consciously and deliberately uses the imagery of magic and incantation. A fantasist

immersed in the gnostic tradition, well travelled in the orient, owing inspiration to popular Moslem art, to medieval alchemy, he not only stands upon the opposite platform to the new Mannerists, but is the descendant of the anti-Platonic tradition that is at least as old as the Platonic. As well as drawing on traditional symbols he also invents his own, which together in his usually small and highly detailed works arrives at a sort of modern and Mediterranean version of Tantric art. By means of a very old tradition Harloff parallels certain qualities that appear in Psychedelic art.

Most inner-orientated artists share a common characteristic, a certain quality of obsession. The language of their images does not follow a code structure that is evident and widely accepted, but is more likely to be a complex of symbols that have a profound meaning for the artists themselves, and when the symbols are 'public' they usually act in an oblique manner, revealing themselves as archetypal symbols, which though familiar, have their central meanings obscured as is usual in esoteric imagery. An image of this sort is bound up with the artist's attempt to come to terms symbolically with his own unique and personal experience, and as such it must inevitably take on a hallucinatory quality. Psychologically it is often the anchor by which the artist secures his identity in an environment of shifting emotions and values.

The 'public' artist confirms the world that we already accept, though he inevitably widens our experience of it; his method is one of research, the progressive uncovering of detail. The revelatory or visionary is the province of the 'private' artist, who in order to render his personal world comprehensible or even tolerable, must force others to believe in it and therefore to share it. It is said that 'the poet does not wish to be understood, but to be *believed*'; this is a condition we discover in the English sculptor Laurence Burt. The uses to which he puts his medium, and the enigmatic presence with which he charges objects, declares him to be a poet in this manner.

There is a profound difference between this artist's method of assemblage and that of neo-Dada. The latter as we have seen are

mainly concerned with irony and allusion; the object is metaphorical (analogous to literary puns, word-play and so on) but the metaphor is one that explains rather than one that reveals. These puns are aimed towards disturbing our concepts of society, indeed frequently of reality itself. In work by such an artist as Burt, however, there is no attempt to distort our preconceptions of reality, but rather to present an entirely different and alternative reality. In no way can his structures be regarded as 'events', they are not even statements about anything else—they are finally 'conditions'. The sculpture here is not an object, it is a state of mind. When you pull the lever offered to the spectator by the assemblage *Machine A.D. 1965, Function (Depopulation of the World and Degradation of Man)*, and reveal a real human foetus cast in bronze when the compartment door slides open, it is of course possible that this image may tell something of man's condition in the contemporary world, of the human trapped inside the mechanical, but it would be true to maintain that this is simply a by-product. We are not really asked to see this as a symbol, but to accept it as a fact. There *is* a foetus in a box. It is as simple as that. We are merely required to believe in it, in the same way as we are required to believe in the vision of a Blake, a Fuseli, or a Bacon. We are confronted by a tangible presence, and Burt has realized that the act of creation finally lies in presenting something which is immanent, something that transcends any need to have meaning.

This sort of 'stripped-down' presence is evident in what has come to be known as Funk art. The whole art world moves so rapidly these days and any new direction or 'ism' stabilizes so rapidly that it seems incredible that it was only little over two years ago that the term Funk was coined. Born out of an exhibition organized by Peter Selz at the Berkeley University Gallery, the term coalesced to describe a certain sort of obsessive object making, usually resulting in organic forms, ambiguously 'soft' and 'hard' at the same time, and occasionally preoccupied with banal, deliberately vulgar or erotic imagery. To a certain extent such movements are created by the mass-media; today a new

family of images suffers almost immediate and total exposure, and both influence and imitation are pretty near instantaneous. The 1967 Young Contemporaries show in London, for instance, showed strong evidence of Funk, and a highly successful show by four young Royal College sculptors about the same time at the Gallery Claude Givaudon in Paris was in the genre, and for a while it seemed as if every College sculpture department and 3-D room in England had its full quota of squashy bulbous forms and enigmatic assemblages.

All the same there have been several mature artists in England who, though it is possible most of them would reject the term, have been working along analogous and parallel lines for some time. These artists can hardly be described as a group in any formal sense, when several of them first showed together in London in 1962 they did so under a common, though far from rigid platform, as *The Leicester Group*. Their original exhibition, entitled *The Visual Adventure*,[1] was, however, a didactic one demonstrating an educational situation, for they were all members of the staff of the Foundation Studies Department of Leicester College of Art. That exhibition was devoted mainly to the work of the students and to illustrating a Bauhaus-derived teaching method and educational ideology, though work by the staff was hung. It was in the following year in a separate show that the unique flavour of these artists' work became apparent.

Writing in the catalogue preface at that time, Jasia Reichardt commented that since their work 'is founded on a subjective rendering of responses to outside stimuli (as opposed to abstract, narrative or reportage processes) this exhibition has been called *The Inner Image*', and she goes on to say 'these artists do more than transform the things seen and experienced in their day to day life; one could say that in their effort to make a personal image they set about to re-invent them.'[2] This already tells us something about the specific point of view held by this group, about how they regarded the role of art itself. Before we go further, however, it would be interesting to compare several personal state-

ments made at different times and taken from different sources.

MICHAEL SANDLE 'My work is a "concrete" of that which preceded language and which language is all about . . . to make a "talisman", to render myself proof from whatever I feel could interfere with the continuation of my personality and volition. A desire to be able to make a choice of some kind. . . . I am concerned with magic, awe and wonder, with ontological insecurity.'

VICTOR NEWSOME 'My aim is to create images for the paradox and "duality" which I see in all things. The sharp lines and painstaking finish do not reflect hard-edge painting, but the hermetic quality of jewellery. The erotic aspect of my work is not pornography but magic, animation and evocation. My figuration makes no references to figurative art or to pop art, but arises simply because I view the world from inside a human figure and tend to feel affinity with things which appear human.'

TERRY SETCH '(I wish to) find a plastic equivalent for the way things act upon me . . . the object entering the environment and the illusion, in both the real and the unreal . . . (my early leather sculptures) weren't associated to visual things, but much more associated to sensation things, to things of the mind.'

LAURENCE BURT 'The true world is within, but is affected and formed by the outer world in terms of sensations and perceptions. Each reflects the other. To be of significance both worlds depend upon contrast and contradictions; birth-death, peace-war, love-hate, happy-sad. . . . Whereas I am not in control of the world around me, my sculpture becomes a world which I can *almost* control. I am ruled by external circumstances which appear to offer little scope for freedom. The freedom of imagination *is* available to me through the medium of art.'

MERVYN BALDWIN 'A character in one of H. G. Wells' novels says that "science is the *work* and art the *dream* of mankind". . . . A dream is open to many interpretations, and surely any work of art is equally variable in meaning . . . at one time I would be concerned

only with formal design; at others I would be telling parables about man's increasing involvement with machinery (or bureaucracy, or war) . . . a simile arises from recent research into the function of dreaming, the results of which indicate that it is essential. . . . Art then becomes essential for the preservation of the sanity of mankind.'

In 1962 it was possible to be struck by common qualities that were stylistic, and this was even more evident at the time of the *Inner Image* show. First of all these artists were deeply concerned with the possibilities of unusual materials (we shall see the reason for this in a moment); Terry Setch, for instance, with leather and cheap plastic artefacts, Christina Bertoni with wood, rope and dyed string, Laurence Burt with welded and forged metal combined with plastics, Michael Sandle, Victor Newsom and Michael Chilton with plastics, resins and polyurethanes. But although they were using 'technological' materials, working with machine tools and 'industrial' equipment, the objects they made never ended up looking like manufactured artefacts. Each relief, each sculpture or assemblage (it is hard to classify these works) seemed the objectification of an inner world of reality.

Any reference seemed symbolic rather than figurative, and the direction appeared to be opposed to what was then, and for that matter still is, the more common mode of contemporary art for the objectification of physical reality. This type of work differs in *intent* from its apparent cousins of post-Dada and Pop in that the latter are concerned with the tangible world of objects; even the spatial ambiguities of 'cool' painting and the visual ambiguities of Op, retinal as they are, are concerned with the objective worlds of perception and sensation. On the other hand the work of these artists are objects which, though physical presences in that they exist in space, can be said to represent psychological presences, to represent mental and spiritual conditions rather than physical ones. They are obsessive, atavistic, symbolic, presenting a sort of intense, possibly distorted, but certainly hallucinatory humanism.

What is apparent from the quotations above is that there is an intellectual, even an ideological, basis for the work of these artists. There is, though not clearly formulated, indeed perhaps even half unconsciously, a common platform. The mainstream can be, as we have stated, thought of as being Logical-positivist in nature, quite clearly so in the case of hard-edge and minimal art; Sandle, Burt, Setch and others have taken an opposing platform, a fundamentally Phenomenological position, that is to say one concerned with being-in-the-world. Their sculptures are not artefacts, aesthetic or otherwise, but 'tools', devices by means of which it becomes easier to cope with the human condition. They are aware of the 'magical' nature of art, of its potential power as symbols. They are aware that reality is as much inside the head as outside the confining prison of the skin, that subject and object are held in a tenuous feedback network. It would seem that, for them, the creative act is a process not a result, that perception is an event not an experience.

By their own statements one understands that they would take the view that the environment can only be transformed by art through an act of the imagination—for Burt speaks of creating an environment he 'can *almost* control', and Sandle, elsewhere, quotes Merleau Ponty on 'wonder in the face of the world', as well as describing his motivation in a revealing and characteristically existentialist phrase as 'a desire to be able to make a choice of some kind'. The work of these artists would seem to attempt to go beyond simple aesthetic responses in the face of an environment and strive after ontological response. The environment is not passively reflected but actively questioned. Existentialism is more than a system of metaphysics, it is a process of transaction, one concerned with personal responsibility, and therefore one that implies social, even political, attitudes. Where much of modern art seems to celebrate, or at least to acquiesce to, the developing rigidity of a corporate and bureaucratic society, these artists are conscious of the alienation of the individual in the modern technological state.

The reason for this social 'content' that is apparent in Burt, Sandle, Setch and their colleagues, the original Leicester ones anyway, is easy to surmise; it would seem to be the influence of Tom Hudson. One of the most original educational theorists in England, Hudson was Head of Foundation Studies at Leicester and exhibited in the *Inner Image* show. His own sculptures, oddly enough, are very different in style from those of the artists we have been considering; he has developed within a formal Constructivist framework. His shapes *are* machined, the form far from organic. 'I like to move', he says, 'between hand and machine. Machines, especially automatic ones, are simple creatures —hands are so delicate, ruthless and complicated.' Yet the end result is a long way from minimal art. The painter Robin Rae, recently seeing his work for the first time, described it as 'almost Pre-Raphaelite'; by this he intended a compliment, he meant that the surfaces, the juxtaposition of various plastics and metals was so rich and complex, one could pore minutely over the whole individual sculpture constantly discovering detail. It was from Hudson that the younger artists learnt to explore and respect new materials, but it is possible that Hudson also helped obliquely to form their particular Phenomenological stance. Hudson's ideas, the base of his thinking, is essentially Marxist, and he sees art education directly acting upon society in that it ought not to be concerned with 'fine' art, but with visual literacy; he believes in 'the innate capacity of every individual to work out a structural language of his own'. Exactly what other influences helped towards the arrival of this specific viewpoint it would be difficult to determine, but it seems certain that Hudson's belief in the necessity for the artist to have a social commitment, and his thinking on the role of the artist in society, have provided a dialectical framework in which it could grow.

'Works of art are not mirrors, but they share with mirrors the elusive magic of transformation which is so hard to put into words.' These words are by Professor E. H. Gombrich, and they come from his book *Art and Illusion*. They are in direct reference to the problems of ambiguity in perception. Gombrich traces a thread in the history of art from early Greek painting and shows that it is possible to recognize a consistent conflict between the perceived, the understood, between the retinal image and what he calls 'mental set', the pre-conditioned image, the thing we *expect* to see. This concern with 'recognizing ambiguity behind the veil of illusion' has of course been in the air for some time. Gombrich himself, first expounded his ideas well over a decade ago in the Mellon Lectures which he gave in Washington. Recent trends in painting such as the shifting and flickering imagery of Op and the equivocal presence of the 'shaped canvas' emphasize the pivotal quality of such ideas; and anyone familiar with the current art-teaching situation will know that the word 'ambiguous' is likely to crop up in student conversation every second or third sentence.

Despite a tendency for the concept to become the latest catch phrase of criticism, a piece of cant or the current portfolio word for lazy thinking, perhaps even because of this, the problem demands serious consideration. Arthur Koestler has pointed out that the creative process is, like humour, the result of the conjunction of previously unrelated ideas. 'When two independent matrices of perception or reasoning interact with each other the result is either a *collision* ending in laughter, or their *fusion* in a new intellectual synthesis, or their *confrontation* in an aesthetic experience.'[1] This act of 'confrontation' is well known as being crucial to Surrealism, one has only here to mention Lautréamont's famous simile: 'Beautiful as the chance encounter of a sewing machine and an umbrella on an operating table.' By and large in the 'other tradition' it is the confrontation of images or symbols which is important. This type of ambiguity is well expressed by Magritte when he describes one of his paintings. 'In front of a

window seen from inside a room I placed a picture respresenting exactly that part of the landscape which was masked by the picture. In this way the tree represented in the picture hid the tree standing behind it outside the room. For the spectator the tree was at one and the same time in the room—in the picture—and, by inference, outside the room—in the real landscape. This is how we see the world; we see it outside ourselves and yet we have only a representation of it inside ourselves. In the same way, we sometimes situate in the past a thing which is happening in the present. So time and space are freed from the crude meaning which is the only one allowed to them in everyday life.'[2] Surrealist ambiguity is of course near magical in nature, it attempts to imbue the everyday with the extraordinary; or to put it another way, to strip the everyday preconceptions we place on objects away in order to reveal the natural visage. As Magritte again says elsewhere: 'One cannot speak about mystery, one must be seized by it.'

This sort of confrontation, the meeting of two previously unrelated images synthesizing into a unique third image is far from confined to surrealism. To clarify this point we shall briefly consider the work of several young English artists. They are not related to each other in any stylistic manner, the only thing that they have in common is that they are roughly of the same age group. Though they do not have stylistic aims in common, it will be noted in comparing them that there would appear to be certain common qualities; and we venture to suggest that these common qualities are endemic to the most interesting work being done at the present time.

We have already noted the work of Terry Setch in our last chapter and remarked that working under Tom Hudson he first began to explore the possibilities inherent in the confrontation of various different sorts of materials not usually thought of as being media for the plastic arts. The first objects which this artist managed to imbue with his own personality were a series of structures using leather and plastic which he made during the later '50s; these works revolved around a series of ideas about

the conflict set up between the organic and the synthetic. 'The first leather objects', he has remarked, 'were very inward-looking associative to visual things. The hide I used, for instance, assumed certain forms; it would stretch more in one place than in another. It would take on the form of the animal. But I very rapidly wanted to set up a tension between plastic and leather, and soon my things became directly related to the visual world. I made a large wall, and to this I attached a plastic flower. It stopped being gestural and became a kind of theatrical convention and environment.'[3]

But the environment that Setch speaks of is already an ambiguous situation. It is, he says, a 'theatrical convention', but it is also by virtue of being a sculpture a *real* object. In the work of this period one finds layers of ambiguity, everything is both real and unreal. There is 'real' wallpaper on the wall, but illusory windows are painted on it. The 'real' flowers are actually plastic ones, and further layers of reality are discovered when other plastic flowers are cast in bronze. Gradually the illusory element, the painted part of the sculpture, has taken over, and his most recent work has reverted to painting on canvas. This process has, from one point of view, been the reverse of that of many of his contemporaries. He has come full circle, but in the process the painted image has achieved a further dimension, it can be regarded as being at one and the same time the concrete object and the representation of it. This 'resolved' ambiguity operates at a basic level on purely formal terms, on contrasts between primary and secondary colours, on the rhythm patterns of a system of repeat images. Nevertheless the figurative image is still there and clearly so; fruit, grapes, a tree-trunk. This image, though, cannot be 'read' by the spectator at the same time as he reads the formal structure; the two are in conflict. Rather in the same way that the eye can read only one of alternate images in an optical illusion at any given instant, never both at the same time, the mind is forced in a painting by Setch to flicker continuously backwards and forwards from image to form, from the associative to the plastic.

Eric Rowan uses colour to produce the more familiar optical 'flicker'. He has arrived at his subtle and intense geometrical paintings through an earlier interest in the sign language of the city, in street furniture, traffic signals and advertising emblems. 'In an attempt', he has said, 'to duplicate the space complexity of an urban environment, close-ups, part-views, scale dislocation, images glimpsed through windscreens and rear-view mirrors, I experimented with super-imposed canvasses, perforated surfaces, relief constructions and even actual mirrors.' This is an area explored fully in America by Allan D'Arcangelo with his paintings of endless roads seen from the point of view of the driver's seat, and in Germany by Winfred Gaul who has invented a sort of contemporary heraldry based upon the signs and symbols of the highway and the urban landscape. What seems to have occurred to these artists is the fact that the idea of 'nature' as experienced by an increasing number of people today is the motorway. The endless ribbon of concrete with its landscaped verges, its intersection points and bridges, and its occasional pull-in cafes and filling stations that are as urban and anonymous as airports, is the nearest that many of us get to experiencing a rural environment. Holidays, if taken, are packaged tours in the synthetic surroundings of beach hotel or camp. These are planned in a specific way to be as unobtrusive as possible, and the very fact of foreignness, of 'abroad' compounds the sense of unreality, emphasizes that 'nature' is of a sparkling sky-blue holiday-brochure artificiality.

From the instructional sign Rowan has simplified the image to a total abstraction, arriving at an idiom of delicate and subtle optical illusion. Unlike other Op painters, however, the 'subject matter' if it can be so termed of his work is not the phenomenological experience, the retinal event, but still remains in a sense figurative. The images, though abstract, remain nevertheless 'signs', in passing beyond the metaphorical they begin to approach the metaphysical. It seems that the circles and squares, the confronted images which do not wrench or shatter the eye, but hold it fascinated by subtly continuous shifting colour and

form, still continue to instruct us, to indicate, warn or order our behaviour but in realms beyond the actual.

This sensation of transcendence which is absent in so much painting and sculpture that aims to directly operate upon our senses ignoring the conscious and rational mind, eschewing attempts to manipulate the spectator by allusion, to thrust the work itself out of the immediate daylight of concrete presence into the landscape of memory and metaphor, can also be noted in the sculptures of Anthony Benjamin. Technically, one notes in the work of Rowan that the pared-down vocabulary of circles and squares produce a network of image relationships where mysteriously the density and weight of apparently equal components vary, yet unexpectedly an absolute stillness is embodied in the painting. As the result of the most exact and refined manipulating of tensions the work emanates a certain silence. This very same quality of silence is found in the most recent sculpture of Benjamin.

Originally a painter, he developed from a sort of 'kitchen-sink' position in the mid-'50s to that of a Lanyon-inspired abstract expressionist landscape on the St. Ives model at the end of the decade. After that, his paintings suddenly broached out into a new direction. His images began to become semantic, consequential; that is to say, instead of presenting anything like a 'total' impact, a frontal presentation to the spectator, they required 'reading' across the canvas. From the very beginning of the '60s he explored a sort of discontinuous image that was articulated not so much in space as across the surface of the canvas. There was a baroque, sinuous quality about these works that seemed to prefigure by several years the renewed interest in the sweep and flow of *art-nouveau*. This sort of image that is both consequential and discontinuous is evident also in the work of the two Cohen brothers, particularly that of Bernard. There would seem to have been no direct contact between these artists and Benjamin however, yet it would appear that the latter was first working upon these lines in comparative solitude; an example of different

artists reacting in a similar manner to the current emotional and mental climate, predating and hinting at from absolutely intuitive and rigidly aesthetic sources what was later to become Psychedelic art.

Benjamin has since moved into sculpture, perhaps more than anyone else logically developing the implications of the earlier idiom; his is a sculpture in which coloured, frequently luminous, plastic plays an important part. By developing his images physically out into space he has been able to effectively objectify the idea of interpenetration. The image plane is extended in a curious, almost non-dimensional, way; and where previously it was the flat surface of the canvas that held the image, it now seems as if the artist is attempting to force or manipulate light itself to do this. (Both the technique and the philosophical intention behind the work are here different from kinetic art as we generally understand it, the latter is concerned with linear and programmed events which take place within organized time.) Sinuous metal forms are juxtaposed with frequently overlapping planes of transparent plastic of contrasting colours; at the same time cast metal, either chromium-plated or highly polished bronze reflect and refract images not only from other elements of the total sculptural group, but also from the surrounding environment, indeed from the spectator himself. There is no simple dimensional 'layer' to work of this nature; the interpenetration and discontinuity explored in the earlier paintings is thrust right down into the core of the object itself. Images exist somehow floating on or apparently above the surface of the curving plastic sheets in a sort of fluid and open space surrounding the sculpture. Images exist also as form and mass at the level of the skin, as it were, of the metal shapes, and they also exist buried deep within the object, distorted mirror-images of the spectator's existential space. Further the spectator, never remaining static himself, conditions the kinetic element of the sculpture, for, compounded by the optical and mobile properties of colour, the forms shift, sway, slip and melt as the unique space of the created object, the space

of imagination, confronts the space of physical being, that of the lived-in world.

The breakdown of the boundaries between media has nowhere been more obvious and dramatic than in the fluid and feedback shifting between painting and sculpture of the mid-60's. Exactly who qualifies as the 'inventor' of the shaped canvas is a moot point, there are many claimants; certainly in England Richard Smith was one of the first to project his image out of the canvas plane when in 1964 he followed the logical impulse to extend his cigarette-pack images out from the flat vertical wall-plane. Since then many artists have worked in what seemed at first a hybrid idiom but which has quickly achieved its own syntactic presence. Like either of its parents the combined idiom can be used to express any sort of style; Smith, himself, developing from a specific English version of Pop paints in direct visual reaction to the urban environment—an artist such as Greek born but London resident Michael Michaeledes stretches canvas on shaped formers to produce extremely elegant and pure articulations of surface—others such as Colin Cina and Robin Rae manipulate the canvas edge rather than forming projections in such a manner as to emphasize a certain figuration so that the work becomes concurrently part-image and part-object—others such as Derek Southall use formed and bowed paint surfaces in order to contrast and configure the main 'subject' content of colour.

The New Zealander Edward Bullmore also works with shaped canvas, but perhaps in a more individual manner than almost anyone else. His final images are extremely complex, and there is an element of assemblage about them, sewn, stitched and stuffed as they are, the wooden formers are occasionally the result of chance discovery, fragments of furniture, unidentifiable structures wrenched from some dim and forgotten utilitarian purpose. Arriving in this country in 1960, his background was a very conventional Beaux Arts one, and his preoccupation was with an expressionist exploration of the human figure. His development, unlike that of most of his colleagues, was not the result of

various formal problems; the figurative, even expressionist, element has always been pre-eminent. Shortly after settling in London he began to paint a series of landscapes; but they were landscapes of the imagination. 'At that time,' he has said, 'I was feeling sort of homesick. I would have liked to have gone home. And then I found that I could. I could get home through my paintings.' But soon the landscapes took on erotic and mytho-logical overtones from his earlier figure paintings; at the same time they began to project from the canvas plane. They were '. . . a sort of mythological idea about the sky and earth being male and female. It was the New Zealand landscape, the land-scape I know. There hasn't been any change though, the human figure flows through it all the time. It was a childhood image sort of thing, very strong and vivid; but later I worked through that phase. They soon became more formal, real structures. I think that this came about through just working, in terms of doing things. I started to push things out from the frame, modelling it a bit and adding curved wooden pieces later. After a while I decided that, instead of pushing it from the inside, I would build it like one was building blocks. In this way a thing would develop a shape of its own.'

Bullmore's work is a statement of duality. The form is both constructed and at the same time painted. Object and image are concurrent; the structure is on the one hand itself, an absolute presence, and on the other it is a painted surface with outside references. Overt erotic imagery is often contrasted with formal linear devices that are reminiscent of Maori magical painting. Bullmore is not a complicated man, there is indeed in his person-ality a sort of essential innocence which gives strength to his work. The clear sexual references come out of a pressing inner necessity, a sense of wonder at human duality; it is a far distance from the sophisticated eroticism of such an artist as Bellmer or Allen Jones or Paul Wunderlich.

'Science has become as true a stuff of poetry as were the wanderings of Odysseus and the tragedies of the House of Atreus'

Ken Adams, in a paper read at the symposium 'Psychology and Aesthetics' at the conference of the British Society of Aesthetics in September 1963 put forward the idea of what he called 'concretisations'. Adams pointed out that there are two forms of reaction to a given work of art. First, there are *serious interpretations*; that is to say, attempts to understand the basic and intrinsic meaning. Secondly, there are *associations*, more or less freely and loosely developed through contact with the work. This second category, which Adams has christened 'concretisations', is what one calls in music 'programme'. It is that element which induces us when facing, say, an informal painting, to recognize figurative elements, the quality of Rorsach blots, or faces in the fire, landscapes on the mottled ceiling, the allusions that any statement must inevitably draw up from our individual memories and experience. However, the most interesting point that Adams raises is that somehow the allusions are not peripheral to the central meaning, but inextricably wedded to it. Not only does the central concept imply certain other elements, but these other elements also support and maintain the *actual* as opposed to the *implicit* meaning.

'The relationship', he says, 'between the central meaning and the concretisations is like the relationship between a number of guide ropes and a central mast which they keep in place. The mast can't be kept upright without the guide ropes, just as the central meaning is difficult to maintain without the concretisation. The mast tends to be displaced if the tension is unduly concentrated on any one of the guide ropes, just as the central meaning tends to be distorted by an obsessional adherence to any one of the concretisations. The concretisations can continue to play an important role even in someone who has not a clear and distinct sense of the meaning.'[1]

Whereas a concretisation is a subjective and allusive reaction to a creative conception, it seems that creative conceptions themselves can both stem from and support a central idea; what may be true of an individual work of art may also be true of a larger

and more complex configuration. A dominant cultural idea will have its own essential meaning; but it will also have its allusive periphery, a series of ideas usually intuitively apprehended which both and at the same time develop from and support the more abstract central concept.

An idea that is dominant in the group consciousness of a culture will be surrounded and supported by its own concretisations. These will appear as art forms of one sort or another, either as phenomena of folk art, or as tendencies, groups, schools, or as the work of isolated individual artists who, though not stylistically close, can be seen to be related to the central idea. It frequently happens that the individual artist or group is not clearly aware of the central idea or its kinship with other ideas, but he is acting, as he often does, as a barometer to the collective consciousness of his society, revealing to society's amazement and his own the fantasies, the dreams and the apprehensions of the group.

Such a fantasy in our time is the idea of space travel, a dominant cultural concept which in recent years has come to colour the thinking of us all. It is not merely a question of technological achievement and possibility, but a query that has caused man to reassess his relationship with the universe as a whole. It is a fantasy since it is an undercurrent running through our consciousness, a fertile ground for myth. In the same way that the frontiers of the nineteenth century gave rise to a cultural situation which created the myth heroes of the Wild West, so we also have already petrified Gagarin and Glenn into the mythology of our time.

Man has always invented his own adversaries in his eternal struggle between his consciousness of himself as Man and that which is not-man, nature. The sudden discovery that man might, in actuality, leave the surface of his planet and voyage among the stars themselves, voyages such as man has dreamed for more than two millenia, arrived at the exact time when the wonders of his own planet have begun to lose their power to astonish. For scarcely does any of this planet's surface remain unmapped, and

near-suburban amenities, we are told, exist even at the South Pole.

Feeling, perhaps, that the essential struggle between man and nature, between flesh and matter, between spirit and object has largely been decided in this arena, he has been constrained to invent new frontiers. Like Renaissance man, 'Americas' and sea-dragons are waiting to reveal themselves before his astonished and apprehensive gaze; yet these Americas are not beyond his own measurable oceans, but beyond the envelope of oxygen within which he has so long been trapped. Small wonder the fantasy runs so deep and colours his thoughts and actions so strongly. To step outside that skin of air and enter the indifferent, hostile cold of space, can be nothing but traumatic. As primitive creatures, so the fantasy runs, clambered from the waters on to dry land, as the child who drops from the warm into the cold alienation of the larger world, so the human race is about to step off the surface of his planet into the ranges and vistas of absolute and infinite possibilities.

The idea of travelling to other worlds beyond our own is, of course, one of which man has dreamed for centuries. Lucian, a Syrian Greek, who was born in Asia Minor in the year 120, wrote in the form of his satire *The True History*, the earliest imaginative account of an interplanetary voyage. The hero, together with his companions on board ship, venturing further than any previous explorers, found their craft plucked up by a violent whirlwind and sent voyaging into space. They visited the moon and many stars, described the bizarre inhabitants, and during their saga were continually involved in inter-galactic warfare. After various adventures they returned to earth, but on the other side of the planet where they discovered the Isles of the Blest and many other wonders. Lucian's other hero, in a different piece of satire, Icaro-Menippus, is more interesting inasmuch as he arrives on the moon as the result of intention rather than accident. Taking the wing of a vulture and the wing of an eagle, which he attaches to his arms, he finally after much practice manages to soar

L

off into space. Shortly after his arrival on the moon, however, he is confronted by another voyager, one Empedocles, a naturalist, who leapt into the mouth of the volcano Etna, but, as he was old and dry and light, the vapours carried him to the moon, where he lived and fed upon the dew.

Lucian, together with other authors of early cosmic voyages such as Plato, Cicero and Plutarch, set the form for the celestial voyage which persisted basically unchanged throughout the Middle Ages and endured down to the seventeenth century. The voyage was always illogical, and the structure of the tale fantasy; the means of travel predominantly magical or accidental. Galileo's invention of the telescope, however, was the cause of speculation on actual physical space travel, though indeed the speculation was at this time naive in the extreme. What is important is that, after the date 1610 when *Siderius Nuncius*, the 'starry messenger', was published in which book Galileo describes the topology of the moon, the heavens and the spaces he had observed through his telescope. Man began to consider such journeys not only possible but also practicable, and with the rudimentary means at his disposal seriously set about trying to effect it.

It seemed, to the new rationalism of the Enlightenment, that the art of flight, far from the impious hubris of the medieval world, was a technological problem that could be solved. And with a naive ignorance of the actual conditions of space and of the powers of gravity, it was thought that once man could rise into the air a small distance, that a voyage to the moon and even to other planets was yet a further small step, a further refinement of the primitive gliders and flying machines then being conceived. Men of science throughout Europe cogitated over the problem, and many of the ideas and concepts put forward were wild in the extreme. What, however, is most striking in this concerted activity is not so much the scientific ambition which so completely overreached the technological means at its disposal, but an uncanny parallel with the basic motivation of our own 'space-race'.

Marjorie Nicholson, in her book *Voyages to the Moon*, writes, 'Of all the many themes—serious or satiric—that entered the literature of this time (early seventeenth century), none is more amusing than the belief that, with true British Imperialism, England might still further extend her Empire, and that the new world would become a British Colony! The original suggestion of lunar colonization was not British, but German.' John Wilkins, later Cromwell's brother-in-law, and an important English scientist, picked it up in his *Discovery of a New World in the Moon* in 1638, when he wrote, "'It is the opinion of Keppler, that as soon as the art of flying is found out, some of their nation will make one of the first colonies that shall transplant into that other world. I suppose his appropriating this pre-eminence to his own country-men may arise from an over partial affection for them. But yet thus far I agree with him, that whenever that art is invented, or any other whereby a man may be conveyed some twenty miles high or thereabouts, then it is not altogether improbable that some other may be successful in this attempt.'" John Bull thrust out his chin. Let the German beware his *over partial affection* to his country! Here was a new world to be colonized, and who but Britain to claim it? You and I laugh, but I am quite convinced that great stimulus to what we call 'aviation' came about in the seventeenth century because of this very belief that the first nation to discover the principle of flight would be the first to plant its flag upon the moon—and even on the planets. One country jealously watched the aeronautical progress of another. I suspect that Oliver Cromwell said a few words in Wilkins' ear—particularly after Wilkins married Cromwell's sister—and Wilkins in turn spoke these words, first to the Philosophical Society of Oxford, later, after the death of his distinguished brother-in-law, to the Royal Society, of which Wilkins was a founder member. The government had changed, but the Royalists had as much reason as the opposition for wishing to add to the British Empire the rich natural resources of the moon.'[2]

The ideas about how space travel might actually be achieved,

as they appear in seventeenth-century satirical literature, were not regarded at that time totally as fantasies. Such a concept as Cyrano de Bergerac's of attaching to his belt bottles of dew which the sun, in its warmth, must inevitably draw up, did not at the time seem as ludicrous as it obviously does to us. In his *Man on the Moone, or a Discourse of Voyage Thither by Doningo Gonsales*, a pre-Copernican romance written by Bishop Godwin, which was published in 1638, but probably written some years earlier, the hero gets to the moon by means of a raft drawn by swans, a method which John Wilkins (despite his earlier quote on the necessity of getting there first) considered quite sound in theory. Though many ideas as far fetched as Bishop Godwin's were considered seriously, there was in the researchers' attitudes to the basic problems, in his logical and deductive methods of inquiry, the beginnings of the empiricism that we would today refer to as scientific. Cyrano de Bergerac, for instance, failing to attain escape velocity with his bottles of dew for his hero, finally caused him to arrive at the moon after attaching bundles of rockets to his person.

The first really serious attempt at an *invention* in regard to flying machines was the airship proposed in 1670 by Francesco Lana. Lana's idea was four evacuated globes attached by ropes to a gondola that could be rowed with oars against air resistance as a boat is rowed against the resistance of water. Though the weight necessary for the structural solidarity of the globes must needs defeat the weight loss potential between the vacuum and the total mass of the ship, the concept is feasible. One hundred years before Henry Cavendish discovered hydrogen gas, Lana had stumbled on the principle of the lighter-than-air machine, and for the first time an aeronautical device had been conceived as the result of strict and empirical principles.

This craft of Lana's, which he envisages as a prototype of the modern military aircraft ('. . . by allowing the aerial ship to descend from the high air to the level of their sails, their cordage would be cut, or even without descending so low, iron weights

could be hurled to wreck the ships or kill their crews, or they could be set upon fire by fireballs or bombs; not ships alone, but houses, fortresses and cities could be destroyed'), became the source for many fantasies of space travel.

Once the concept of flight began to be considered in this empirical way rather than in any allegorical or satirical manner we find the beginnings of the literary genre we call Science Fiction. Science Fiction is in essence the fantasy of probability, its action never hinges on the magical or inconsequential, but takes place in a culture that is affected by an advance of technology; the possibilities of which are inherent in it, or else are suggested by speculations that are at the same time logical in terms of the story and consistent with the possibilities and probabilities of actual physical law. 'Science Fiction', defines Kingsley Amis, 'is that class of prose narrative treating of a situation that could not arise in the world as we know it, but which is hypothesized on the basis of some innovation in science or technology, or of pseudo-science or pseudo-technology, whether human or extra-terrestrial in origin.'[3]

Perhaps the most interesting literary work of the eighteenth century which used Lana's flying machine was the epic poem *Navis Aeria* by Bernard Zamagna, the first to describe an imaginary aerial voyage around the world. 'It was as characteristic of his age as of himself', says Marjorie Nicholson, 'that Zamagna should have turned back to the classical past for his motto, his style, his allusions, as that he should have glorified in hexameters not the art of Virgil, nor the grandeur of Rome, but a highly technical flying machine produced by another kind of "art". Far from avoiding technicalities and mathematics, the poet seemed to delight in turning such details into the stuff of a new kind of poetry. As Caesar built a bridge and made it into literature, so Zamagna built a flying machine. The first canto of *Navis Aeria* is devoted to a description of the construction of Lana's machine to celebration of Euclid and Archimedes as well as those modern scientists and mathematicians who had built upon them. The first canto ends dramatically, when the ship is ready to take off, with a

panegyric to pioneers of the past who set sail in frail barks and discover new lands and those of the future who may ascend in even more precarious ships to expand the "intellectual globe" as their fathers had expanded the geographical.'[4]

From Italy, Zamagna travels around the globe. Europe, England, '. . . the remote shores of Thule . . . largest of earth's tracks discovered after so long a time . . . the golden country of New Castile, the Kingdoms of Peru, the land of the Amazons, the Canadian Wilds, vast regions yet unsubdued where tribes of savage name yield obedience only to their own regions and their own customs', and another great ocean is passed. Past the Orient, China, Persia, Egypt, once-proud Carthage, and Zamagna finally returns to Europe. Greece passes below him, and here 'modern man', having traversed the whole vast globe unknown to antiquity, and only half-discovered to his contemporaries, confronts the cradle of his civilization.

'So for a moment the most modern of inventions passes over the greatest of classical civilizations in a symbolic conclusion. In the poem are merged two great contributions to the history of civilization; the old classics and the new science. The art of the Italian poet—and it was no mean art—has welded into still another whole the "ancient" and the "modern". In often flawless hexameters, with a deftness and sureness of touch not inferior to any but the greatest of Latin poets since the revival of learning, Zamagna unites old classical traditions, new scientific discoveries. In his mind there was no conflict between science and literary imagination, for science had become as true a stuff of poetry as were the wanderings of Odysseus, the tragedies of the House of Atreus. As Lucretius wove into a unified poem the philosophy and science of his period, so Zamagna passed inevitably from Urania and Phoebus to the Copernican theory, from Daedalus and Icarus to the chariots of John Wilkins, from Tiphys and Argo to the flying ship of Francesco Lana.'[5]

We can see from the foregoing that a 'utopian' view in the popular attitude to science makes its first appearance in the eighteenth century. From then on, the *astonishing* invention appears with increasing frequency in literature, paralleling and anticipating the actual technical achievements of the age. John Daniels' *Surprising Adventures* in his 'engine' *The Eagle*, which was operated in some mysterious way by pump handles, envisages a device which worked on some sort of principle of relative pressures clearly derived from the ideas of Boyle; other writers suggest magnetism as a possible motive power, an idea stimulated by the researches and experiments of Gilbert and others. Pier Jacopo Martelli (*Gli Occi di Gesu*) and David Russen of Hythe (*Iter Lunare*), as well as Cyrano de Bergerac, imagined flying machines powered in some way by magnetism, a method suggestive of the Science Fiction *donné* of the 'anti-gravity device'.

Considerations of adapting Gilbert's magnetic discoveries to flight were not all literary however. A certain Lourenco de Gusamo (self-styled *Précurseur des Navigateurs Aériens et Premier Inventeur des Aérostats*), a Portugese gentleman who renounced Holy Orders and turned to the natural sciences, demonstrated a curious machine which he named the *Passarola* (the 'swallow'), claiming to have discovered a unique principle of heavier than air flight. Purporting to be operated by magnetism, the main feature of his machine being two large amber spheres, he 'successfully' demonstrated his invention before King Juan V on 8th August, 1709, when the small model apparently maintained itself in the air for an appreciable time before the astonished eyes of the assembled court. There is a division of opinion regarding Gusamo's well documented claims among modern historians of aviation, and many consider him to have been a pursuasive charlatan, though some feel that he may have stumbled upon some unknown principle. This is unlikely, but as we shall see, there is within the type of utopianism we are considering a particular tendency to rationalize the apparently magical.

Daniel Defoe naturally made use of science orientated material,

often using the lunar voyage as a springboard for his own particular brand of parable. As his purpose was almost exclusively polemical, he would refer to his 'engines' and other assorted gadgets (amongst which were numbered a special 'glass' through which it was possible to see '. . . what was Transacted and now Transacting in our own World', a sort of proto-TV) mostly without any attempt at conveying to his readers their *probability*; this was not his purpose, it was enough to create the Utopian situation in which he could extend his satire.

Among the flying machines that his heroes were likely to come across in their voyages was the one discovered in China, '. . . called in their Country language, *Dupekasses*; and according to the Ancient Chinese or Tartan, *Apeolanthukanistes*, and in English a *Consolidator* . . . a certain Engine in the shape of a Chariot, on the backs of two vast Bodies with extended Wings, which spread about fifty yeards in breadth, composed of Feather so nicely put together that no air could pass, and as the bodies were made of lunar Earth, which would bear the Fire, the cavities were filled with an ambient Flame, which fed on a certain Spirit, deposited in a proper quantity to last out the voyage; and this fire so ordered as to move about certain Springs and Wheels as kept the wings in a most exact and regular Motion, always ascendant.'[1]

The passage referring to the 'ambient Flame' and 'certain Spirit' is rather remarkable in that Defoe appears to be thinking of a fuel that can be carried 'in a proper quantity to last out the voyage', and in this he seems to have been the first to have considered the economical question of power consumption. Marjorie Nicholson, of course, notices this, though she is inclined to see in it (as with a certain exact number of feathers in the wing structure) some now forgotten topical and satirical reference.

The physical researches of the late seventeenth century, particularily into frictional electricity, with the work of Gilbert and Von Guericke, had its obvious effects on the romancers. The first 'electrical' flying machine appears in *Le Philosophe sans Prétention* or *l'Homme Rare* published in 1775 by Louis Guillame de la Follie,

a scientist himself specializing in chemistry. Where this tale seems to be unique is in the imaginative reconstruction of an alien culture and in the prefiguration of various themes that were to become common in Science Fiction proper. The hero is a visitor to this earth from Mercury, one Ormisais. It appears that on Mercury, as here on Earth, there exist academic institutions and pedantic obstinacy. The centre of Mercurian intellectual life, the *Academy* known as the 'Luminacie' bore a strong resemblance to the then British Royal Society. Scintilla, a young inventor, applied for membership and wished to demonstrate a remarkable machine of his own devising; a flying chariot in which he claimed a Mercurian could fly, even into space as far as the other planets, singling out for example the third planet which burned so brightly in the night sky.

Ormisais, leading an academic chorus of entrenched conservatism declared such claims to be flat impossibility. Remembering futile and disastrous attempts to fly in the past, he offered, jeeringly, and believing himself safe from any test, to pilot the so-called machine on an inter-planetary voyage. It is impossible that man will ever fly, he claimed, the laws of physics, of gravity, flatly contradict any such eventuality. On closely examining the machine, however, he found that it was not the flimsy structure of levers, feathers and pulleys that he had expected, but an elaborate combination of wheels, globes of glass, springs, wires, glass covered uprights, a plate rubbed with camphor and covered with gold leaf. He was faced, not with a technical experiment on known principles, but with a total scientific and theoretical breakthrough. As any Science Fiction fan would anticipate, this machine *did* work. Scintilla successfully proved this before the assembled Academy, and poor Ormisais was forced to make good his boast. After a comparatively uneventful, but spectaculatively observed, voyage he crashes his ship while making a clumsy landing on Earth, and is marooned, a lonely alien upon an inhospitable and incomprehensible planet.

La Follie's story is remarkable in that it prefigures themes that

are central to Science Fiction. The idea of the marooned space traveller is too common to need illustration, but the idea of the creative scientist with a breakthrough concept thwarted (only for a while, however) by the hidebound conservatism of Academic theory is a recurrent theme in the genre. The inherent inertia of society in the face of change is a constant preoccupation of Science Fiction, indeed it is one that extends beyond the mere literary element, and is endemic to the whole Utopian phenomenon. There is a strong element of 'cult' in Science Fiction, and one dominant idea, one that almost amounts to a dogma, is that organized 'science', that is to say the scientific spokesman of society at large, the military, the universities, the powers-that-be, automatically block, almost in the form of a tacit conspiracy, the work of the maverick creative individual. Though there may well be elements of truth in this, the average Science Fiction fan would hold the idea as *given*, and it is just such attitudes as this which give Science Fiction a vaguely Messianic and revolutionary flavour. But, as Kingsley Amis has pointed out, the revolutionary flavour is distinctively conservative and the political attitudes are usually those of a romanticized *laissez-faire* Capitalism.

Analog magazine, formerly *Astounding Science Fiction*, regularly presents feature and editorial articles, and quite often they underline this attitude. From 1960 to 1962, the editor John W. Campbell Jnr., whom Amis refers to as himself '. . . a maverick, defiant figure of marked ferocity',[2] campaigned for what he claimed was a space drive operating on a totally new principle. The 'Dean Drive', he maintained has been satisfactorily proven to work, both as a model and as mathematical theory, but the authorities have flatly refused to consider it at all seriously, relegating it at every submission to the 'cranky-inventor' out-basket. We are not here concerned whether the Dean Drive is really the genuine article or not, there is always a possibility that it is; what is interesting is the total and unconditional support for it which one suspects is exactly *because* it is a maverick idea. Campbell's support of Dean's idea is, though, not unique; at one time

or another he has vociferously championed other such causes. One particular campaign in regard of a 'psionic' machine stands out in the continuous intensity of his support and the heightened language used to argue his case. The question that we are raising is not so much the justice of the cause, but the methods of its campaigning, and further the essentially cultist reaction of many Science Fiction fans at large who display an uncritical acceptance of the marvellous at all costs, a Utopian situation in short.

This raises another aspect of 'scientific' imagery appearing in an art form. We have seen how from the eighth century onwards a body of eschatological literature made its appearance, much of it depending on an earlier tradition, that foretells how out of an immense cosmic catastrophe there will arise a new Eden. Many Science Fiction stories attempt to rationalize such ideas into scientific and technological terms. How often has one come across the apocalyptic fire and brimstone described as the outcome of a nuclear explosion, or the apprehensions of the Millenial catastrophe described as being the folk-memory of some cosmic disaster which resulted from inter-galactic warfare long ago in time and objectively forgotten. The very frequency of this theme in popular literature, the continuous insistence of the rationalism of a myth, can lead us only to conclude that the myth is still very potent indeed, it still has the power to move and condition us.

The phenomenon of the Flying Saucer Cult which we have already briefly mentioned is clearly Millenial; it is in essence revelatory and the salvationist aspect is predominant. The *Aetherian Society* appears to be typical of many such groups that first began to appear during the late 1940s. Aetherius, himself (unlike the Venusian space-men with whom George Adamski claims to have held conversations on the slopes of Mount Palomar) lives either in the fastness of space or on some distant galaxy, and his admonitory communications to the people of Earth are through the mediumistic agency of a certain Mr. King. The typical message is a familiar one, prophesying doom, the holocaust, unless mankind mends its ways, but it also offers the

ultimate salvation of the initiated. The implications are that, unless we can speedily learn to live together in brotherly amity, and revert to an idyllic and near pastoral type of society, we shall either destroy ourselves or else be destroyed by remote aliens of a superior moral order before we, as a result of our intrinsic violence and psychopathic tendencies, can contaminate the balanced harmony of the universe.

(Incidentally, a common Science Fiction theme is one where an alien culture attempts to frustrate the space travel plans of Earth as it considers humanity not yet mature enough to have contact with other cultures, and regards the human species as either a small boy who must have a dangerous toy taken away from him before he breaks something, or as a dangerous and unbalanced organism which must be clinically isolated.)

Despite his admonitions, Aetherius holds out the promise that the 'saved' will be removed in flying saucers before the final atomic catastrophe; as even though the society be a psychotic menace, there are individuals, those to whom has been vouch-safed the light, who in some unspecified way contain within themselves all the positive aspects of our species which esoteric quality would be of inestimable value to the 'Galactic Culture'. A typical proposition, and the only point of difference from a classical Chiliastic one is that here blindness and stupidity is the mark of evil rather than traditional worldly preoccupations. Sin resides in the lack of faith concerning the existence of a superior culture of mortal beings rather than God Himself as the Emperor of the Last Days.

It is interesting to note that in traditional revivalist cults, 'God' is seen as the white-bearded father figure with a stern Blakean countenance while in the space-orientated cults as a race of remote, though indeed mortal, beings, as superior to us as to be almost like Hebraic or Rilkean angels, stern father figures also, prepared to stamp on a presumptuous antheap should it, in its blind and egoistic wilfulness, threaten to disturb the peace and harmony of higher creatures, but who, alternatively, should we show ourselves

worthy, would welcome us with open arms into the everlasting bliss of their advanced technology.

Science Fiction as a literary form seems to extend in a spectrum, a band that stretches across the poles of the extremes we have been considering, from the outright cultist, through the Chiliastic and the Utopian to the pragmatic. It is a 'popular' genre, or rather was until just recently when it has shown signs of merging with *avant-garde* experimental literature, and though read by a comparatively small number of devoted fans, it nevertheless mirrors widely held social attitudes.[3]

It should be clear that an interest in space travel, or in its parallel, time, travel is not necessarily indicative of an interest in actual physical or technological possibilities, the method is satirical in the sense of Defoe or the Classical authors. There are, of course, other fantasies operating in Science Fiction. We have already referred to the 'frontier' fantasy, in this area it specifically operates as the idea of the alien environment providing an arena in which man operates in his metaphorical struggle with a natural objective world. A typical and familiar example of this is very often straight speculative fact and for a purist perhaps not part of the genre, where a story might describe the setting up of a moon station or a manned satellite in orbit. There would be no appreciable cultural shift from our actual present, the story being an imaginative prefiguration told in almost documentary terms of a process that is already under way.

Another group of fantasies centre round the psychological discoveries of our age, and are in effect the contemporary version of the 'gothick' horror tale. Direct parallels with the Frankenstein myth indeed are very common. The machine or robot who destroys its creator, the malevolent everyday objects that threaten the protagonists in the stories of Ray Bradbury and the B.E.M.s, mad scientists, sinister and dangerous vegetation, psychopathic androids abound. Invasions from outer space of one sort or another, in particular those in which an alien organism 'possesses' the human (the updating of Dracula), threats from radiation-

mutated insects and resurrected prehistoric monsters, together with the more sophisticated forms of the theme, where the protagonists are confronted with the *Beast from the Id* rather than an anachronistic Tyrranosaurus Rex, as in the film *The Lost Planet*, as well as the recurrent womb images, the most remarkable of which probably appears in the novel by Hal Clement, *Under Pressure*, are all common themes, expressing in one way or another at a primary level wish-fulfilments of sex and violence, but at a deeper level a marked Utopian urge.

As one might expect, it is often with the tales of straightforward Utopias, that one comes across some of the best stories. These Utopias are either satiric or admonitory, either way Millenial in nature, and it would seem that this is the hallmark of Science Fiction proper, distinguishing it from the allied groups of fantasy and horror tales, and it is this quality, rather than elements of genuine science or technological interest, of adventure, or thinly veiled imagery of sheer escape, which is the fundamental reason for its appeal. A Utopia, of course, is an imagined society; but it is one that need not necessarily be one of an ideal nature, be the archetypal Second Garden of Eden. The 'Golden Feast' is, of course, often described in Science Fiction; usually it is some sort of rural paradise where man has been released from suffering and toil by advances of technology which have obviated all struggle and conflict by the production of plenty. Here man is visualized in a sort of state of ideal pastoralism, following the arts and engaged eternally in philosophical speculation, as in the novels of Clifford Simak.

The admonitory Utopia, however, is more predominant in the medium. Frequently a society is postulated where technology has, in permitting adequate production, in obviating the need for competition without evolving from a competitive society, given rise to a situation of cultural stasis. A vast urban population, numbed by tranquillizers or kept mentally subservient by means of some sort of extension of the television spectacle is presented; it is a society where man has relinquished his freedom to a

selfperpetuating and inert State, and approaches the condition, himself, of becoming an object. The hero is usually an anti-social character, a deviant from the enervating norm, who, becoming aware of the denial of humanity, attempts to get society once more on the road of cultural evolution. A book such as *Sweet Dreams, Sweet Princess* by Mack Reynolds, envisages a world where America, the Eastern Bloc and a Third Power 'the Neut World', have collapsed into cultural inertia. Production is more than adequate, and the masses are sedated with issues of a free drug, Mescaltranc, and with elaborate and sadistic television spectacles in the manner of the Roman Circus. The chief protagonist, a latter-day gladiator, becomes finally involved with a group of revolutionaries who are dedicated to breaking this evolutionary trance and to creating the ideal society.

Such Utopias, either of an ideal or of a conformist nature, can be set in an extra-terrestrial situation or in the future on this planet, or, quite often, in the here and now, but in a different and parallel dimension of space. The varieties are endless, the possibilities of ingenuity and imagination infinite. Such writers as A. E. Van Vogt, Ray Bradbury, William Tenn, Frederick Pohl, Robert Heinlein, James Blish and Kurt Vonnegut have all proposed at one time or another political or economic Utopias, and the majority of these have had in some way Millenial undercurrents.

The relevance of the destruction-of-the-world fantasy, of Armageddon, is obvious. This has been a basic theme from H. G. Wells onwards, and was central to most of the pre-war 'mad scientist' stories. During the years of speculation about the atomic bomb these stories were frequent (for instance the astonishing prediction by Robert Heinlein, *Blowups Happen*, written in 1939 which was so remarkably accurate in its supposition of detail that it was thought at a high level that a serious breach of security had taken place) as they still are in children's and pulp strip-comics. This concept still runs like a bass note through the whole field; but it has become modulated as the genre has become more sophisticated. Perhaps one of the most striking Armageddon

stories of recent years, and one that is oddly disturbing, is Arthur C. Clarke's *The Nine Billion Names of God*. A Tibetan lamasery has bought the latest model of a very advanced, complicated and fast computer. The idea is that, with its aid, they will be able to list and utter the nine billion names of God, for which task, they maintain, the human race was expressly created. The two technicians, sent by their company to install the device, having completed their task, are riding down the mountainside to catch their aircraft home, and as they do so they become aware that the stars are beginning to go out one by one.

BURT

. . . a certain quality of obsession . . . (*p. 133*)

BALDWIN

SETCH

. . . the work can be said . . . to represent psychological presences . , .
(*p. 137*)

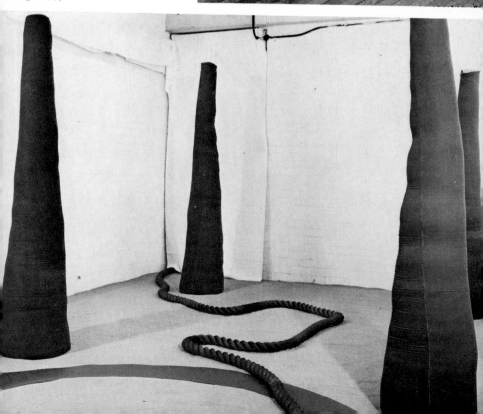

PICHÉ

. . . a sort of intense, possibly
distorted, but certainly
hallucinatory, humanism.
(*p. 137*)

FLANAGAN

. . . organic forms,
ambiguously 'soft' and
'hard' at the same time.
(*p. 133*)

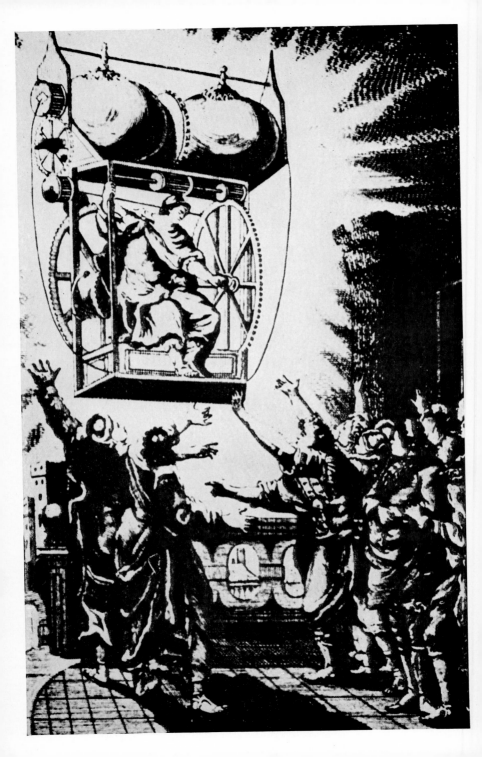

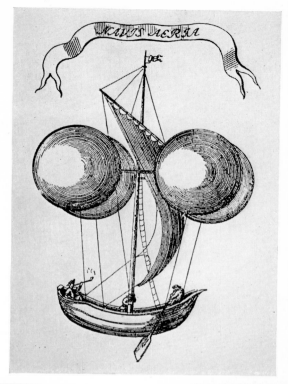

Opposite LA FOLIE

... an undercurrent running through our consciousness, a fertile ground for myth. (*p. 148*)

Right LANA

The fantasy of probability ... action takes place in a culture that is effected by an advance of technology. (*p. 153*)

Below MATTA

'an awareness of nature in its latest undisguise seems to be held in common by science and art.' (*p. 166*)

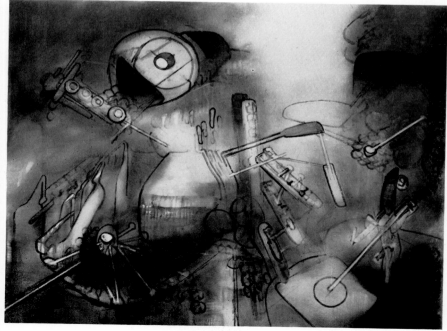

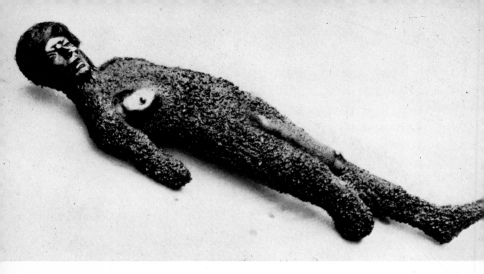

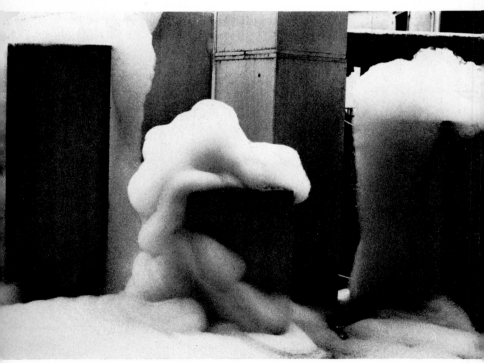

COLIN SELF

The anxiety of an atomic holocaust . . . (*p. 174*)

MEDALLA

The inner view of the modern physicist manifests itself in an
internalised art. (*p. 169*)

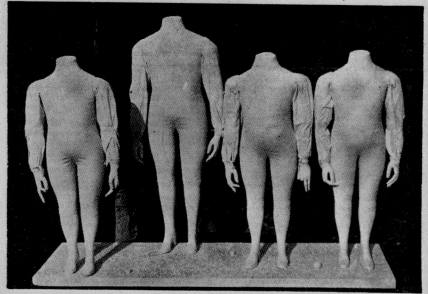

iris.time

UNLIMITED
Tiré à 4 500 ex.

2 f

Directrice : Iris Clert. Rédacteur, Le Brain-Trust. Siège Social, 28 Fg St-Honoré, Paris 8°. Anj 32-05. 23 Janvier 1964 - N° 11

L'HOMO-SPATIENS ET IRIS CLERT VOUS PRÉSENTENT LEURS VŒUX SIDÉRÉS

HAPPY NEW YEAR FROM VAN HŒYDONCK'S "SPACE-BOYS"

GRANDE RÉCEPTION DE COSMONAUTES le jeudi 23 janvier 1964 à 21 h, 28, fg St-Honoré, Paris VIII

'IRIS. TIME'

. . . the anti-utopia is a phsycial presence. (*p. 174*)

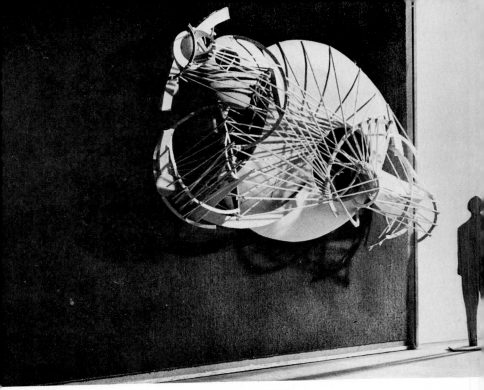

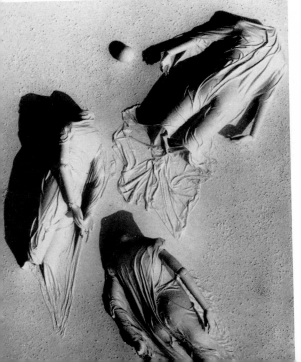

GLADSTONE

'The work often looks like an imagined interstellar world held together by metal leisons representing time and light.' (*p. 175*)

VAN HOEYDONCK

The artist does not only react to actual or potential situations, he can invent his own Utopia. (*p. 174*)

We are used to the idea of the influence of the visible aspects of scientific research on the plastic arts. The imagery of the laboratory has had an incalculable effect on modern painting, and sculpture has drawn its forms from mathematical ideas and topology as well as from specific shapes first created through the exigencies of technology; painting particularly has reacted to the stimulus of both the microcosmic and the macrocosmic as revealed by the use of the camera in research. The biomorphic forms of much modern painting owe their roots clearly to micro-photographs of organic matter. Nuclear physics has contributed in the form of electron-trace and cloud-chamber photographs to a great deal of Tachist painting, and astronomical photographs to informal painting. The frequency which such a book as *Forms and Patterns in Nature* by Wolf Strache, with its extraordinary images derived from biology, crystallography and other sources, appears in the libraries of artists and students, shows the impact that the objective visual aspect of scientific activities has had on our sensibilities.

Art as an expression of our perceptual faculties, must mirror those of our conceptual ones. When the physicists began to discover that matter was not what it appeared to be, that the seemingly solid was finally a question of waves or of particles, or perhaps of neither, our feelings about an objectively perceived environment, indeed about our very subjective physical presence, began to change. If matter was not to be seen as real in terms of sense-data, could it possibly be recorded in the objective terms of a traditional language whose vocabulary was that of so-called solid objective matter? Indeed, could any form of vision be valid in the merely immediate terms of the unrelated physical senses' reaction in art? And particularly, when the mathematicians began to arrive at totally unexpected conclusions regarding space and time, could artists still think in terms of Euclidean geometry and three-dimensional spatial relationships?

Such questions have been asked for some time. Writing in *Partisan Review*, as long ago as 1953, Leo Steinberg said: 'It has

M

been suggested the very conceptions of twentieth-century science are finding expression in modern abstract art. The scientists' sense of pervasive physical activity in space, his intuition of immaterial functions, his awareness of the constant immutability of forms, of their indefinable location, their mutual interpenetration, their renewal and decay—all these have found a visual echo in contemporary art. Not because painters illustrate scientific concepts, but because an awareness of nature in its latest undisguise seems to be held in common by science and art.

'Modern painting inures us to the aspect of a world housing not discrete forms, but trajectories and vectors, lines of tension and strain. Form in the sense of solid substance melts away and resolves itself into dynamic process. Instead of bodies powered by muscle or by gravity, we get energy propagating itself in the void. If to the scientist solidity and simple location are illusions born of the grossness of our senses, they are so also to the modern painter. His canvases are fields of force; his shapes the transient aggregates of energies that seem to be on their way. In the imagery of modern art waves of matter have usurped the place of tangible visible things. And the perceptual form, whether in motion or at rest, is dispossessed by forms of transition.'[1]

It is this point, this question of Euclidean as opposed to what has been called Einsteinian space, that is one which is central to modern art. In discussing a concept of space that is not Euclidean we have perhaps some difficulty in defining this idea, and it is perhaps necessary to use a statement of negatives, to decide what it is *not*. Faced with a typical *Ecole de Paris* work, a Poliakoff, for example, one descended from Synthetic Cubism, it is possible to see that the spatial values are those of the traditional dimensions of length, breadth and depth. The forms and tensions move in straightforward compass point directions in a flat plane situated at the canvas surface—further forms and tensions are active at various other planes within the apparent recession of the picture. This can be brought about by linear means, by the propensity of certain colours to recede, blues to appear, for instance, more

distant than reds, or by the tonal effects of traditional perspective suggestion.

Clearly, then, the forms of such a painting are activated within the familiar three dimensions; they can be said to be articulated within a cube of which the picture plane is one surface. That much recent work has relief elements breaking out of the canvas does not in any way alter the fundamental spatial structure of the work; the cube's surface is simply abstracted to a position somewhere between the picture itself and the observer's eye.

Take, however, a painting by Rothko. The forms certainly have a physical presence within three dimensional space. His typical bands of colour can be measured; they are so long, they are so broad. The flat areas of colour fulfil their normal recessive role— the reds advance to us from the oranges. Yet there seems to be another form of space, one that permeates the forms rather than describes them, one which can only be thought of as describing the *inner shape* of the forms in the way that length, breadth and depth describes its outer shape, a dimension which, instead of tracing the edges of something, appears to transverse it.

As Steinberg has it, '. . . space is no longer a passive receptacle wherein solid forms may disport themselves, as once they did in Renaissance and Baroque art. In modern painting—barring those which are nostalgic throwbacks to the past—space is an organic growth interlocking with matter. There is a painting by Matta entitled *Grave Situation* in which long tensile forms stretch through a space generated by their action—a space which nevertheless seems to compel the curvature of their path.'[2]

Of necessity such an idea of space cannot be described in familiar dimensional terms. Perhaps only the symbology of physics or the language of mathematics are able to make an ultimate statement as to what it *is* as opposed to what it *does*. Certainly it is something that can be recognized intuitively. It is to be recognized in Rothko but not in Poliakoff, seen in Mathieu and Pollock but not in Appel and de Kooning, in Paul Jenkins but not in Hilton, Lanyon,[3] Frost and the basically landscape-

orientated St. Ives School. Being as it is the objectification of a
reality we intuit, but apparently cannot verify, directly with our
senses, it must needs remain a quality in art that we cannot totally
articulate. A man sensitive to the currents and tributaries of the
international field in modern art, however, should be able to
recognize it unerringly; he can say; 'it is here—it is not there, it
is in this picture, not in that'.

Frank Avray Wilson shows in his book *Art as Understanding* an
awareness that our present historical situation precludes an
altered awareness of space. 'Times have changed', he writes, 'and
the emotional criteria of the Renaissance are not longer valid in an
artificial denatured age. Fortunately, a Newtonian space is not the
only kind of space which can be symbolized in art, nor is a precise
Euclidean geometry the only geometry. One finds different
expression of this primordial need for order in the perspective of
the Orient, and in the most recent paintings which are non-
Euclidean.'[4]

He argues, however, that modern painting stems from an
attitude on the part of our society to nature. The highly urbanized
and technologically orientated culture which we are in the process
of creating is seen by him as an act of de-naturing, and the forms of
modern painting are for him the result of the artists' reaction to a
totally synthetic environment. Men's aesthetic reactions are of a
different order, he seems to claim. In an earlier age, man reacted to
the natural world, the world of trees, lakes, forests, mountains,
seas; now, 'an entirely synthetic environment and a total dispensing
with nature has at last become possible, and indeed inevitable'.

While this element is recognizable in the attitudes held, for
instance by certain hard-edged painters who showed in the
Situation exhibitions of some years ago in London and in the
culturally descriptive wing of Pop art, Avray Wilson's point holds
true only for certain art manifestations that are finally superficial.
He maintains that man's relationship to constructed objects (as
opposed to organic objects) is the prime mover in the current
aesthetic. The Existential attitude, however, makes no distinction

between the *reality* of a table against that, say, of a stone, a lake or a mountain. Furthermore the artists' concern with nature is finally the concern with that-which-is-not-him, with the other, with matter itself. True it can be said that it is no longer viable to talk about the Other in terms of romantic landscape or humanist studio figure compositions, but the present day artist's concern with the immaterial is still an attitude towards 'nature'. The terminology, though, is different.

In Renaissance painting, objects, as Frank Avray Wilson points out, are 'solid entities immersed in a neutral Newtonian space. The individuality of things is respected, even when mistings and apparent blurrings are resorted to. Indeed, as Professor Gombrich remarks, Leonardo achieved his most remarkable feats of life-likeness by blurring just those which are most obviously lifelike and so forcing us to notice them. This is just the opposite of an attempt to render ambiguously. Drawing becomes the supreme means of material delineation and emphasis, and the world-view of an entire age is shown in the emphasis placed on its importance. In painting, the step by step build up, the juxtaposition of paint, the enhancement of natural structure and the texture of brushwork, induce a strong feeling of externality.'[5]

The 'inner' view of the modern physicist, however, manifests itself in an internalized art. The internal structure of matter, or of a perceived object, appears to be the main obsession of many contemporary artists; one only has to think of how such painters as Harold Cohen or Richard Smith present an image that is opened up and dissected; the folded cardboard cut-out before the fold is effected, when the dotted line is yet unbent, reveals finally a scheme for the structure of the solid object.

A great deal in the best of contemporary sculpture, also, examines the interior structure rather than presents the objective presence. This concern with structure, however, is different from the Cubist interest in con-structure (the latter being essentially a reaction to perceived nature) in that it may be said to be a concern with structure from the basic molecular level outwards. If this

idea is acceptable, it follows that a serious reaction to the natural order (as opposed to the cultural order) will stand beyond the point of making any distinction between an organic and a man-made object. Both are *outside* the artist in his Existential situation. The artist must somehow come to terms with the two equally and without discrimination.

Frank Avray Wilson, however, is profoundly aware of the paradox of reality. 'It is important to realize that there is no passage from classical physics to modern physics. If a virus or even a group of molecules under the electron microscope casts a shadow just like a billiard ball and would be best portrayed by the traditional techniques of realist art, when one comes to the tremulous fields of force between molecules and atoms, or to energy tracks, one is dealing with a quite different imagery for which the tradition techniques of painting are useless. The only conclusion possible is that the view of classical physics has in one sense omitted an aspect of reality, and that the precision and determinism it aspired to and found in the larger pieces of matter was in truth illusory. Basic reality is quite different. There is no passage from the one to the other, for the simple reason that as soon as we realize the illusion the firmness of reality disappears. There can be no doubt that this conclusion amounts to a profound cultural shock, for our entire culture has been based, since the Renaissance, on a confidence in material finality and reliability. . . . Reality is double-faced and paradoxical. If the new physics has its way of saying this in Heisenberg's Principle, so the new paint-ing have theirs, and so have the new writing and the new music . . . once again art becomes a legitimate way of knowing as science.'[6]

Wilson's use of the word *knowing* reveals an important point; for the modern artist differs from that of the Renaissance in that his concern is to comprehend objective reality (and the total cultural situation in which he finds himself) rather than merely recording it. During the post-war period of Tachism, many artists held their 'action'-dominated images to be equivalents for actualities which

existed in objective space and time, a sort of emotionalism of experience finally divorced from the creative act. It took the influence of Pollock to draw attention to the importance of the gesture, to act out the creative moment within the field of the painting itself, so the art-work became a sort of negative print of the artist's actual conditioned existence as a man. Many Abstract-Expressionists, however, used the freedom of this breakthrough as individual demonstrations of ego in the grand nineteenth-century bohemianist manner. The inevitable reaction, particularly among American second-generation Abstract-Expressionists and 'post-painterly' abstractionists, tends often to overlook how Pollock, Franz Kline and others pared down beyond the individual ego to the abstracted spiritual man beneath.

Whereas Kline used, to a certain extent, a traditional space, Pollock with his dense weaving of colour, his externalization of the charged structure of matter, produced images which relate directly to current concepts in physics. Energy itself became the subject matter of painting. Pollock's idea of 'getting inside' the painting was an attempt to make energy concrete, to record the imprint of movement. The most striking aspect of modern art is the concern with movement. The Futurists and Vorticists were the first to attempt to portray more than a diagrammatic representation of growth, change and interaction—the Cubists, also, with their dislocation of space implied the dimension of time in their simultaneous viewing from different vantage points. This new approach to space, as being inextricably involved with time and movement, is central to the particular breakthrough of Picasso in Analytical Cubism. 'Former movements of revolt such as Impressionism', writes Roland Penrose, 'have been limited to visual problems, but Cubism pursued its enquiry into the very nature of the objective world and its relationship to us.'[7]

A work such as Picasso's portrait of Kahnweiler of 1910 is a groping towards a realization of non-Euclidean space in painting. Penrose, in speaking of this work, says, 'the desire to penetrate into the nature of form, to understand the space it occupies and

the space in which it is situated, brought about a searching analysis in which the familiar contours of its surface have all simultaneously forfeited their opaqueness. The screen of outward appearance has been made to undergo a crystallization which renders it more transparent. Each facet has been stood on its edge so as to allow us to appreciate the volume that lies beneath the surface. Instead of being invited to caress with a glance a smooth outer skin, we are presented with a transparent honeycomb construction in which surface and depth are both visible.'[8]

Continuing to describe how, under the impact of Cubism, every aspect of painting has undergone a revision, he says, 'Under the rigorous dissection of Analytical Cubism objects had lost their momentary superficial appearance; they had been made to reveal their existence as entities plotted in time and space. The new sense of objects conceived in three or even four dimensions and from many angles had surpassed the narrow conventions which required the single viewpoint of Vitruvian perspective.'[9] If the Cubist fragmentation of space can be related to the physicist's sudden realization of the complexity and the ambiguous nature of matter, it is surprising how short lived was this particular period of spatial research in painting. After three or four years Cubism had flattened to an interest in the picture plane, and returned to a Renaissance orientated language; the particular form of so-called 'cubist space', which survives to this day, for instance in the work of Poliakoff, came into being. The Synthetic Cubism of Gris and others can now be seen to have been an exercise in aestheticism, the operative concern being the relating of shapes *to each other*. Picasso, himself, moved on in the direction of his own unique preoccupation; and there was, at that time, no other artist able to see the possibilities or the implications of the breakthrough.

With the exception of one or two outstanding exceptions, early de Chirico[10] for instance, or Matta, it was not until the 1940s that these spatial problems were again approached in a systematic manner, in an effort to find an alternative to either the flat plane or

the Renaissance 'framed box' concept. As we have seen earlier, the work of Hartung, Wols, Fautrier and others, depending on a background of Surrealist *automatic writing*, led to informal and action painting, enabling such artists as Riopelle, Mathieu, Benrath, Degottex, Denis Bowen and Paul Jenkins to explore a vibrant and fluid non-bounded space, as well as contributing to the birth of a form of painting concerned with a total overall image, a sort of self-contained 'charged-field', best represented by Rothko and Dorazio and the monochrome paintings of Yves Klein.[11]

The very discoveries of science have, in themselves, withdrawn the nature of reality from our immediate awareness. 'Today', writes Victor Pasmore, 'the dynamic and synthetic reality presented by modern physics and philosophy has placed "nature" outside of the range of direct sensation'; and the French critic, Alain Jouffroy, in a different context, has stated '. . . we are no longer concerned with a myth or with an idealistic conception of man and the universe, but with a *materialization* of the presence of invisible energy'.[12] Energy and matter, space and time; the very preoccupations of the physicist have now become those of the artist.

One would expect to find Utopian ideas expressed in the imagery of science appearing in the plastic arts. An examination of this field reveals this to be so. The anxiety of an atomic holocaust is directly responsible for a tendency which has resulted in a particular sort of image that is found perhaps more often in sculpture than in painting. This is a horrifying vision of disintegration and destruction, a pre-occupation which has been explored specifically by Germaine Richter, Giacommetti, Marini, and in England, Elizabeth Frink. Marini, describing one of his works says, '. . . as if they (the horse and rider) had both been suddenly overcome by a tempest of ash and lava like the one beneath which were found the petrified victims of the last days of Pompeii. The horseman, and the horse in my latest works, have become strange fossils, symbols of a vanished world which, I feel, is destined to vanish for ever.'[1]

Of course, this vision of Marini's is a Millenial vision. It is also stark reality, or at the very least, probability. The anti-Utopia is a physical presence; Armageddon can be unleashed at the touch of a red button, the critical mass of historical suicide be achieved when a run-of-the-mill political crisis is tightened up one notch too many. Cuba has demonstrated that if nothing else. The artist, of course, does not only react to actual or potential situations. He can invent his own Utopias. The Canadian, Gerald Gladstone, for example, says of his work, '. . . my sculpture is based on the thought that the universe is not expanding, but is a definite shape held rigidly in place in an undulating sea of dimensions. I use the cone as the shape of this universe because it represents pure invention, or a residual dimensional shape. It is the shape that the planet throws a million miles into space. I assume we are in the thin end of a cone shaped universe, and moving towards the fat end. We use light to position ourselves in this shape and mistake the expanding walls of the cone for an expanding universe; the expanding cone shape is a type of pulse symbol which we assume to be infinite.'[2]

Here is a view of the universe that is conceived without any

basis of empirical evidence whatsoever, a highly personalized and hallucinatory *rationalization*. Though the theoretical continuum in which he places both himself and mankind is an invented one rather than a discovered one, his actual sculptural images do relate to a more accepted view of the nature of the universe; the typical cone and sphere structure creates a synthetic equivalent for astrophysics. There are implications of radio-telescopes and of satellites which have achieved orbit and have extended their delicate apparatus and antennae. 'The work', writes Charles Spencer, 'often looks like an imagined interstellar world, held together by metal leisons representing time and light.'[3]

Gladstone's personalized view of the nature of the physcial universe is evident in a statement published in *Living Arts* No. 3, from which the preceding quotation is also taken. In this he describes his particular concept of colour. 'I assume that colour represents different speeds of insight, or information, or existence at different intervals of time in the space that the universe occupies. I also assume that all energy is in a state of deceleration or expansion. I would say that we only see colour as a reduced aspect of insight because we use it as an interpretative form to relate back into the universe instead of utilizing it as a direct tangential shape contained by our limited understanding of its speed.'[4] Elsewhere he maintains, 'Water is Braille', meaning that it is suffused with memories of the surface of the earth transmitted to man who himself came from the water.

Empirically, of course, ideas of this sort are nonsense. This is a personal language and a symbology which cannot relate factually, as even the meaning of individual terms may well have a separate invented connotation that is not that of the common stock of language. There is here a distinct eschatological quality, a slightly schizoid use of words and images. There is a semi-mystical jargon which perhaps may form a sort of poetic insight into the creative process which is a commonplace of much art-criticism and statements of individual artists; and it is notable that in recent years this jargon uses the terminology of physics and astronomy where

a previous 'metaphysic' would have been based on the humanities or on the terminology of Jungian psychology. In Gladstone's thinking, however, the jargon has moved clear into a dimension of its own. The ideas are presented with a pre-logical intensity of imagery, as in a psychedelic vision the sense and meaning seems fluid and it appears to slip and slide between and around the concepts.

Here is a sort of 'multi-dimensional' or 'non-Aristotelean' (to use examples of this specific jargon) verbal logic, presenting a point of view that is Chiliastic in the extreme. It is for this reason that we have devoted so much space to an artist who is perhaps not all that well known and whose work is possibly not all that outstanding. During this section of our argument we shall discuss several other contemporary artists of limited reputation; for, as illustrations to our specific concerns at this point, indeed as barometers of cultural and social attitudes, such artists frequently provide better examples than established figures. Also, leaving actual achievement aside for one moment, isolated and fringe personalities often display greater seriousness and integrity than their colleagues in the mainstream. This is due to specific social, not to say political, reasons central to Capitalist society where art has become a consumer good subject to market pressures which will be discussed in a later chapter.

All the same Gladstone seems peculiarly mixed. His idea of a cone-shaped universe, untenable in the hard light of observed fact, is a coherent concept solipsistically (and a lot of contemporary plastic artists seem to live existentially divorced from society); it could make as good a sense as any to the unique individual. The idea that 'colour represents different aspects of insight' is sheer jargon tinged with a personal mysticism, yet on the other hand he is capable of remarks highly pertinent to the whole question of the relationship of science and art.

According, again, to Charles Spencer, '. . . these thoughts he (Gladstone) calls "insights", not based on scientific learning, which he seeks to transmit. Art, he says, no longer exists. The

scientist is to contemporary society what the artist was to the past. A rocket ship expresses our problems more emotionally than does a painting. Artists lack contact while scientists create the philosophical bridges.'[5] Spencer notes an intuitive recognition of the role of the scientist in our society, and a finger is placed squarely on a central aspect of the cultural crisis of our times. Both C. P. Snow and Bronowski have discussed this matter in length.[6] They have implied that the humanities are both morally and socially less in touch with the realities of our age than the sciences. The sub-culture of science is a unified international body of intellectuals who have perhaps a more acute moral sensibility in regard to humanity as a whole than any other comparable body. We are told that this is because the scientist is dedicated to elucidating *facts*, and any attitude that is not verifiable is untenable. The climate of woolly thinking or confusion in which self-deceit can thrive is excluded by their very discipline. Whereas science presents an integrated and co-operative complex dedicated to a common aim, that of elucidating the truth, the arts demonstrate an altogether different situation. Science is communal in the best sense of the term, art is individualistic.

It is, naturally enough, the very cultivation of individual personality, frequently bordering onto arrogance, that permits the artist to delve up meaningful symbols. For this reason we do not often discover Utopian ideas in Pop art (as distinct from Neo-Dada), for, as we have discovered, Pop is a public and mannerist manifestation. Rocket-shaped objects have appeared from time to time, Derek Boshier devoted several excellent canvases to the subject at the beginning of his career. These, however, do not seem to be a direct reaction to the unique adventure of extra-terrestrial flight, but rather a reaction to a reaction. The stimulus is clearly published media material, and in this manner there would be no distinction between incorporating Colonel Glenn or Marilyn Monroe into a painting. Colonel Glenn just happened to be around, that's all.

The only Pop artist who falls into this category we have been

discussing is Richard Hamilton. Deeply influenced by Duchamp (he was responsible for mounting the great Tate Gallery exhibition of 1966 and reconstructing the *Large Glass*) he is very much committed both to his own intelligence, upon which he imposes a most rigid form of critical screening, and to the human situation as a whole. His desire is to *understand* rather than merely experience the web of forces both social and historical at the centre of which the individual man of our time continually discovers himself, and in this he leans towards the 'scientific' method. 'Intuition', he says, 'should be regarded as a marginal bonus, a mysterious sharpening of the senses and ability which belong to a particular man.'[7] He takes a phenomenological interest in 'events'; these alone concern him.

'Subjective reactions are filtered out in his search for the unique attributes of our epoch—the particular character of our community as it is to register its identity on social history.' Throughout his work he has sought to isolate *evidence* of the fantasies which mould our particular group consciousness through the examination of advertising and mass media material. To those who have followed him, he has bequeathed a concern with advertising which no other artist has had the sharpness of intelligence or the restless empirical curiosity to use as a springboard for pertinent questions—it has for them rather become an excuse for indulgence in decoration, mere aestheticism.

As would be expected, his sources for material range wide, though they largely seem to concentrate on the moral implications of luxury consumer goods such as motor cars, refrigerators and the world of fashion. In the important series of paintings entitled *Towards a definitive statement on the coming trends in men's wear and accessories,* he touches on space imagery. Panel 'A' of this series, *Together let us explore the stars*, depicts part of the face of President Kennedy in a configuration of abstract forms suggestive of an astronaut's helmet, together with suggestions of electronic equipment and wiring diagrams. Here are implications of both the actual current mythology which humanity is always in a state

of re-creating together with the public awareness of a re-orientation of thought in regard to the natural universe resulting from an increased familiarity with electronic equipment in our private lives as well as in the public domain.

Writing about this composite work, Hamilton says, '(it) came directly from a fragment of text; in this case a heading from a *Playboy* section on male fashion. The "Towards" was added to my title because I hoped to arrive at a definitive statement but never reached a point where I felt able to drop the tentative prefix. It became immediately apparent that fashion depends upon an occasion, season, time of day, and, most importantly, the area of activity in which the wearer is involved. A definitive statement seems hardly possible without some preliminary investigation into specific concepts of masculinity. Man in a technological environment was the first area. Space research was then throwing up its early heroes, every freckle on Glenn's face was familiar to the world. J. F. Kennedy had made his incredibly moving speech inviting all peoples to join together in the great tasks awaiting mankind—the exploration of the stars among them.'[8]

The artist is here interpreting a group aspiration as revealed through a fantasy mediator, in this case, male fashions. Another panel in Hamilton's series relates to what he refers to as 'the sporting ambience'. But one notes how the sportsman figure carries the suggestion of a crash helmet which echoes the astronaut image; and the third panel, though perhaps not intentionally, has implications of the spaceman's tight-fitting pressurized clothing. Hamilton's use of space-travel fantasy is opposite and complementary[1] to the romantic attitude of, say, the young German artist, Phillipe Weichberger.

His is a strange hallucinatory vision of a world which is both familiar and alien. It gives the same odd sensation of vertigo that much Science Fiction does, as if the possible had been slight shifted. Here is a world of probability, but one where disquiet is manifest in every form, an admonitory Utopia, dehumanized and final. To describe the unique quality of Weichberger's work, it is best to quote at length from the monograph by Will Grohmann on this artist: '. . . atomic reactors, somewhere in the world, but it is still that upon which we live, only a little more turbulent, more menacing, more complicated. Imaginary architecture, a skyscraper, a hydraulic power station, halls leading into endless depths . . . missiles, rocket-like shapes, satellites, metatechnical phantasmagoria, which do not appear entirely unknown or inconceivable. . . . Objects which do not exist, but which are possible and, with Weichberger, even extant. They do not stand nakedly in the picture but are incorporated into distant atmospheric spaces, in oscillating or rotating layers of movement. . . . Closest to him would be Matta with his fluctuating lines of consciousness. . . . Strangely enough man does not appear in Weichberger's paintings at all. Perhaps his world is not inhabitable at all, it is so ruthlessly technical, so full of structures that there is no room for living things, neither man nor beast nor plant. Air and water are closer to him than earth and fire. His *Alexander Battle* is a reflection, not a historical event, for this would involve earth, terrestrial space and divisible world—and for this reason

man does not appear in his pictures, he remains in the background as the initiator of the world of tomorrow. . . . Weichberger's world is controlled and accident proof. It catastrophes are necessary, they will be calculated in advance and turned to positive use. Fate would be neutralized if it no longer related to the individual. Until the day came on which man had the ambition to step upon the stage of this world too. But what would this man be ? . . . Realism does not apply. The things and events are no more real than those of an abstract picture. Instead of triangles we see lances, skeletons, buoys, fishnets, jets, entire landscapes and seas beyond our world but with analogous institutions . . . he aims at the possible which concerns everyone taking an interest in the world of tomorrow.'[1]

In Weichberger we find a landscape created out of a direct apprehension of mythological strata which exist deep below the crust of current social life, a landscape such as might be peopled by the characters from novels by Pohl, Aldiss or Ballard.

This strange spatial and cosmic landscape quality is related to the work of a group of painters known as *Nuagistes* who flourished in Paris in the late '50s and early '60s. A painter such as Benrath often creates an other-worldly ambience in his work, and though he and the group of artists who are stylistically related to him would probably prefer to talk in terms of 'inner-space', it is difficult not to read S.F. associations in a *Nuagiste* painting. Among a group of spatialist painters who followed Benrath and Deggotex, the work of Rué, Maiello and San Martin contain elements of this 'cosmic landscape'. Of them, Fernando San Martin presents the most overt image. His paintings continually present astronomical connotations, vast interstellar spaces, the drama of the collision and collapse of galaxies, the self-creation of matter in an immense and non-dimensional void.

This mysterious shifting imagery which is evoked in such a manner as to be non-referential, is indeed one which unites both the inner space of the heart and the outer space of fantasy. It is also at the core of the work of Frank Malina. This artist, like the

N

Englishman, John Healey, makes structures in which moving light and colour are projected from behind onto a translucent glass screen. It is not surprising that Malina's imagery has connotations of outer-space, for he himself is an aeronautical engineer with an interest in astrophysics, having designed and launched America's first successful high-altitude rocket, the W.A.C. Corporal. 'In 1954', writes Frank Popper, 'Malina brought a new vision to art when he introduced electric light and movement into painting . . . by choosing his themes in the world of science, he has tried to focus attention on the interplay between science and art in our time. To Malina, movement is a fact, as aspect of modern life, and it would be like tying our hands behind our backs not to use this important element in the plastic arts. Science, he says, offers us a new vision of the universe generally unseen by the naked eye, but it is up to the artist to translate this vision into rhythmic aesthetic terms.'[2]

Many artists are concerned with what we may call the debris of space. Their objects invent and prefigure cosmic disasters, and many sculptures are suggestive of alien abjects ravaged by time and fused by unimaginable catastrophies of the sort that might possibly be unearthed by future archeologists examining a distant planet—mute evidence of a vanished culture. The 'relics of the future' that the critic Pierre Rouve referred to when discussing the work of Walter Nessler. This is obviously a pre-occupation that parallels and merges with the tendency we mentioned earlier of reaction to atomic destruction; one discovers, however, artists working with this sort of image who present definite cosmic references.

This is a territory that is being explored by the young Israeli artist Yoel Schwarcz among others. His untitled constructions resemble objects that have been destroyed by radiation and by the slow wearing of immeasurable time—they are like discovered artefacts whose original purpose can no longer be fathomed, but which have acquired an intrinsic presence as the evidence of a holocaust, of a total cultural disaster. Even if such a subjective

reconstruction is only part of a total aesthetic experience, it is clear that this particular phenomenon is romantic in nature, being conceived through the mechanism of fantasy, through the dream of possible situations. No matter what sort of concretisation one places upon a work, or what associations are raised in our minds by it, we must remember that the final form of an art-work springs from the necessities of its materials. An image should certainly not be a literal rendering of an idea, but be the result of plastic considerations—of how the material *wants* to go—producing the unique forms that the material demands. If any individual work is to succeed in achieving an aesthetic presence, it must spring originally from intuitive and non-rational areas of the sensibility.

The work of Denis Bowen is a perfect example of this. He has arrived at his 'planetary landscapes', at what William Gaunt, in writing about this artist in his book *A Concise History of English Painting*, called 'his conception of non-terrestrial space'[3], through grappling with the technological problems of paint itself. We have mentioned this artist already when discussing the development of Tachism, but as the one English artist who has consistently developed the idiom he would be worth discussing in detail even if he was not the most potent example of our present thesis.

As long ago as 1950 he found himself searching for a sort of 'handwriting' which was abstract in nature, at a time when many presently successful English abstract painters were still exploring post-war figurative neo-romanticism. By 1952 he had discovered and refined his pictorial language, and embarked upon his first series of 'atomic' paintings. Bowen has always insisted on the final image being the result of the actual dynamics of the technique; in this he had been the very first, and subsequently the leading exponent of 'action' painting in England. As Charles Sewter, Senior Lecturer in Art History at Manchester University, has it, 'he has placed his faith from the beginning in a method of rapid and free execution which at the same time deliberately exploits the inherent properties of his medium and allows an

imagery to arise spontaneously from the subconscious.'[4]

Identifying the gestural speed of the hand with the explosive possibilities of the time, he arrived at pertinent images. During the middle '50s the tragedy of Hiroshima was still clearly in people's minds, and the implications were a constant dread. His *Atomic Images* and *Atomic Landscapes* conveyed eloquently a common apprehension. John Coplans, writing in *Arts Review*, said 'Bowen's painting is identified with the scientific revaluation of the twentieth century. He has been inspired by the possible transformation of his medium so that it automatically externalizes his inner thoughts. At first sight his paintings appear to have elements of the accidental and to be uncontrolled in certain passages. But by involving his image with the interaction between the liquid nature of the material and the automatic control of the brush-stroke, an ultimate structure is revealed. His image is the atomic landscape, born out of the attitudes to his material and the times in which we live. Ugly, compulsive, yet inescapably transformed by its inner realization.'[5]

As the dread of the holocaust receded, so Bowen's work became less violent. As he said himself in a lecture delivered to the Cambridge University Art Society in 1961, 'the fact of nuclear fission directly involved me in a situation where I became concerned with energy in its most naked aspect. Fusion, however, has suggested energy controlled towards an end. My recent paintings are no less *atomic*, that is to say concerned with the technological aspects of our age, than earlier. The energy of matter has always interested me . . . and it now seems possible that atomic energy may yet, instead of destroying mankind, open up great new possibilities and permit us finally to travel to the stars.'

By 1962, Anthony Tucker could write in the *Guardian*, so clear had the imagery become, that 'Bowen deals with inter-planetary space . . . has echoes elsewhere in Science Fiction, the power to escape gravity.'[6] And Guy Burn could quote from Van Voght's *Voyage of the Space Beagle* in a review of an exhibition at the Molton Gallery, and continue to say '. . . his paintings and

drawings are of limitless spacescapes, copper deserts which draw the eye hypnotically onwards to infinity, dully sparkling with a deadly metallic miasma; or of petrified structures, shaggy weightless images, conjured up with a single gesture from airless infinity, flimsy ethereal presences lit by silver and golden suns.'[7]

Through the Tachist idea of the gesture, the direct involvement with the material that creates an image appropriate to the energy applied to it, Bowen first put out feelers to the unthinkable energy that is inherent in matter, and then, through an instinctive grasp of technological possibility, to a vivid awareness of the space travel fantasy; and probably more than any other artist his inspirational source has been the ideas which revolve around the central Utopian concept of science.

Gianni Secomandi, a young Italian painter from Bergamo, explores similar dimensions to those of Bowen. Where in Bowen, though, one sees a concern for a certain concrete imagery, that of a 'landscape', the work of Secomandi presents an image of the void. His soft matt canvas areas are not the theoretical 'charged fields' of the *phenomena* painters: they describe, rather, ambiguous spaces that could be either macro- or micro-cosmic, enormous interstellar distances, or the minute but equally immeasurable void within which the basic particles of matter describe their movements. The black ground is usually activated, however, by luminous metallic forms which seems to be at the same time both physical objects and signals. His typical boomerang shape is suggestive of an extra-terrestial probe which transmits information, not only as a result of data gathered by its sensory apparatus but also by implication as a result of its very behaviour. The track it follows reveals and documents the gravitational forces which act upon it. His highly original technique of incorporating coldcast metal, and in his more recent development, mirrors, brings out this analogy with the orbital behaviour of independent masses.

The work reproduced, for example, is suggestive of electron trace photographs; it is clearly related in any dimension of scale to the behaviour of moving bodies. The central configuration is a

shattered mirror, a sphere in the process of disintegration, which is diagramatically indicated by a cold-cast metal line to be moving vertically up the canvas. A separate line implies the trace of a smaller body moving in exactly the opposite direction on a near collision course. This track, however, is deflected orbitally by the presence of the larger body, which itself is in the process of breaking up as a result of the forces acting upon it. This painting has a spareness and simplicity, a paring down of non-essential detail, which results in a remarkably satisfying aesthetic statement.

The concretisation, or interpretative continuum, in which we have placed this painting is of course irrelevant to its aesthetic presence. This is an abstract painting which ultimately communicates formally. Though the artist has no figurative programme in his mind, the painting surely is 'about' gravity. As with previous examples, the artist has been concerned with purely technical problems, with integrating the separate elements he has chosen into a satisfactory whole. A contemporary painter does not find himself constrained by appearances, but, being an artist, and sensitive to the mental climate in which he finds himself, he instinctively incorporates into his work a symbology of his age. Only a subjective and 'eccentric' painter, a Bacon for instance, is able to impress us with a syntax of his own—most artists move us by the use of discovered images which are both self-evident and self-contained.

In general sculpture embodies a *concrete* sense of reality, for its basic effect is that of presence. Where a painting is iconographic, a sculpture is the object itself as well as the image. As an object it is more than the sum of its various references but exists in its own right; it is irrevocably *there*, present in the same continuum that the spectator finds himself in. There is a distinct totemic quality in all sculpture of quality. Of course, even the most 'abstract' work must have figurative references of one sort or another, contain what we have earlier described as concretisations; it would not seem possible to refine any work entirely down to absolute and pure form devoid of any external implications without abandoning the object itself. Figuration will always exist if only as the result of the spectator's projection upon the blank screen of the work. Nevertheless a great deal of sculpture of the recent past would appear to lean heavily upon figuration frequently at the expense of the plastic qualities which create 'presence'. The so-called 'revival' of English sculpture of the early 1950s though as a result of the impact of Moore it was responsible for what is good in contemporary sculpture in England, it also almost completely obscured the real problems of sculpture. Few of the original artists who were presented internationally with such élan at that time can be seen today to have achieved anything very much. The falling off of the work of Chadwick in recent years is a case in point, and Butler, Meadows and McWilliam can only be compared with some trepidation with their contemporaries in other countries. This is probably the result of the fact that the 'revival' was really a return to that perennial Anglo-Saxon phenomenon of narrative bias, neo-Romanticism; the sculptural equivalent perhaps of Craxton or Minton. The *Icarus* figures of Ayrton, for instance, are images of classical symbology seen, as it were, through a nineteenth-century English translation. It is the Homer of Pope, Dryden and Arnold—not the Virgil of Max Broch or the Odyssey of Katzanzakis. On the other hand, the Icarian figures of Laurence Burt's *Astrohelmet* series are both of our time and presuppose our anxieties. They are at the same time

concrete and utopian, actual and predicted. Here is work that is a confrontation of reality, not an avoidance of it—symbols for the uncomfortably unknown rather than the comforting known.

Sculpture obviously, no more or no less than any other art form, presents many possibilities as a vehicle for conveying utopian ideas. Very often in the search for telling and evocative forms a sculptor appears almost to be inventing alien artefacts; alien, that is to say not merely in the social or cultural sense, but as it were even originating outside of the human race altogether. And from an opposite point of view an artist such as Van Hoeydonck presents us with an idealized and terrifying vision of the astronaut, and it is important to comment that he has consistently been so doing for many years since a time when the now familiar television images of space-walkers and moon-orbiters were conjectured and future events. Eduardo Paolozzi, in one way or another, has also always dealt with an imagic morphology that was very much Utopian in character. There was a time some years ago that it was possible to comment upon his work with the phrase 'the Frankenstein syndrome', meaning the idea of the machine in revolt. His sculptures of the mid-'60s, though abstract in the sense that references were not overtly linked to an objectively perceived reality, were figurative inasmuch as the images were anthropomorphized. It would not be flippant in drawing a parallel between the work of that period and those sequences in cartoon films where the hero is menaced by some familiar *thing* that has suddenly acquired human characteristics and become malevolent. This would seem to be Paolozzi's nightmare (like that of Michaux and Ionescu); the sense of threat inherent in inanimate matter, the fear that objects may one day turn and take their revenge on mankind.

His work of the early 1960s consisted of images that were reminiscent of machines; but machines totally of our time—non-mechanical and solid-state. One visualized the dense interior of the sculpture as being composed of electrical circuits and relays. They gave a suggestion of brooding intent, and one was reminded

of the sense of contained power that is experienced when one is facing a computer or complex electronic mechanism, all the more disturbing for the lack of moving parts. Within a few years, however, the static object had suddenly burst into furious activity. The machine itself, in sympathy with dissociations both in the individual and in the culture of its creator, is seen to be in the state of becoming schizophrenic. Here, in the place of merely implied threat, is active danger. The machine is getting out of hand. In descriptive terms, the sculpture retained its familiar box-like components but it has also sprouted a cluster of serpentine tentacles, writhing arms that flay and whip about the central core in an almost frustrated rage. The object has thrown out pseudopods and become mobile and walks like a hydra.

The machine fascinates him. As Christopher Finch puts it: 'To Paolozzi the anonymous beauty of technology offers a model for art. There is no point, however, to competing with technology; accept its methods—and economics if necessary—but compete and everything is lost. In his sculptures Paolozzi simulates the elegance of technology but translates it into another context where it does not have to compete with its functional antecedents (to lay a work of art open to direct comparison with a gas-turbine would be absurd). Paolozzi takes the imagery and methods of technology but energizes them within a totally different language structure.'[1]

And it is this idea of 'language structure' that suddenly becomes important, for he involves himself as an intuitive interpreter not only at the level of the logical pre-determined function of mechanisms or the utopian image of a technologically structured society, but has also queried the whole idea of programmed function. Doing so one would assume at the social or even individual level as well as at the technological. As long ago as 1952, when, at the I.C.A., he, together with Richard Hamilton, Reyner Banham, Laurence Alloway and others raised the subject of advertising material and demotic imagery as material for 'fine'

art and so launching Pop art, and began to explore what Finch has so aptly termed 'the media landscape'.

By way of film and word collages executed in a random manner reminiscent of the techniques of William Burroughs, he arrived at a series of folios of lithographs based on 'scrambled' or variable functions, language games and the ideas of Wittgenstein. As Finch, discussing this matter, has written: 'To draw a scientific parallel, the emphasis on the conceptual role of the artist leads to the notion of the artist as programmer. What seems to be emerging in the arts is an equivalent for cybernetics; communication systems are emerging, linking various previously separate disciplines. Each of these disciplines has its own technical skills. The artist, by adopting the role of programmer, can utilize all of these skills. Paolozzi's programming is largely concerned with the media landscape; movies, discs, military stylings, the literature of fashion, kitsch, technology, etc. His method in recent projects such as *Moonstrips* and *Universal Electronic Vacuum* has been to programme material drawn from this landscape—Mickey Mouse to transistor circuits—re-energizing this material in new contexts. Language structures are superimposed upon one another to produce new patterns of syntax (the superimposition of patterns creates, in fact, its own context). The syntax often "flutters", functioning as a semantic equivalent for Op art. Other configurations of imagery—while remaining complex—seem more stable and here the term "language clusters" is perhaps more useful (but these shifts in pace are, in any case, all part of the linguistic complexity). The media landscape can, in fact, be more easily grasped in terms of language patterns than as a material phenomenon.'[2]

Here the analysis of 'syntactic' images is related to games theory in the same sort of way that random and aleatory imagery is related to communication theory. In either case it is, despite the insistence of personal statement or manifesto of 'scientific method', the intuitive and aesthetic instinct that is responsible for the final effect and form of the art object. This is clear in the area known as

Cybernetic or Computer art. Of course with electronic mechanisms it is possible to produce computer generated graphics of a certain order, this was made clear in the large I.C.A. exhibition of 1968 entitled *Cybernetic Serendipity*. Yet though these graphics have a certain visual interest they appear to lack any real aesthetic presence. It was notable that the most impressive images were those of a completely aleatory nature, produced more often than not with the least complex systems and equipment; the various feedback projection devices and oscillascope patterns, particularly those operating on various versions of synasthesia, colour and movement, for instance, being transposed from sound.

That science is influencing the artist in Cybernetic art is undeniable, but perhaps not in the way that the artist so often claims. A rather nagging question seems insistent here; is it science itself, the theory and practice, or is it a romanticization of science that is operative? Some artists clearly gloss their work with a surface film of pseudo-scientific thinking which is Utopian in the manner which we have discussed in terms of the influence of Science Fiction on painting and sculpture. Others, on the other hand, have attempted to use the visual media in the manner of a scientific continuum, the act of painting being handled within an experimental framework, as an act of *research*. The English artist Roy Ascott is such a one. He works directly in terms of information theory; his *Diagram Boxes* and *Analogue Structures* are conceived of as operating within the total social structure as *analogues* of scientific and philosophical ideas rather than as self-enclosed art objects which embody a scientific principle indirectly as an attempt to apprehend reality. Reality is not his concern as much as communication. Considerations as to how a message may be conveyed, and the processes involved in the transmission of information, are here applied to plastic art. Ascott takes the line that the intangible *message* of a work of art can be treated in the same way as an item of information. Certainly an aesthetic action can be seen to be conditioned by its relationship to other factors, to take on different qualities in different situations. In the larger

historical framework it is clear that taste behaves both as a catalyst and operates in terms of widescale social attitudes. This sensibility to broad outside forces allows a conclusion to be drawn that aesthetic function operates in a manner that makes it totally dependent. The idea that aesthetic communication relies on a great many diverse factors, some random, many apparently unconnected, which process is interactive—the artwork revealing the factors and the factors revealing the artwork—is one that would appear to be pertinent in the present development of art, and is one that will clearly assume a more and more central position during the coming years.

'Cybernetics', writes Ascott, 'has provided me with a starting point from which observations of the world can be made. There are other points of departure; the need to find patterns of connection in events and sets of objects, the need to make ideas solid (working in wood, etc.), but interfusable (transparent panels, hinged sections), an awareness of change as fundamental to our experience of reality; the intention to make movement a subtle but essential part of the artefact. For long periods I think with a pencil in my hand and amass large quantities of small notes which are loosely collated over the walls of my work area. My independent inquiry is regularly reinforced with close references to scientific publications and search into their methods of analysis and investigation.'[3]

An artist of totally different temperament, Eddie Wolfram, has worked over the last few years on a series of remarkable paintings which explore firstly the ambiguity of surface, of *traces* and interchangeable levels, but which also contain implications of cybernetics. However, where Ascott is directly involved with the theory of information, producing work confined to and conditioned by a rigidly experimental method, Wolfram intuitively re-presents it. Unlike the 'programmed' elements of an audience participation work by, say, Agam, the patterned elements in a Wolfram are static. As the result of purely aesthetic means—optical effects for instance—the grouping of elements invariably gives the sensation

of being on the point of suddenly re-combining into a pattern which symbolizes a different and separate message. His configurations of torn and slashed plastic, and complexes of string and painted ping-pong balls are emotionally relevant to the subject. For being in no way a theorist like Ascott, yet being a person who is aware, (and states) that '. . . the art work is the key to co-existence between modern man and his science'[4], he creates images for certain scientific and philosophical ideas which he has grasped intuitively. It is interesting to note how Wolfram spans various clear-cut tendencies; the concern for surface on the one hand, stemming from the philosophical ideas of Heisenberg, ideas of movement, variability and time developed from Bergson, and notions of code and message derived from Norbert Weiner.

The artist is here intuitively reacting to science, attempting to discover a metaphysical equivalent to the realities of the objective world as revealed by the physics and technology of our time. It would seem that Wolfram, previously a powerful expressionist painter within a figurative idiom, was influenced by contact with the German *Group Zero* whom we have already mentioned. If we are to regard such tendencies as constituting a 'romanticization' of science, there are clearly areas where the case is much more extreme. We have noted that space travel and Science Fiction are seminal to much contemporary iconography. Well within the 'other tradition' we find an artist such as the German Claus Geissler who creates robot-like objects that have a deliberate and overt Science Fiction orientation together with an obsessional presence that borders on the hallucinatory. His sculptures, with their glass ports and 'legs' are often suggestive of B.E.M.s, but they are also oddly reminiscent of space capsules. They have that organic look which is noticeable in machinery that fulfils a highly specialized function. Their uniqueness lies, however, in the dichotomy between the mechanical and depersonalized exterior and their content. One has a feeling of what they *should* contain, and is reminded of aeroplane engine nascelles or the housing of some complex electronic machinery. On looking inside, though,

one is confronted with a dream-like world where distance and space are disturbingly warped by mirrors and lenses. Human figures or isolated hands perform mysterious and enigmatic functions. Inextricably wedded into a complex of machinery, tubing and dials, they become androids of a sort; a foetal image in a mechanical womb.

Many artists of vastly different sensibilities, of widely varying interests seem, either consciously or unconsciously, to be creating work with the imagery of outer space. John Warren Davis's sculptures, particularly in the *Nova* series, implode upon themselves, silent yet clamorous with invisible forces and pressures. Otto Piene, with his *smoke paintings*, pursuing invisible phenomena and basically concerned with the inherent properties of his materials, nevertheless presents us with images of vast dense suns and black shrouded planets. Others like Rotraut, Samona and Takis consciously incorporate images of cosmology. Writing of the latter, who has made such a striking innovation with the introduction of magnetism into his structures, Alain Jouffroy says, '. . . for Takis, human space is changed by science, and his change of space results in a change in the optics of art. Tele-magnetic sculpture, in which the elements are held in suspense in the air by the forces of attraction exerted over them by magnets, coincides perfectly with this change of space. We recognize in it what constitutes the singularity of the human situation in the universe of the twentieth century; man's realization of a *planetary journey*.'[5]

As a manifestation in painting and sculpture this realization of a 'planetary journey' is not a school or 'ism', but a cultural undertow that permeates our whole society. It is an imagery that has been evident in art for the last few decades, an image that clearly has precursors in Surrealism, in such an artist as John Tunnard, and the *Psychological Morphology* of Matta. And, as with literary Utopianism, it cannot be said to be strictly a reaction to the actual existing space research programme; indeed with the physical achievement of moonshots it has seemed to be less overt in the

visual arts. A parallel might be drawn also between the seventeenth-century cosmic voyages and the iconography of Bosch and others; for frequently in the apocalyptic visions of these artists there appear strange machine-like objects which would not be out of place in the cover illustrations of a Science Fiction magazine.

The awarness of the future in art is more than a simple reaction to the technical achievements of our first tentative paces into space. Any work, of course, that embodies a merely literal transcription of fact, no matter how current or fashionable, must be relegated to that special limbo reserved for it, along with narrative pictures of boats in harbours and bowls of fruit. Utopian concerns, however, presuppose another and better society, and the admonitory or anti-utopia confronts us once more with our unbounded capacities for destruction, stupidity and evil. Violence has become such a commonplace of our society, that the artist is rare who can create his work in joy and wonder, express his astonishment, reverence and praise as did Renoir. Indeed it is very likely that this is no longer possible at all in present-day society. Yet no matter how psychotic, even sadistic much modern work is, it does express an awareness of disquiet, a moral judgement. And it is just this sense of perfectibility, this refusal to accept things as they are, that would seem to lie behind science-orientated imagery, behind the obsession with future possibilities and apprehensions in much contemporary painting and sculpture.

The myth of Icarus is a potent image of man at any time; but in ours it is one that has become to a certain extent objectified. The struggle to join the Gods is the great aspiration, the fuel of evolution. It is that which motivated the protozoa to crawl up from the slime, from out the amniotic fluid, onto dry land. When Prometheus grasped fire from heaven, he wished to steal the power of the Gods for men—Icarus, more proud, aspired to join their company as an equal.

23 'The appearance of movement in art accompanies the modern adventure that has enabled us to become aware of essential forces formerly invisible'

How much the invention of the cinema has given us a new awareness of time it is difficult to say; certainly the ambiguity of time and the interpenetration of movement and place have been explored in literature from Proust via Joyce to the *nouveau roman* of Robbe-Grillet, Duras and Burroughs. The early Futurist researches of Marinetti, Balla, Carrà and, above all, Boccioni, were centred upon the ideas of sequence and simultaneity, and were consciously based upon the thinking of Bergson about the interplay between space and time. Their attraction to the machine as an ideological symbol was essentially a reaction to its dynamism. Despite their extraordinary ability to prefigure later developments in art such as certain paintings by Balla concerning 'interpenetration' which are almost like the works of such contemporary artists as Stella or Kidner, there was a definite 'romantic' and nihilistic quality about their fundamental thinking which was inevitably to lead to a reactionary political standpoint.

In exactly the same way, the essential optimism of the Moscow groups of Constructivism and Suprematism as well as the Dutch De Stijl Group was to engage them logically into a progressive social platform. Writing about the Russian artists Herbert Read commented, '. . . the new medium was to be, not paint, but rather steel; the new method not composition on a plane surface, but rather construction in space. The form to be achieved was not necessarily harmonious or beautiful, but rather dynamic and quasi-functional. The work of art, that is to say, was to have the expressive qualities of an efficient machine. If the house, in Corbousier's famous phrase, was to be a machine to live in, the suprematist work of art might be described as a machine to live *with*.'[1] The Suprematist approach was the first attempt to formulate a directly social role for art. As Camilla Grey writes, '. . . October 1917. The Bolshevik Revolution. The revolutionary art becomes the art of the revolution. By virtue of their youth and energy, the "leftish" artists—the suprematists, followers of Tatlin and various other "non-objectivists"—were given the opportunity, surely unique in the history of Western civilization, to organize artistic

life, to put into practice their ideas for "ordering the new world according to the new vision". Mass festivals and pageants, street decorations, buildings hung with cubist and suprematist banners and posters, pictures hung in public squares—propaganda of the "new communist" way of life in a "new communal" language. Already in their violent public discussions before the revolution (which so often ended in scandal), one sees a protest against a society in which the artist had ceased to be a living member, had become an appendage, his work a luxury to be enjoyed by the elite. They therefore leapt to the support of a regime promising a new order, rejecting the old; the futurist in them delighted in a new world based on electrification. In Malevich's words, taken from his manifesto *On New Systems in Art*, 1919: "According to the old aesthetic, art did not take part in the construction of the contemporary world. . . . But art must grow with the stem of the organism, must give it form, must participate in its movement. . . . We wish to master (the world), to appropriate it, to seize it from the hands of nature, to build a new world, belonging to ourselves".'[2]

In the same year as Malevich's statement the Bauhaus was opened in Weimar, and the De Stijl Group had been in existence for two years, both groups maintaining the new socially-orientated role of art. Gropius has written about his school that '. . . our guiding principle was that design is neither an intellectual nor a material affair, but simply an integral part of the stuff or life, necessary for everyone in a civilized society'[3]. And Van Doesburg stated that '. . . under the supremacy of materialism, handicraft reduced men to the level of machines; the proper tendency for the machine (in the sense of cultural development) is the unique medium of the very opposite, social liberation'. With the integration of various media, the final ideological breakdown of 'fine' art into a total aesthetic continuum consisting of architecture, design and environment relating directly to the emotional and social needs of the whole group, a step was taken towards discovering an art form genuinely relevant to a technological

society. The formalist artists of the '20s all saw 'fine' art as being a consumer product specifically created for an elite, as being a facet of Capitalist society. We have already noted that in the pre-Capitalist era, that is to say before the Renaissance, art fulfilled a much more 'communal' role; these artists were the first to suspect what is now surely clear to us today that art must once more find this sort of role again. Unfortunately in Russia itself, and subsequently in other communist countries this genuine 'socialist' art was soon perverted into the propagandist and aesthetically reactionary form of Social Realism. At the same time, in the 'democratic' West the same ideals were eventually corrupted into a élitist art by the mechanism of the art-market. This is a problem we shall revert to later on; for the moment we shall briefly consider the aesthetic rather than the social implications of formal art.

The early social element was centred upon recognizing the 'machine' as constituting the new environment of man, replacing the pre-technological 'rural', organic and romantic environment. Naturally there has been considerable resistance to this shift of viewpoint, if for no other reason that an outdated social structure attempts like an organism to defend itself against change. Progressive art is revolutionary in every aspect, it implies that conditions change; it is a sort of foreign body that enters the organism of society and a process akin to cellular rejection takes place. For this reason the old 'romantic' art forms erect the myth that the sort of work we have been discussing is anti-humanistic; it is described as 'cold', and the machine itself is regarded as hostile. At this point it is ignored that machines, computers, the urban environment and so on have no quality in themselves of being either humanistic or anti-humanistic. Man alone is either of these and has the freedom to choose between them. The technological world is undeniably present, and any art-form that does not operate within this premise is either dishonest or irrelevant.

We have already seen that the various implications, philosophical as well as aesthetic, of the technological world are

essentially non-linear and interpenetrative. As a result of this it is possibly a reassessment of the quality of time that is most apparent. In the 'global village' time has a totally different quality from the familiar sequential forms of the pre-technological era. The artists were quick to note this. 'Constructive sculpture', Gabo states, 'is not only three dimensional, it is four dimensional in so far as we are striving to bring the element of time into it. By time, I mean movement, rhythm, the actual movement as well as the illusory one which is perceived through the indication of the flow of lines and shapes in the sculpture or in the painting. . . . I would say that the real sources of the conception of space in sculpture are to be looked for in the whole state of our intellectual development and of the collective mind of our time. Space did not play a great role in the previous art, not because the previous arts did not know anything about space, but because space represented to them only something which is there together with, or attached to, a mass volume. The volume and the material world around them was the main peg on which they hung their ideas and vision of the world.' Gabo finishes this statement with the quotation we have already noted in a slightly different context. 'I would say that the philosophic events and the events in science at the beginning of this century have definitely made a crucial impact on the mentality of my generation. Whether any of us knew exactly what was going on in science or not, does not really matter. The fact was that it was in the air, and the artist with his sensitiveness, acts like a sponge.'[4]

The idea of actual movement in art began to be examined seriously in 1920; Gabo himself, Maholy Nagy and Rodchenko all produced kinetic works in that year. In 1921 Viking Eggling and Hans Richter had produced their first abstract films, and in 1925 Duchamp had made his very important work *Rotary Demi-Sphere*, which not only moved but also incorporated optical effects of colour, and was to lead inevitably to his optical *rotors* of some years later. Dada, in fact, descending in part from the Russian experience was to become concerned among other things with the

basic phenomena of light, colour and movement. Speaking of this, Richter remarked, 'There was, of course, the axiom of the *laws of chance* which let things fall where they wanted, and revealed new possibilities. But the free-wheeling laws of chance were only one side of the picture. The "scientific method" of analysing laws and principles of plastic expression, the desire to penetrate into the *generalbass der Malerei* (Eggeling), to find the clue for a universal language, to search into the equivalence of opposites, into an understanding of the principle of contrast and analogy . . . was deep behind our cynical acrobatics.'[5]

Due perhaps to the shifting political situation in Europe from the mid-'20s onwards this optimistic and progressive movement was by and large abandoned. Art remaining, as it must, a manifestation that is parallel to the main political and social currents, somewhat despairingly, despite the continuing efforts of the Bauhaus, yielded the *avant-garde* to Surrealism; and it remained perhaps for the existential experience of the '40s to once more inject idealistic attitudes into the mainstream. A sort of post-constructivist situation survived in Paris, it is true, with such artists as Hélion and Closon and the groups *Circle et Carré* and *Abstraction-Création*, but it was not until a post-war reassessment that a concerted international movement concerned with kinetics resurfaced.

As Guy Brett has put it, '. . . the appearance of movement in art accompanies the modern adventure that has enabled us to become aware of essential forces formerly invisible . . .'.[6] This awareness of 'forces formerly invisible', of the complex dynamic flux within matter, which finds its expression in kinetic art is parallel to the awareness of a different form of space within which dynamism operates. This is an awareness that is part of the larger consciousness which gave rise also to Tachism, the physical presence of nuclear physics, the new and monstrously disturbing concepts of matter, of the dynamism latent in the material, brought into the light of day by Los Alamos, Hiroshima and Nagasaki.

Post-war, as opposed to '20s-optimistic, kinetics and Tachism

are related at their roots, though progressing in apparently opposing stylistic directions. In kinetics, during the last fifteen or twenty years, the play of light, the ambiguities of contrasting action, of tensions and balances, the directions of forces, of movement, have all been explored in a range of work that stretches from Vasarely, Accardi, Kosice and the Argentinian *Group Madi*, Agam, Soto, Schoeffer, Calder, Munari, the French *Groupe de la Résearch Visuelle*, Groups 'N' and 'T' in Italy, *Novi Tendencija* with Pircelj and Srnec in Yugoslavia, *Zero* in Germany and *Nul* in Holland, through to the innumerable artists throughout the world working in allied idioms such as those in London at the moment, Riley, Sedgley, Kidner, Steele, Salvadori, Robbins, Culbert, Brisley, Willats and Shurrock.

Tachism is often nowadays thought, especially in England, to have been a brief and extremely self-indulgent form of romantic expressionism, perhaps important only in its relationship to the American School of Abstract Expressionism; that remarkable creative explosion that took place in New York during the '40s. To think of the two manifestations as being related and the European one as being somehow the poorer cousin, could not be further from the truth. The two schools were entirely separate both in effect and intention. It would seem that the greater part of the impact, of the way a specific group of American painters caught the imagination of sensitive and creative people elsewhere was due to something that was not necessarily an intrinsic aesthetic quality. It was perhaps more a romantic and dramatic situation which symbolized a certain spirit, a total commitment to a creative attitude.

The drama of the New York phenomenon lies in its very condensation and intensity, in the manner in which a group of artists, under the stimulus of emigré talent, compressed into a few enormously exciting years a process which was essentially different from the parallel one in Europe. It is the second half of this term Abstract Expressionism which gives us a clue to its specific quality, for despite the Surrealist influence of Masson on the early

work of Pollock, despite a certain influence of automatism from Ernst, despite the transatlantic Surrealism of Gorki and Lam, the truly seminal figures were Hoffmann and De Kooning, both steeped through and through with Central European Expressionism. When De Kooning says: 'In Genesis, it is said that in the beginning was the word and God acted upon it. For an artist that is clear enough. It is so mysterious that it takes away all doubt. One is utterly lost in space forever. You can float in it, suspend in it, and today, it seems, to tremble in it is maybe the best, or anyhow very fashionable. The idea of being integrated with it is a very desperate idea. In art, one idea is as good as another. If one takes the idea of trembling, for instance, all of a sudden most of art starts to tremble. Michaelangelo starts to tremble. All the Impressionists start to tremble. The Egyptians are trembling invisibly, and so do Vermeer and Giacometti, and all of a sudden, for the time being, Raphael is languid and nasty; Cézanne was always trembling but very precisely. The only certainty today is that one must be self-conscious. The idea of order can only come from above.'[7] Taking in not only the statement but also the general emotional flavour, the point of view, it could almost be Kokoschka speaking, or Munch.

The expressionist, that is to say the personal visionary element in the New York School is amply reinforced in the case of Franz Kline. His sudden conversion to abstraction was typical of a highly charged, but individualistic and artist-centric creative climate. For many years a figurative, indeed one understands an almost academic, painter, he suddenly exhibited a complete change of direction (and obviously a total emotional reorientation) into the territory that he was later to explore. We use here the word 'conversion' advisedly, for this process seems to have been the result of a blinding flash of insight, a moment of illumination analogous to that of spiritual enlightenment. The particular experience that marked the turning point for Kline has been frequently mentioned, indeed it seems well on the way to becoming one of those hagiographic incidents of our culture, like

the accidental mould that Fleming left on a window sill, the day that Francis Bacon saw the film *Battleship Potemkin* or Kekulé's dream of a snake with its tail in its mouth.

In describing this watershed experienced by Kline one can do no better than to quote the description by Daniel and Eugenia Robbins: 'While playing with a Bell-Optikon in a friend's studio, Kline saw one of his rapid brush sketches enlarged against the wall. The subject, a rocking chair, was enlarged out of all proportion. As a subject it was obliterated by the technique. The image rather than the object became the seat of expressiveness, line and space themselves became form, so that their (and his) energy infused a limitless space. The vibrant strokes of black ink, weighty even in rapid motion, were involved in a dialogue with what had originally been the white ground.'[8]

Clearly this is the Expressionist (in the Central European sense) individual vision. Parisian informal abstraction on the other hand, was steeped in the philosophical pessimism of Sartrean Existentialism. Where the American engaged his plastic vision with his subjective awareness of the world as an individual, the European engaged his plastic vision with the collective awareness of the world as a member of a group. The one was ego-centric, the other socio-centric. Witness Marcel Brion: 'It will be noted that Existentialism, which is truly the system of thought most characteristic of our epoch, corresponds to two very different tendencies of contemporary art. One is dramatic realism, whose subject is the spectacle of human misery most strongly expressed in absurd situations of which human suffering is most often the consequence; the other is abstraction, by means of which modern man escapes from the uncertainty and insecurity of the modern world, creating an absolute and absolutely new reality, freed from the precariousness and unreality of the objectively real.' Brion, as were other critics and artists of the Tachist period, was also deeply conscious of the importance of the scientific ideas in art that we have been discussing in this essay, for in the same text he goes on to say: 'It can also be conjectured that scientific progress

may have influenced art, that the unique beauty of some unusual representations (photographs of nebulae, of crystals, of microscopic sections) discloses a new visual world to the artist, in which he finds not models but creative stimulus. In short, new aspects of nature, rarer, more surprising, more varied, testifying to the majestic beauty of cosmic life, arouse the painter's emotions even though he may have no scientific training and may merely come across such powerfully inspiring images in popular magazines. By making such vicarious use of the microscope or telescope, the artist becomes intimately acquainted with a nature different from the one known by his predecessors. Just as philosophic theories influence the artist, not dialectically, but atmospherically, as it were, so scientific insights into the structure of the universe reach him as images, and whether or not he is aware of them, become part of the complex of plastic forms that strike his senses, and helps to determine the character of his creations.'[9]

These rather longish quotations are composite and opposing texts which illustrate the fundamental difference between Abstract Expressionism and Tachism. The first is concerned, even in the case of Pollock's dynamic gestures, with a personal interpretation of the visible world of perceptions, while the second is concerned with the invisible world of phenomena, the microcosmic world of the structure of matter or the macro-cosmic world of the structure of the universe. Tachist reality is not the perceived but the intuited, its subject matter is not the objective physical world, but the network of forces and tension that brings the physical world into being. In the first the artist's involvement with his image is emotional and interpretative, concerned at one level or another with the act of recording. In the second, the artist's involvement with his image is conceptual and speculative, concerned with the invisible dynamics of matter, with chance, risk, gesture and the revelation of the structure that lurks behind the irrational.

Bryan Robertson has written about Pollock saying that he '. . . has
made one of the most potent gestures of art in the twentieth
century. He showed us that painting is a primitive activity.'[1] The
imagery of Pollock's early work was, of course, archetypal, even
Jungian, a sort of post-Surrealist symbolism influenced to some
degree by Masson. It is possible, and this is what is usually done,
to take the major work, the great canvases that were such a
dramatic revelation, as being total abstractions, dynamic ana-
logues and regarding them rather in the same way that one does
those of a painter like Mathieu (in terms of intention, that is, not
quality). This, however, would not seem to be quite accurate; for
veiled beneath the familiar all-over network of splashes and
dribbles, growing organically out of them, conditioned by
'random' gestures and accident, are images of a sort—totems,
mandalas, eyes, that have an enigmatic and magical force.

Though Pollock's stated intention was to '. . . paint an entirely
"free" abstract picture, divorced from any literary content
whatever',[2] there is a good case for making out that his intuitive,
though no doubt sub-conscious, intention was to create out of a
crucible of violent action a series of 'magical' symbols similar in
character to the Indian *sand paintings* which fascinated him so
much. Certainly he realized that violence was a releasing force;
and that it was only by an absorbtion in *action* that he could hope
to break through the mask of conventional and social behaviour
and plunge down to hidden levels of experience beneath. His
way of attempting this was to manipulate the very structure of
violence, and it was, as Robertson points out, '. . . the inner
springs and tensions of violent action or a dramatic situation
which moved him and aroused his imagination, rather than
violence itself as an emotional display.'[3]

If it is true to say that for Pollock painting was a 'primitive
activity', we must not understand by this that it was completely
magical or atavistic in nature. The importance given by Pollock
to Amerindian ritual, not only in the plastic sense of an interest
in the temporary ritualistic designs made of coloured sand, but

also within the context of the romanticizing of American aboriginal culture we have discussed earlier, is clearly dominant. But
there also appears to be a different sort of primitivism operating,
one which does not seem to have been previously discussed, that
is analogous to the art of children.

It is necessary to make it clear that this element of primitivism
to which we now refer is not the 'primitive' we speak about when
we should actually be using the word 'naive', nor is it the child-art
expressionism that has captivated and influenced such artists as
Dubuffet and Asger Jorn. It is a level of image-making that predates either of these developments, existing at aesthetic levels
which take place at phylogenetically, that is to say evolutionary,
older stages of behaviour and experience. The squiggles, dribbles
and splashes which are the dominant and familiar images resulting
from Pollock's painting techniques seem to take on a quality
that can only be described as semantic. The more familiar approach
to his work is to regard the overall network of spattered paint as
constituting a sort of continuum or tensor-structure, particularly
in view of the painter's method of working from the centre of the
canvas placed flat on the floor, and his preference for being
personally 'in the middle of the picture'.

However, the final effect takes on something of the quality of
calligraphic, or rather pre-calligraphic, signs. Clearly Pollock was
familiar with the work of those artists influenced by oriental
brushwork like Hartung or Mark Tobey but this would not
necessarily have had any impact upon him. If this idea is anything
more than a mere projection on the part of the current author,
and that a semantic element does exist in the work of Pollock,
then it is very likely that its appearance took place at an instinctual
level of which the artist was unaware. The suggestion that this
process may have occurred arises from a comparison of certain
passages in the paintings with the ideas of the child-psychologist
Rhoda Kellogg. An analyst of the drawings of small children at a
very early stage of their development, Kellogg noted that, before
figuration appears, the child's plastic vocabulary is limited to a

series of about twenty basic scribble forms. These later develop by way of 'diagrams' such as cross, circle, triangle, via combines and aggregates of these elements to the first tentative pictorial images. The basic scribbles, however, constitute the most primitive syntax of plastic form; indeed this is not restricted only to the behaviour of human infants as we have seen in the experiments undertaken by Desmond Morris with the chimpanzee Congo. Morris discovered that apes were capable of visualizing and objectifying forms up Kellogg's development 'scale' almost to the point of actual pictorial figuration. It is quite possible that the 'primitivism' of Pollock was as much an intuitive attempt to recapture that pristine vocabulary which exists at the first dawn of visual sensibility and motor control, as it was the more familiar 'wild man' the 'primitive' in the context of Thoreau attempting to rediscover a lost American innocence.

If this was not a conscious activity in this painter, it was and still is very much an area of deliberate research in the case of two European artists. The Italian Luciano Lattanzi and the German Werner Schreib have collaborated for many years in what they have christened *Semantic Painting*, which, according to the critic Robert Estivals, writing in the preface of Lattanzi's own book, '... has its origins in the liberation of the individual instinct which expresses itself through natural signs. The standard linguistic classification is applied because there exists between the signified (the appearance) and the significant (the value) no intellectual, conventional or symbolic bond, but the one participates in the nature of the other.'[4]

Thought and imagination are not considered as intervening in the 'automatic' development of the image; yet, unlike total automatism, the painting is made up of a series of 'basic gestures', that is to say elementary and primitive signs that are similar to those discovered by Rhoda Kellogg. Lattanzi's fundamental idea is that in this way the work of art is expressed in a language that is truly universal since its component 'vocabulary' exists and operates at such a fundamental level; this is in contrast to less basic

forms or signs, which being more complex begin to acquire some quality of the symbol and are therefore of necessity beginning to be restricted to a cultural nexus, their interpretation to be confined to members of a common culture. 'What distinguishes semanticists from others', Lattanzi says, 'is their attempt to find an objective meaning in the vitally constructed work. These meanings can be found if we agree that semantic paintings are signs which produce conceptual responses according to universal rules.' [5]

We have seen throughout this essay that art appears to be operating today upon two different and completely divergent premises. Both of them are fundamentally and intimately concerned with the immediate environment. Both of them are attempting in one way or another to *manipulate* the environment. One method is intuitive, the other concrete. One method is 'magical' the other pragmatic. Happenings and Minimal. Dada and the Bauhaus. All the arts seem to be currently polarizing, dividing themselves into a right and left, as it were, and this is not surprising since this is an increasingly evident tendency throughout the whole of Western society. It seems ironic that at the beginning of the century the Suprematist and other 'purist' areas were the bearers of the revolutionary ideas in the social sense in the face of a general 'conservatism' of post-Cubism. Today it would seem to be the Minimal and purist tendencies that are conservative while the socially progressive idioms are expressed within the 'other tradition'.

Post-Dada, however, shows none of that optimism demonstrated during the full flush of concrete socially-orientated art—indeed it has a tendency, as we have noted, to be pessimistic, even desperate. Like the political New Left it is more conscious of the past it must shuck off than what it will replace it with. It is possible, of course, that all genuine revolutionary situations have been 'negative' in this way. Apropos the student revolt one is always hearing the question raised by the establishment, 'but they have nothing *constructive* to offer in the place of what they wish to pull down!' Have not all revolutions had only the haziest idea of

the 'replacement', been movements against rather than for? The new situation grows organically out of the ruins of the old. To regard the post-Dada activity as nihilistic is to make a mistake; it is not the result of despair, but of an inexorable historical necessity for change, by the evolutionary pressures to come to terms with the realities and implication of technological society, an action that can hardly be said to have yet commenced.

Harold Rosenberg has spoken of the 'tradition of the new', referring to the present 'tradition' as being one which must continually search for new idioms, containing a proposition that each individual artist must produce a totally new and more extravagantly mutated rabbit out of the conceptual hat. 'Etonnez-moi!' demanded Diaghilev, and ever since Cocteau immediately complied, the artists have followed suit. This is of course partly the result of a groping around during a period of social change. Style disintegrates in moments of transition. The tremendous bursts of activity into all possible directions of the aesthetic compass, the self-consciously exploratory and 'radical' stance, the whole creative explosion of recent years, may well be seen by the future as a violently confused, diffused and trivial period. They may well regard Cubism as the last fling of the Renaissance rather than as the beginning of the new; they may see Picasso as the final monumental peak in that individualistic chain of ego-centric artists developing through the ages from Giotto and Duccio, the final escarpment at whose bluff the character of the terrain completely alters; they may consider everything since 1908 as the birth pangs of whatever style their society will have stabilized into.

Art, we have argued, should be an instrument of change in a period of change. As Ernst Fischer puts it: 'In a decaying society art, if it is to be truthful, must also reflect decay. And, unless it wants to break faith with its social function, art must show the world as changeable. And help to change it.'[6] We opened this essay by noting a crisis in our relationship with the objective world, a world which has changed and evolved faster than our

attitudes, beliefs and institutions. Of course art is dissociated from society at the moment, since society is clearly dissociated from itself.

There is indeed much contemporary art which reflects decay, vast areas of Pop, acres of Minimal, clamorously mouthing the latest media catchphrases, like the tags from a late-night radio show; finally 'the medium is the message' has no more validity that 'it's that man again', for it is not thinking of McLuhan that is in question, but a mantric phrase, an easy and dishonest solution to a problem, a rubber patch slapped temporarily on the rent in the leaking dinghy. A great deal of work is finally less 'reflecting decay' than compounding it; for, unlike the art Fischer speaks of, it is not truthful and it does break faith with its social function. Large areas of contemporary art have ceased to be revolutionary in anything other than in outward form, that is to say in style which is at less than skin-deep. As an instrument of change art is at risk of becoming one no more fundamental than a couturier, no more barbed than a new pop-record. It begins to become itself ephemera, on the edge of fulfilling a role as trivial as that of fashion.

It would be untrue to say that art has exactly moved into this position of its own accord; however, it has permitted itself to be seduced. The Renaissance is finally over, and by that we mean not only as an art form, not even a social pattern, but more a whole civilization. It was a way of life based upon certain assumptions which have been labelled bourgeois and capitalist, a social structure based on trade, profit incentive, the individual aggression of laissez-faire and the group aggression of colonialism. The appearance of the technological world has closed the door upon this civilization, it constitutes not a development of it but a new path opened up; a fact that would even today appear not to have been grasped by those we have permitted either through ignorance or impotence to govern our affairs. As a fact it is not merely a political one, for political facts are malleable, subject to change, subject to manipulation, but it is an evolutionary one, an

inexorable fact of historical pressure than no political action can divert.

In a way one can say that there is no such thing as the twentieth century. It is a sort of pot-hole in the path of evolution, and we poor creatures here below are busily trying to scramble out of the nineteenth century into the twenty-first. Of course we do not want to leave the comforts of the past, the tried and trusted values, we try to drag them along with us into the modern world. Society is an organism, and like any organism it is conservative by nature, it is resistant to change. No organism *wishes* to mutate. It only does so when it is forced to by the final whip of evolutionary selection. Change or die. Until the point arrives it will attempt every ploy to avoid disturbing the status quo. Art, as we have noted, is a barb in the body of society, but in Capitalist society it is a barb that has by and large been bridled by the mechanism of patronage. It is worth noting as an aside here that whatever future society the technological world finally settles into will probably be Socialist in nature. Socialism, however, is as open to interpretation as Christianity, whose role it seems by and large to be superseding. Yet today's Socialist societies (with one or two notable exceptions, briefly Czechoslovakia, possibly Cuba and Yugoslavia) are as embedded in the nineteenth century as is the Capitalist West, and their technique for containing the barb of creative cultural change is by 'controlling' the artist; they use the older and more simple method of the knout, psychological if not physical.

The West is more subtle. It buys the artist. By turning art into a commodity good, by incarcerating it into museums, by a system of competitions and prizes, a structure of prestige and success, the collector, dealer, historian and art-official manage between them to emasculate art. A work that was brought out into the light of consciousness in creative silence, in the pain of conviction, is turned into a mere thing. The artist who has worked in the hard light of idealism is swiftly turned into a careerist struggling up a ladder of competition to the background sound effects of gallery

private-views where seemingly inexhaustible supplies of gin tinkle merrily to the accompaniment of an abrasive mutter of gossip, scandal and the struggle for prestige.

This all began with the Medici. The first of them was responsible for one of the most crucial moments in the history of art. This took place in Florence one day in 1439 when Cosimo di Medici, a banker, commissioned a life-sized statue from the sculptor Donatello. This was the first major work of art of a secular nature and it heralded the entry of the artist into the social revolution that was to be known as the Renaissance. Before that date the artist was regarded as a junior member of a guild such as those of Joiners or Masons. He was a craftsman ekeing out a living painting tournament banners and furniture, carving pulpits and heraldic devices, and occasionally he might be lucky enough to get a big commission to paint a madonna or carve a crucifix. He was totally subject to the conventions of his time, he was an artisan deploying a skill. Indeed, the concept of 'artist' had not yet been invented, and it took the individual act of patronage, the appearance of the private collector to create the situation which allowed the individual 'artist' to appear. The visionary was essentially a creation of a commercial society, he could only come into existence when his work became a commodity, when the patron appeared and with his wealth was able to impose the taste of an influential minority.

The advent of the patron changed the very nature of art. Where before it had been an expression of the community, fundamentally 'primitive' and magical in nature as we have already remarked, it quickly became a matter of taste and preference. Aesthetics was invented (at least as far as Europe was concerned—classical aesthetics was, of course, rediscovered and developed). A sculpture or painting was expected to fulfil a different role, and unlike medieval art which was basically anonymous and completely religious, it assumed a heroic quality. The patron was personally glorified, either directly through a portrait, pompous equestrian statue or florid tomb, or indirectly by

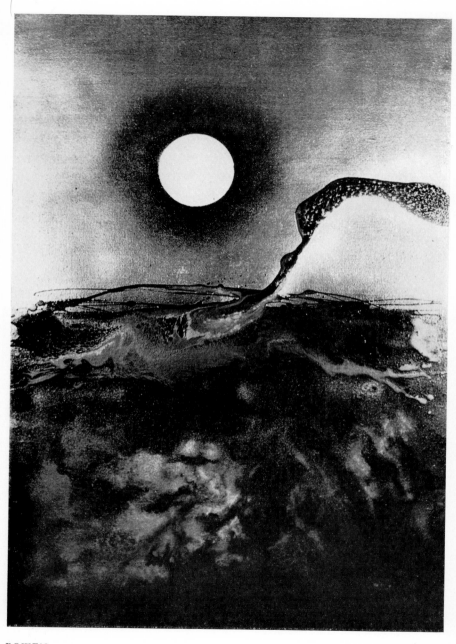

BOWEN

'. . . a conception of non-terrestrial space . . .' (*p. 183*)

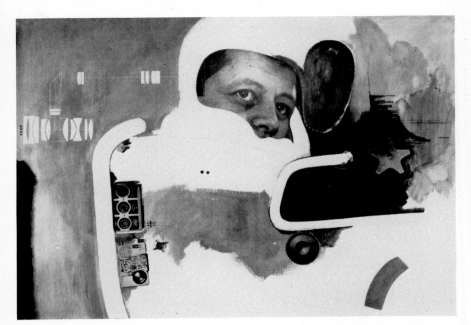

HAMILTON
'. . . man in a technological environment was the first area.' (*p. 179*)

WEICHBERGER
'. . . a landscape created out of a direct apprehension of mythological strata . . .' (*p. 181*)

Above left CLOUD CHAMBER

Above right SECOMANDI

Ambiguous spaces that could be either macro- or micro-cosmic . . . (*p. 185*)

Below PAOLOZZI

'The artist . . . is largely concerned with the media landscape . . .' (*p. 190*)

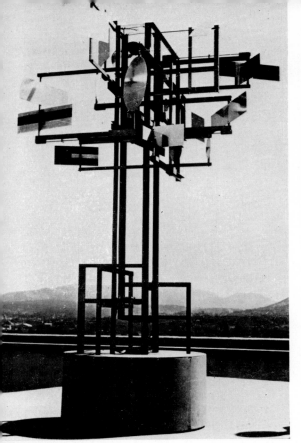

Above SCHOEFFER

Below NESS (COMPUTER ART)

'. . . the attempt to use the visual media in the manner of a scientific continuum. (*p. 191*)

Opposite above DE GOEDE

Paintings which explore the ambiguity of surface . . . (*p. 192*)

Opposite below WOLFRAM

. . . on the point of re-combining into a pattern which symbolises a different and separate message. (*p. 193*)

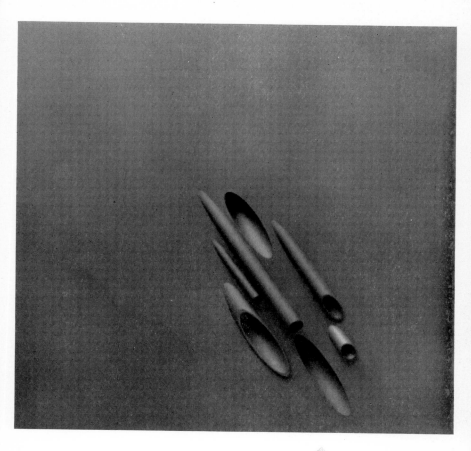

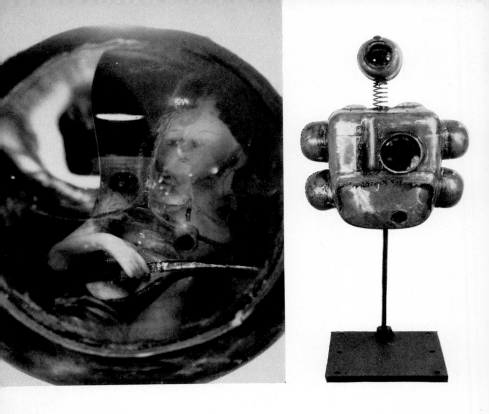

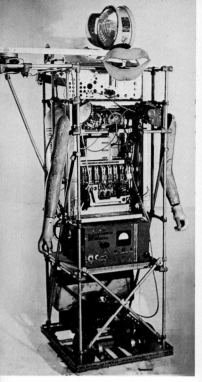

Far left GEISSLER
(INTERIOR)

Left GEISSLER
(EXTERIOR)

Above B. LACEY

. . . overt science-fiction connotations together with an obsessional presence that borders on the hallucinatory. (*p. 193*)

Right TAKIS

'. . . man's realisation of a planetary journey.' (*p. 194*)

LILIAN LIJN

. . . the awareness of 'forces formerly invisible' . . . (*p. 200*)

SCHREIB

'. . . the liberation of the individual instinct which expresses itself through natural signs.' (*p. 207*)

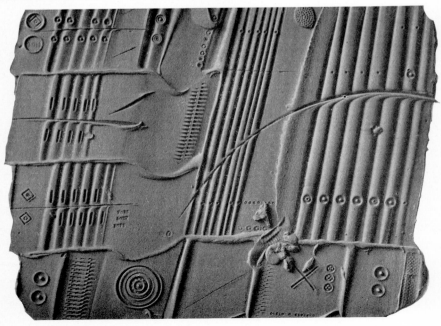

providing the vehicle by which the patron exercised his taste. In fact the idea of 'keeping up with the Jones's' was born. When the Pazzi family commissioned the architect Brunelleschi to build them a palazzo, their rivals the Rucellai family immediately ordered a more extravagant building from Alberti. The competition for prestige through the ownership of works of art was under way.

The artist himself quickly evolved. From the humble artisan he blossomed into the temperamental and idiosyncratic bohemian. If anyone thinks that the romantic artist, the 'roaring boy', was a product limited to the nineteenth century, he should read the autobiography of the sculptor and jeweller Cellini, or the poems of Michelangelo. Not only art itself, but also the temperament of the artist became inextricably involved with the existence of the patron and has remained so almost up until the present. From the fifteenth century until recently, the private patron, whether he was a Prince, aristocrat, merchant or young man collecting souvenirs from the Grand Tour, bought paintings and sculptures to adorn his house and expand his prestige. The individual collector was the sole support of the artist, but this pattern has been radically altering during recent years.

The artist has usually been by nature a dissident, particularly so since the Romantic movement of the mid-nineteenth century. Up to just recently the patron has also been in his own way a dissident. That is not to say he was not a political revolutionary, but he was usually a man in conflict with the system, a man on the make. In the case of the Medici and other Renaissance patrons they were, of course revolutionaries of a sort, surplanting the old feudal order. The same can be said for the merchant patrons in Germany, Holland and elsewhere in Europe: at the same time the Courts were using art to consolidate themselves against the rising tide of republicanism. Recently, and specifically since about 1950, a totally new form of patronage has appeared. The individual patron, frequently a businessman, tends to have a vested interest in the stasis of society; his influence, however, is no longer of

prime importance. The real patron today is the State. Success for a young artist nowadays is by and large caught up with his acceptance and promotion by an art 'establishment', made up not only of critics and dealers as in the past but also of enormously powerful art officials who hold patronage in their hands in the form of prizes, representation in major international exhibitions, attendance at Symposia, and purchases by museums and Public collections, all necessary cachets to be achieved before an artist's work begins to sell to the general public, and more importantly achieves a saleroom price. This latter is also a development of recent years. Collectors in the past have often been concerned with the element of investment in their purchases, but invariably in the work of long dead masters. Today the saleroom places a living artist's work, frequently a very young living artist's work, into the investment category of stocks and shares. This not merely turns the art work into commodity goods, but, rivalling Midas himself, actually turns it into *money*, or its bond equivalent.

The pertinent factor about these shadowy art officials is not the apparently paradoxical appearance of public office culture bureaucrats in almost every country in the world, but the fact that they are employed *by the State*, and must therefore be dedicated, whether they recognize it or not, to maintaining the status quo. Indeed the most influential organizations staffed by art officials, those that have final control of the critical international festivals like the Venice Bienniale where reputations and fortunes are made or broken, such as the British Council in England, and the United States Information Service in America, are departments of their respective countries' Foreign and Diplomatic Services; through them the promotion of art has become a factor of political P.R. As is well known the activities of artists in Communist countries are controlled to a greater or lesser extent by Artists Unions, generally adhering to an extremely conservative line. They are not unique, for the Western state art bodies are perhaps more than analogues. It is true that an Artists Union generally favours 'Official' art, usually the most rigid and academic

social realism. But then bodies like the British Council inevitably, because they are victims of pressures larger than themselves, favour a different sort of 'official' art. It is true of course that they promote the most *avant-garde* developments, they are not reactionary in aesthetic terms, that is a role they happily leave to the Royal Academy. Yet does not their assimilation of the *avant-garde* render it immediately acceptable by a form of cultural osmosis? Certainly, what they and like bodies throughout the world present is a sort of academism, it is the 'progressive' art that the establishment agrees between itself has virtue. These bodies have enormous power; and few young artists without their support are able to develop their careers in any real sense, and generally end up unexhibited, known only to professional colleagues, teaching in some provincial art school.

The promotion of art abroad as we have noted is a sort of political and nationalistic window-dressing. But in recent years painting and sculpture has been widely promoted at home also. There would seem to be a paradox, however, at the heart of the widespread apparent interest in the visual arts, travelling exhibitions, lavish coverage in popular magazines and Sunday newspapers and on television. True, vast crowds turn out to see exhibitions by Van Gogh, that is to be expected; but is the real audience for the fine arts all that much bigger? The level of attendance at certain exhibitions would seem to answer this in the negative. True, there is a new superficial visual literacy (for the moment one is discounting the student population, those most likely to visit exhibitions, but nowhere near sufficient in number to effectively balance) resulting from the mass-media which seems to result in the visual arts being assimilated; assimilated, that is, in the sense of being digested, and thereby de-fused.

This process is a slightly less obvious version than that sort of de-fusing that takes place when a particularly violent anti-social Happening is performed under official auspices, usually at a museum, to an appreciative audience of well-fed and dinner-jacketed bourgeoisie. The would-be bomb is rendered into a

harmless squib. A similar 'mystification (using the term in the usage of R. D. Laing) can be seen in terms of social rebels; the Underground, its magazines and Press, the hippie 'ghetto', the pot 'problem', public demonstrations, pickets and sit-downs, provided they remain within certain bounds, that the Demos are 'democratic and responsible', are all different forms of a permitted safety valve. Not even so much permitted, but actively encouraged, for they channel dissent harmlessly off to where it can do little or no damage. As long as it is contained, our society can feel good and warm and democratic; but one step outside those permitted boundaries and up goes the tally-ho cry: 'Hooligan!', 'Drug-addict!'. 'Violence!'. This is something well understood by the militant student activist, but it is a lesson the artist has never seemed to have caught on to.

Possibly this is because he has no wish to. The idealism of the art student is soon blunted, his attention caught by the goodies held glitteringly up by Bond Street, Madison Avenue and Faubourg Ste. Honoré. In this essay we have spoken briefly of the charms of the art-game. Mannerism, we have seen, is a hall-mark of a transitional society, and usually an authoritarian one. The student revolt has nothing to do with the generation gap, their protest is unlike any previous adolescent protest. It is the Corporate State, East or West, they oppose; meanwhile the Corporate State becomes more and more authoritarian. Comparing periods of Mannerism, can one say that Andy Warhol's soup can, or better, painting of the electric chair, nurtured under an increasing bureaucratic state, is the present-day version of Miss Murphy's bottom, commissioned from Boucher by an equally autocratic and unwieldy State?

We have spoken of Millenial ideas in art. We have also seen them operating in society. In a sense the millenium is already with us. Possibly the Second Coming took place on 16th July, 1945, at Los Alamos. The world hasn't come to an end, but a culture has. We have noted that political as well as cultural revolution grows out of Millenial situations. It was the dissent of Wycliffe and

Cromwell that led via Methodism to British Socialism and the Labour Party; now a totally spent force but crucial to the whole history of Socialism. The Black Power Movement of today also grew out of a Millenial movement, from Garvey's 'Back to Africa', via Ras Tafiri and Muhammed Ali to the militant Panthers. But here the transition from a Millenial cult to a political party has only taken thirty years to the parallel European development which took 300 years.

The Utopian world, however, stretches still in front of us. The human species is possibly facing the biggest challenge he ever has since he began to socialize himself. From a fruit-gathering nomad he has adapted when and where necessary to his altering environment, but can he adapt now to the implications of his own machinery, caught as he is in a feedback situation with the environment? Can he alter his society and if need be his psyche to meet the technology he has produced? The alternative ossifying monolithic state with the values of the old choking in the mis-used machinery of the new, while the environment and ecology is progressively poisoned and eroded away, would lead to a diminution of culture and a Dark Ages that would make the last one look like a mild autumn twilight. If we are going to adapt it will probably, knowing the greed and stupidity of man, not be without considerable violence; it is more than likely, as we have suggested, that the true social and political revolution of our age is yet to come; coming about, not as a planned insurrection or putsch, but just igniting spontaneously, forming organically. The flaws, the volcanic rifts and scars are there for all of us to see, we have neglected them long enough, and when the pressure rises beyond a certain point we can expect the crust to shatter in a dozen different but already defined places.

And art? What has art got to do with all this? Reading the paper, watching the news, art seems a trivial activity in the face of events around us, sometimes even an impertinent one, with suffering and civil war and revolution all about. But that is perhaps because of what we have made of art. We have

demystified it, materialized it, trivialized it. We seem to have lost the faculty of using it as a common activity, as a way of sharing our experience of the universe.

Sartre has commented that '. . . one of the chief motives of artistic creation is certainly the need of feeling that we are essential in relationship to the world'[7]. But we do not have this feeling of being essential in relationship to the world. Perhaps we can regain it with a re-ordering of society; but what sort of art will we have then? It certainly won't be the romantic-hero-creator tradition at the tail end of which we find ourselves today. It may well be a form that we Renaissance-orientated people won't recognize at all, or if so, even dimly only by the youngest among us. What it must be though, if it is to be art, and what we seem to have lost in the painting and sculpture of our immediately contemporary scene, is a spiritual quality that speaks to both man as an individual and to man as a member of a collective.

Notes

Chapter 1

1 Albert Camus, *The Rebel*, Peregrine Books, 1962, p. 237.
2 Martha Wolfenstein, *Disaster*, Routledge and Kegan Paul, 1957.
3 One interesting way in which this 'solidarity' has operated in the art world can be seen in Skopje, Yugoslavia. After the disastrous earthquake of 1963 people throughout the world responded with medical and material aid. The international art world also reacted, denoting 'cultural aid', and painters and sculptors from many different countries gave works of art to rebuild the museum. The result of this is that Skopje now possesses one of the best collections of modern art in South Europe. The remarkable thing is that a certain 'spirit of solidarity' has been kept alive, largely due to the efforts of the Director of the Museum of Contemporary Art, Boris Petkovski, whereby this museum has acted as a cultural nexus transcending political and cultural barriers and permitting art to operate genuinely outside of the national and promotional complex discussed in Chapter 24.
4 The term *chilliastic* is synonymous with *millenial*, its root being found in the Greek word for 'one thousand'.

Chapter 2

1 Patrick Seale and Maureen McConville, *French Revolution*, 1968, Penguin, 1968, page 30.
2 Ibid, page 32.
3 Brad Cleveland, 'A Letter to Undergraduates', in *The New Radicals* edited by Paul Jacobs and Saul Landau, Pelican, 1967, page 227.
4 Patrick Seale and Maureen McConville, op cit, page 25.

Chapter 3

1 Herbert Marcuse, *One Dimensional Man*, Sphere Books, 1968, page 19.
2 Ibid., page 25.
3 Michael Harrington, *The Accidental Century*, Pelican, 1967, page 33 ff.

4 Herbert Marcuse, *Eros and Civilisation: a Philosophical Enquiry into Freud*, Allen Lane, The Penguin Press, 1969: Marcuse puts forword in this book his idea of the 'performance principle' as an anology to Freud's 'pleasure principle'.

Chapter 4

1 Stokeley Carmichael, 'Black Power', in *Dialectics of Liberation*, edited by David Cooper, Penguin, 1968, page 165.
2 Alan Brien, *The Sunday Times*, 24th November 1968.
3 Jeff Nuttall, *Bomb Culture*, MacGibbon and Kee, 1968, pages 20–21.
4 Quoted by Christopher Driver in *The Disarmers, a Study in Protest*, Hodder & Stoughton, 1964.
5 Paul Jacobs and Saul Landau, *The New Radicals*, Pelican, 1967, pages 13–14.

Chapter 5

1 Allen Ginsberg, *Howl*, City Lights.
2 *The Coney Island of the Mind* is the title of a book of poems published by Lawrence Ferlinghetti who also ran the City Lights Bookshop and published the first poems by the 'Beat' writers.
3 Ralph J. Gleason, in *Evergreen Review*, No. 49.
4 Leslie Fiedler, *Waiting for the End*, Pelican, 1967, pages 146–7.
5 Ibid., pages 119–120.
6 Michael Wood, *Sunday Times Magazine*, 12th January 1969.
7 In this context it might be interesting to mention the precursors in England to *International Times*. During the period we discuss on pages 40–41, several magazines were published in London. Emanating from the Soho 'bohemia' which prefigured the Underground during the middle fifties there were, among others, *Intimate Review* edited by John Rety, the present editor of *Freedom, Other Voices* edited by the painter Ralph Rumney, and *London Broadsheet* edited by Antony Borrow. This present writer was involved with the publication of the latter paper, which, like its contemporaries was comparatively short-lived.
8 Werner Stark, *Study of the Sociology of Religion*, volume 2, *Secterian Religion*, Routledge and Kegan Paul, page 5.

Chapter 6

1 Al Hansen, *A Primer of Happenings and Time/Space Art*, The Something Else Press, 1965, page 24.
2 Hugo Ball, *Journal*, quoted by Hans Richter in *Dada, Art and Anti-art*, Thames and Hudson, 1965, page 30.
3 Ibid., page 26.
4 Calvin Tomkins, *Ahead of the Game* (published in America as *The Bride and the Bachelors*), Penguin, 1968, page 36.
5 Ibid., page 124.
6 Ibid., page 192.
7 Ibid., page 193.

Chapter 7

1 Al Hansen, op cit., pages 119–124.
2 Kenneth Walker, *Diagnosis of Man*, Pelican, 1962, page 100.
3 Jean Tinguely, quoted by Christopher Finch in 'The A.D. Fix', *Art and Artists*, August 1966.
4 Frank Popper, 'The Inspired Anarchist', in *Art and Artists*, August 1966.
5 Gustav Metzger, 'Machine, Auto-creative and Auto-destructive Art', *Ark*, 1960.
6 Jasia Reichardt, 'Expendable Art', *Architectural Design*, October 1960.
7 Gustav Metzger, quoted by Eddie Wolfram in 'In the Beginning', *Art and Artists*, August 1966.
8 Georges Boudaille, in *Cimaise*, No. 60, August 1962.
9 Banesh Hoffmann, *The Strange Story of the Quantum*, Pelican, 1963, page 150.

Chapter 8

1 Herbert Read, *The Philosophy of Modern Art*, Faber and Faber, 1953, page 46.
2 Banesh Hoffmann, op cit., page 168.
3 Fillipo Tommaso Marinetti, 'First Futurist Manifesto', *Le Figaro*, 8th February 1909.

4 Barnard Gay, catalogue preface to the De Stijl exhibition, Camden Art Centre, 1968.

5 Gene Swenson, *The Other Tradition*, Institute of Contemporary Art, University of Pennsylvania, 1966.

6 Pierre Rouve, 'The Waste Land', in *Art and Artists*, August 1966.

7 Peter Hutchinson, 'Mannerism in the Abstract', in *Art and Artists*, September 1967.

8 Simon Watson Taylor, 'Rudolf II's Mannerist Court', in *Art and Artists*, June 1967.

Chapter 9

1 From a private conversation between the author and Asger Jorn, as are the following quotations from Jorn in this chapter.

2 Colin Wilson, *Origins of the Sexual Impulse*, Barker, 1963.

3 Douglas Cooper, *Morlotti*, Edizioni dell'Ente Premi Roma 1966, page 17, the catalogue preface to an exhibition at the Palazzo Barberini in Rome on the occasion of Morlotti being awarded the Rome Prize for 1966.

4 Ibid., page 21.

Chapter 10

1 Rudolph Arnheim, *Art and Visual Perception*, University of California Press, 1954, page 75.

Chapter 11

1 Lorus and Margery Milne, *The Senses of Animals and Men*, André Deutsch, 1963.

2 Ernst Cassirer, *Essay on Man*, Yale University Press, 1944.

Chapter 12

1 Ernst Fischer, *The Necessity of Art*, Pelican, 1963, page 14 ff.

2 Leonhard Adam, *Primitive Art*, Pelican, 1940.

3 Miroslav Lamač, *Modern Czech Painting 1907–1917*, Artia, 1967.

Chapter 13

1 André Breton, *Crise de l'objet*, written on the occasion of the International Exhibition of Surrealism in Paris 1936, and published during the exhibition. Published in English in a translation by Angus Malcolm in *Art and Artists*, July 1966.
2 E. H. Gombrich, *Art and Illusion*, Phaidon Press, 1960, page 84.
3. Patrick Waldberg, *Surrealism*, Thames and Hudson, 1965, page 16.
4 Dore Ashton, 'From Achilles' Shield to Junk', in *Cimaise*, No. 64.
5 Christopher Finch, *Pop Art, object and image*, Studio Vista/Dutton Pictureback, 1968, page 37.
6 Stephan Lupasco and F. A. Viallet, 'Dialogue: Science and Abstract Art', in *Cimaise*, No. 64.
7 Henry Stone, 'Youths and Motorcycles', in *The Man Made Object*, edited by Gyorgy Kepes, Vision and Value Series, Studio Vista, 1966, pages 184–185.
4 Sir Roland Penrose, catalogue preface to the exhibition *Violence in Art*, held at the Institute of Contemporary Arts, London, January to May 1964.

Chapter 14

1 Henri Michaux, *Miserable Miracle*, translated Louise Varèse, City Lights Books, 1963, page 14.
2 Aldous Huxley, *Heaven and Hell*, Chatto and Windus, 1956, page 27.
3 Ibid., page 28.
4 Werner Stark, op cit., page 204.
5 Norman Cohn, *The Pursuit of the Millenium*, Mercury Books, 1962, page xiii.
6 Ibid., page xiii.
7 Ibid., page 20.
8 Ibid., page 310.
9 J. H. Plokker, *Artistic Self-expression in Mental Disease*, translated by Ian Finlay, Charles Skilton, 1964, page 138.
10 Ibid., page 144.

Chapter 15

1 Exhibition at the Drian Galleries, London, June 1963.
2 Jasia Reichardt, catalogue preface to the exhibition, Inner Image, at the Grabowski Gallery, London, September 1964.

Chapter 16

1 Arthur Koestler, *The Act of Creation*, Pan Books, 1966, page 45.
2 René Magritte, quoted in the catalogue of the Tate Gallery exhibition, Magritte 1969, organised by David Sylvester. This text originally appeared in Louis Scutenaire *René Magritte*, Brussels Librarie Seléction, 1947.
3 From a private conversation with the author, as are the remaining quotes in this chapter.

Chapter 17

1 Ken Adams, Notes on Concretisation, in *The British Journal of Aesthetics*, April 1964.
2 Marjorie Nicholson, *Voyages to the Moon*, Macmillan, 1948, pages 29–30.
3 Kingsley Amis, *New Maps of Hell*, Four Square, 1963, page 14.
4 Marjorie Nicholson, op cit., page 173.
5 Marjorie Nicholson, op cit., pages 174–175.

Chapter 18

1 Daniel Defoe, quoted by Marjorie Nicholson, op cit., page 185.
2 Kingsley Amis, op cit.
3 Just recently the basic character of mainstream Science Fiction seems to have radically changed, there is a clear development on the part of many writers towards exploring what J. G. Ballard calls 'inner space', and many novels are now concerned with a problematical and existential situation that parallels other developments of the 'modern movement'. There would seem to be a certain influence from such writers as William Burroughs and the neglected Mervyn Peake. This shift of direction would

seem to be mainly the result of the influence of one magazine, *New Worlds*, edited by Michael Moorcock, which suddenly deflected s.f. into a new direction in 1967.

Chapter 19

1 Leo Steinberg, 'The Eye is Part of the Mind', in *Partisan Review*, Volume XX, No. 2, 1954, pages 114–212.
2 Ibid.
3 The apparent para-dimensionality in Lanyon's painting is not an aspect of non-Euclidean space, but is simply solid objectified landscape seen from the unusual viewpoint of a hovering glider. During the most productive years of this artist's life, and right up to his tragic death in a flying accident, Lanyon's fundamental visual language was concerned with the visual aspect of the pilot's experience. ..
4 Frank Avray Wilson, *Art as Understanding*, Routledge and Kegan Paul, 1963, page 18.
5 Ibid., page 12.
6 Ibid., pages 28–29.
7 Sir Roland Penrose, *Picasso, His Life and Work*, Victor Gollancz, 1958, page 152.
8 Ibid., page 155.
9 Ibid., page 184.
10 Writing about *The Regret* by Chirico (1914), Robert Melville comments '. . . in the de Chirico there is an expression of antagonisms so intense and so irremediable, and of desires consummated in the face of such repressive forces, that the picture plane has been disrupted in such a manner as revolutionary as that of Cubism, but more vital in origin.' 'Apocalypse in Painting', contribution to the anthology *The White Horseman*, Routledge, 1941, page 141.
11 In the large and revealing retrospective exhibition of the work of Mirò at the Tate Gallery in 1964, one small painting (untitled of 1925, Dupin catalogue number 149) stood out. This was an 'overall field' image which predated by many years certain concerns of other artists. Referring to this painting, and to Mirò's re-exploration of this theme in the large blue canvases of

1961, Michel Ragon writes, '. . . even if Mirò is against the idea of being 'abstract' (but this is merely a misunderstanding of language at least in this circumstance) these works are sufficient to make him one of the major painters of the abstract movement and the precursor of numerous present-day artists preoccupied by the concern for a new, pure pictorial space'. *Cimaise*, No. 64, March 1963.

12 Alain Jouffroy, 'In the Centre of All Things', in *Signals*, Vol. 1, No. 4–4, November 1964.

Chapter 20

1 Marino Marini, statement in *Dialogues on Art*, compiled by Edouard Roditi, Secker and Warburg, 1960, page 45.
2 Gerald Gladstone, statement in *Living Arts*, No. 3, published by the I.C.A., 1964.
3 Charles Spencer, 'Gerald Gladstone', in *Studio*, June 1962.
4 Gerald Gladstone, op cit.
5 Charles Spencer, op cit.
6 C. P. Snow, *The Two Cultures*, Cambridge University Press, 1959, and *A Second Look at the Two Cultures*, Cambridge University Press, 1963; J. D. Bronowski, *Science and Human Values*, Hutchinson, 1961.
7 Richard Hamilton, statement in the catalogue of his exhibition at the Hanover Gallery, London, 1964.
8 Ibid.

Chapter 21

1 Will Grohmann, *Weichberger*, Editions Galerie Europe, 1961, pages 7 ff.
2 Frank Popper, *Malina, Artist-scientist of the Space Age*, in UNESCO Courrier, September 1963.
3 William Gaunt, *Concise History of English Painting*, Thames and Hudson, 1964.
4 Charles Sewter, catalogue preface of Denis Bowen exhibition at the Manchester Institute of Contemporary Arts, May 1962.
5 John Coplans, 'Denis Bowen' in *Arts Review*, June 1957.

6 Anthony Tucker, *Guardian*, May 8th 1962.
7 Guy Burn, *Arts Review*, May 1964.

Chapter 22

1 Christopher Finch, 'Language Mechanisms', in *New Worlds*, August 1967.
2 Christopher Finch, *Pop Art, Object and Image*, Studio Vista/ Dutton Pictureback, 1968, pages 158–162.
3 Roy Ascott, statement in the catalogue of his exhibition at the Molton Gallery, London, February 1963.
4 Eddie Wolfram, *Commuters and Computors*, privately circulated statement, 1964.
5 Alain Jouffroy, op cit.

Chapter 23

1 Herbert Read, op cit., page 228.
2 Camilla Grey, catalogue preface to the exhibition *Casimir Malevich* at the Whitechapel Gallery, London, 1959. Statement by Malevich from his *On New Systems in Art* originally published Vitebsk, 1920, is quoted by Grey in this text.
3 Walter Gropius, 'My Conception of the Bauhaus Idea', published in the catalogue of the Bauhaus exhibition at the Royal Academy, London, 1968.
4 Naum Gabo, statement in interview reported in *The World of Abstract Art*, George Wittenborn, 1956.
5 Hans Richter, contribution to *The World of Abstract Art*, George Wittenborn, 1956.
6 Guy Brett, preface to the catalogue of the exhibition Movement at the Hanover Gallery, London, 1964.
7 Willem de Kooning, paper read to a group of fellow artists on February 18th 1949, quoted by Thomas B. Hess in the introduction to the catalogue of the de Kooning exhibition at the Tate Gallery, 1968.
8 Daniel and Eugenia Robbins in Studio International, May 1964.
9 Marcel Brion.

Chapter 24

1 Bryan Robertson, preface to catalogue of Jackson Pollock exhibition at the Whitechapel Gallery, London, 1958.
2 Quoted Bryan Robertson, op cit.
3 Bryan Robertson, op cit.
4 Robert Estivals, in the preface to *La Peinture Sémantique* by Luciano Lattanzi, Guy le Prat, 1962, page 7.
5 Luciano Lattanzi, manifesto issued in London on the occasion of his exhibition at the New Vision Centre, November 1957, published later in *Semantic Painting* by R. K. Eliott, Bassani-Carrara, 1958.
6 Ernst Fischer, op cit., page 48.
7 Jean Paul Sartre, *What is Literature?*, translated B. Frechtman, New York Philosophical Library, 1949, page 60.

Index

Adam, Leonard, 101
Adams, Ken, 147
Adams, Robert, 73, 74
Adamski, George, 159
Aetherius, 159, 160
Agam, Yacov, 192, 201
Albers, Joseph, 74, 84
Alberti, Leon Battista, 213
Aldiss, Brian, 181
Ali, Muhammed, 216
Ali, Tariq, 33
Alloway, Laurence, 189
Amis, Kingsley, 46, 153, 158
Annesley, David, 74
Antonioni, Michelangelo, 1
Appel, Karel, 75, 167
Apollinaire, Guillaume, 113
Archimedes, 153
Archipenko, Alexander, 68
Arman, F., 58, 61, 117
Arnheim, Rudolph, 84
Arnold, Matthew, 187
Arp, Hans, 48, 50
Arrowsmith, Pat, 32
Art and Illusion, 139
Art and Visual Perception, 84
Artaud, Antonin, 25
Arts Review, 184
Ascott, Roy, 191, 192, 193
Ashton, Dore, 112, 113, 115
Atomic Image, 184
Atomic Landscape, 184
Aubertin, facing p. 37
Ayrton, Michael, 187

Bacon, Francis, 133, 186, 203
Baj, Enrico, 58, 77

Baldwin, James, 43
Baldwin, Mervyn, 136, between
 pp. 164 and 165
Ball, Hugo, 48, 49
Balla, Giacomo, 196
Ballard, J. G., 181
Banham, Reyner, 189
Baudelaire, Charles Pierre, 24
Bayer, Herbert, 74
Bellmer, Hans, between pp. 84
 and 85, 146
Benjamin, Anthony, 143, 144
Benrath, Frederick, 173, 181
Bergson, Henri, 193, 196
Bertoni, Christina, 136
Beuve, Saint, 88
Black Dwarf, 33
Blake, William, 133
Blish, James, 163
Blow Up, 1
Blowups Happen, 163
Boccioni, Umberto, 68, 113, 196
Bohr, Niels, 106
Bolus, Michael, 74
Bomberg, David, 81
Bonalumi, A., 63
Boone, Daniel, 43
Bosch, Hieronymus, 125, 195
Boshier, Derek, 177
Boudaille, Georges, 61
Boudnik, 58
Boulez, Pierre, 51
Bowen, Denis, 173, 183, 184,
 185, facing p. 212
Boyle, Robert, 155
Bradbury, Ray, 161, 163
Brando, Marlon, 36
Braque, Georges, 104

Brecht, George, 54
Breton, André, 37, 77, 110
Brett, Guy, 200
Breughel, Pieter, 125
Brien, Alan, 26
Brion, Marcel, 203
Brisley, Stuart, 201
Broch, Max, 187
Bronowski, Jacob, 177
Bronzino, Angelo, 72
Brunelleschi, Filippo, 213
Bullmore, Edward, 145, 146
Burn, Guy, 184
Burri, Alberto, 66
Burroughs, William, 190, 196
Burt, Laurence, 132, 133, 135,
 136, 137, 138, facing p. 164,
 187
Butler, Reg, 187

Caesar, 153
Cage, John, 25, 51, 52, 54, 57,
 58, 114, 118
Calder, Alexander, 201
Campbell, John W., Jnr., 158
Camus, Albert, 4, 59
Carmichael, Stokeley, 25
Caro, Anthony, 74
Carra, Carlo, 196
Cassirer, Ernst, 97
Castellani, E., 63
Caulfield, Holden, 36
Cavendish, Henry, 152
Céline, Louis Ferdinand, 37
Cellini, Benvenuto, 213
César, 58, 112, 120
Cézanne, Paul, 202
Chadwick, Lynn, 187

Chamberlain, John, 112
Chiari, Guiseppe, 51
Chilton, Michael, 136
Chirico, Giorgio de, 80, 114, 172
Christo, Javacheff, 117
Cicero, 150
Cina, Colin, 145
Clarke, Arthur C., 164
Clement, Hal, 162
Cleveland, Brad, 11
Closon, Henri, 200
Cocteau, Jean, 209
Cohen, Bernard, 143
Cohen, Harold, 143, 169
Cohn, Norman, 119, 125, 126
Cohn-Bendit, Daniel, 10
Coltrane, John, 39
Communist Manifesto, 20
Concise History of English Painting,
 183
Constant, facing p. 84
Cooper, Douglas, 81, 82
Cooper, James Fenimore, 43
Coplans, John, 184
Corbusier, 196
Corneille, Pierre, 75
Cornell, Joseph, 114
Corso, Gregory, 37, 41
Craxton, John, 187
Cromwell, Oliver, 151, 217
Culbert, William, 201
Cunningham, Merce, 51, 54

Dali, Salvador, 110
Dangelo, Sergio, 58
Daniels, John, 155
D'Arcangelo, Allan, 142
Daumier, Honoré, 119

Davie, Alan, 84, 130, 131
Davis, John Warren, 194
Dean, James, 36, 40
Defoe, Daniel, 155, 156, 161
de Gaulle, Charles, 12
Degottex, 173
de Kooning, Willem, 38, 167, 202
Delacroix, Eugène, 2
de la Folie, Louis Guillame, 156, 157, between pp. 164 & 165
Derain, André, 104, 107
Diaghilev, Sergei, 209
Dine, Jim, 38, 54
Disaster, 5
Doesburg, Theo van, 105, 197
Donatello, 212
Dorazio, Piero, 173
Dryden, John, 187
Dubuffet, Jean, 78, 130, 206
Duccio, di Buoninsegna, 209
Duchamp, Marcel, 49, 50, 51, 97, 111, 112, 178, 199
Duff, Peggy, 32
Dufrêne, F., 58
Dufy, Raoul, 81
Duras, Marguerite, 196

Eggling, Viking, 199, 200
Einstein, Albert, 105
Ellis, Havelock, 121, 122
Euclid, 153

Fautrier, Jean, 173
Ferlinghetti, Lawrence
Fiedler, Leslie, 42, 43, 44
Filla, Emil, 105
Finch, Christopher, 114, 188, 190

First Surrealist Manifesto, 37
Fischer, Ernst, 99, 209, 210
Fitzgerald, F. Scott, 38
Flanagan, Barry, between pp. 164 & 165
Flavin, Dan, between pp. 84 & 85
Fontana, Lucio, 61, 62, 63, 64
Fontguré, Paul, 56
Ford, Henry, 105
Freud, Sigmund, 105, 111
Frink, Elizabeth, 174
Frost, Terry, 167
Fry, Roger, 69
Fuchs, Claus, between pp. 84 & 85
Fuller, Buckminster, 127
Fuseli, Henry, 133

Gabo, Naum, 199
Galileo, 150
Gagarin, Yuri, 148
Garvey, Marcus, 217
Gauguin, Paul, 197
Gaul, Winfred, 142
Gaunt, William, 183
Gay, Bernard, 69
Geissler, Claus, 193, between pp. 212 & 213
Genet, Jean, 25, 37
Ghandi, Mahatma, 13
Giacommetti, Alberto, 174, 202
Gide, André, 59
Gilbert, William, 155, 156
Ginsberg, Allen, 36, 37, 41
Giotto, Di Bondone, 86, 103, 207
Gladstone, Gerald, facing p. 165, 174, 175, 176
Gleason, Ralph J., 41,

Glenn, Colonel, 148, 177, 179
Godwin, Bishop, 152
Goede, Jules, de, between pp. 212 & 213
Goethe, Johann Wolfgang, 88
Gombrich, Prof. E. H., 79, 103, 110, 139, 169
Goodman, Paul, 11
Gorki, Maxim, 106
Gorki, Arshile, 202
Goya, Francisco de, 119
Graham, Martha, 51
Greco, Juliet, 36
Greenberg, Clement, 38
Grey, Camilla, 196
Gris, Juan, 172
Grohmann, Will, 180
Gropius, Walter, 74, 197
Grunewald, Mathis, 125
Guardian, 184
Gusamo, Lourenco de, 155

Hains, R., 58
Haley, Bill, 39, 41
Hamblett, Charles, 36
Hamilton, Richard, 178, 179, 180, 189, between pp. 212 & 213
Hansen, Al, 48, 54, 55, 56, 57, 58, 120
Harloff, Guy, between pp. 84 & 85, 131, 132
Harrington, Michael, 16, 18, 20
Hartung, Hans, 173, 206
Healey, John, 182
Heartfield, John, 37, 49, 111
Heaven and Hell, 123
Heidegger, Martin, 65, 111

Heinlein, Robert, 163
Heisenberg, Werner, 61, 112, 193
Hélion, Jean, 200
Hemingway, Ernest, 38, 44
Henning-Pedersen, Karl, 76
Henry, Alexander, 43, 44
Higgins, Dick, 54
Hill, Anthony, 74
Hilton, Roger, 167
Hitler, Adolf, 30
Hoenich, P. K., 64
Hoffman, Banesh, 62, 66
Hoffman, Hans, 38, 202
Hoggart, Richard, 40
Homer, 87, 187
Hudson, Tom, 74, 138, 140
Huelsenbeck, Richard, 48, 49, 111
Hunt, Holman, 103
Husserl, Edmund, 78, 105, 106
Hutchinson, Peter, 71, 72
Huxley, Aldous, 20, 120, 123

I Ching, 51
Ingres, Jean Auguste Dominique, 68
Ionesco, Eugene, 115, 188
Irvins, William, 85

Jacobs, Paul, 34
Janco, Marcel, 37, 48, 49, 50, 111
Jarry, Alfred, 48, 58
Jeans, James, 62
Jenkins, Paul, 167, 173
Johns, Jasper, 38, 57
Jones, Allen, 146

Jorn, Asger, 76, 77, 78, 79, 83, 206
Jouffroy, Alain, 173, 194
Joyce, James, 106, 196
Judd, Don, 74
Jung, Carl, 130

Kafka, Bohumil, 105
Kahnweiler, Daniel Henry, 171
Kandinsky, Wassily, 49, 50, 106
Kaprow, Allen, 54, 58
Katzanzakis, Nikos, 187
Keinholtz, Edward, 117
Kekulé, F. A. von, 203
Kellog, Rhoda, 206, 207
Kennedy, President John F., 35, 178, 179
Kerouac, Jack, 37
Kidner, Michael, 196, 201
King, Martin Luther, 13
King, Mr., 159
King, Philip, 74, between pp. 84 & 85
Klee, Paul, 49, 130
Klein, Yves, facing p. 37, 60, 62, 63, 117, 173
Kline, Franz, 38, 58, 171, 202, 203
Knizak, 58
Koestler, Arthur, 139
Kosice, Gyula, 201
Kotera, Jan, 105
Kruschev, Nikita, 33
Kubista, Bohumil, 105
Kujawsky, Jerzy, between pp. 84 & 85
Kupka, Frantisěk, 105

Lacey, Bruce, between pp. 212 & 213
Laing, Ronald, 56, 118, 127, 216
Lam, Wilfredo, 202
Lamać, Miroslav, 104, 105
Lana, Francesco, 152, 153, 154, between pp. 164 & 165
Landau, Saul, 34
Lanyon, Peter, 167
Latham, John, between pp. 36 & 37, 58, 60
Lattanzi, Luciano, 207, 208
Lautréaumont, Conte de, 139
Lawrence, D. H., 44
Leary, Timothy, 47, 127
Lebel, Jean-Jacques, between pp. 36 & 37, 58
Leonardo da Vinci, 169
Lichtenstein, Roy, 38
Lijn, Lilian, facing p. 213
Linström, Bengst, 76
Living Arts, 175
Lissitzky, El, 103
Loos, Adolf, 106
Lorenz, Konrad, 4
Lucian, 149
Lucretius, 154
Lupasco, Stepane, 114, 115
Luther, Martin, 72

Mack, Heinz, 63
Mackintosh, Charles Rennie, 105
Magritte, René, 84, 139, 140
Maharishi, 47
Maholy Nagy, Lazlo, 58, 74, 199
Maiello, 181
Mailer, Norman, 39, 42, 44
Malevitch, Casimir, 103, 197

Malina, Frank, 182
Mann, Thomas, 106
Manzoni, Piero, 61, 62, 63
Marcuse, Herbert, 13, 15, 16, 18, 23
Marinetti, Filippe Tommaso, 196
Marini, Marino, 174
Martelli, Pier Jacopo, 155
Martin, Kenneth, 74
Martin, Mary, 74
Marx, Karl, 17, 20, 25
Masson, André, 201, 205
Mathieu, Georges, 167, 173, 205
Matisse, Henri, 81
Matta, Roberto, between pp. 164 & 165
McConville, Maureen, 9, 10, 13
McInnes, Colin, 36
McLuhan, Marshall, 18, 31, 127, 210
McWilliam, F. C., 187
Meadows, Bernard, 187
Medalla, David, between pp. 164 & 165
Medici, Cosimo de, 212
Merleau-Ponty, Maurice, 63
Merlin, 41
Metzger, Gustav, 58, 59, 60, 120
Michaeledes, Michael, 145
Michaux, Henri, between pp. 84 & 85, 115, 121, 127, 188
Miller, Henry, 37, 39
Millett, Jean Francois, 119
Milne, Loris, 95
Milne, Margery, 95
Mingus, Charlie, 39
Minkowski, E., 128

Minton, John, 187
Misoffe, Francois, 10
Modigliani, Amadeo, 80
Mondriaan, Piet, 69, 74
Monk, Thelonious, 39
Monroe, Marilyn, 177
Moore, Henry, 187
Morlotti, Ennio, 80, 81, 82, 83, between pp. 84 & 85
Morris, Bob, 74
Morris, Desmond, 207
Morris, William, 41
Morris, William, 113
Munari, Bruno, 201
Munch, Edward, 104, 105

Neitzsche, Friedrich, 17
Ness, Georg, between pp. 212 & 213
Nessler, Walter, 182
New Harmony, 45
Newman, Barnett, 74
New Radicals, The, 34
Newsome, Victor, 135, 136
Nicholson, Ben, 74
Nicholson, Majorie, 151, 153, 156
Nine Billion Names of God, The, 164
Nuttall, Jeff, 29, 31, 33

Oldenberg, Claes, 58, 117
On New Systems in Art, 197
Oppenheim, Meret, 116
Ormisais, 157
Orwell, George, 20
Osborne, John, 46
Outsider, The, 2

Owen, Robert, 45

Palmer, Samuel, 131
Paolozzi, Eduardo, 188, 189, 190, between pp. 212 & 213
Parker, Charlie, 30, 39
Partisan Review, 165
Pasmore, Victor, 74, 173
Patchen, Kenneth, 37
Peeters, Henk, 64
Penrose, Roland, 118
Phenomenology of Perception, 63
Phillips, Peter, between pp. 36 & 37
Picabia, Francis, 49
Picasso, Pablo, 65, 81, 84, 104, 107, 113, 171, 172, 209
Piché, Roland, between pp. 164 & 165
Piene, Otto, 193
Plank, Max, 105
Plato, 150
Plokker, J. H., 127, 128
Plutarch, 150
Pohl, Frederick, 163, 181
Points, 41
Poliakoff, Serge, 166, 167, 172
Pollock, Jackson, 37, 38, 167, 171, 201, 204, 205, 206, 207
Poons, Larry, 54
Pope, Alexander, 187
Popper, Frank, 59, 182
Porter, Jimmy, 28
Pottle, Pat, 32, 33
Poussin, Nicolas, 68
Powell, Enoch, 27
Preisler, Jan, 105
Proust, Marcel, 106, 196

Pursuit of the Millenium, The, 119, 125
Rae, Robin, 138, 145
Raphael, Lanzio, 202
Raysse, Martial, 58
Rauschenberg, Robert, between pp. 36 & 37, 38, 53, 57, 58, 63, 114, 115
Read, Herbert, 65, 73, 196
Rebel, The, 4
Reichardt, Jasia, 60, 134
Reinhardt, Ad., 74, 84
Renoir, Pierre Auguste, 195
Requichot, Bernard, 117
Restany, Pierre, 58
Reynolds, Mack, 163
Richier, Germaine, 174
Richter, Hans, 111, 199, 200
Riley, Bridget, facing p. 84, 201
Rilke, Rainer Maria, 106
Rimbaud, Arthur, 112
Riopelle, Jean-Paul, 173
Robbe-Grillet, Alain, 196
Robbins, Brian, 201
Robbins, Daniel and Eugenia, 203
Robertson, Bryan, 204, 205
Rodchenko, Alexander, 199
Rohe, Mies van der, 71
Rosenberg, Harold, 38, 209
Rotary Demisphere, 199
Rothko, Mark, 38, 167, 173
Rotraut, 194
Rouve, Pierre, 70, 182
Rowan, Eric, 142, 143
Rué, Miquel, 181
Ruskin, John, 3
Russell, Bertrand, 13

Russen, David, 155
Russolo, Luigi, 51

Sade, Marquis de, 37
Salvadori, Marcello, 201
Samaras, Lucas, 116
Samona, Mario, 194
Sandle, Michael, 135, 136, 137, 138
San Martin, Fernando, 181
Satie, Erik, 51
Satre, Jean Paul, 65, 218
Schoeffer, Nicolas, 201, between pp. 212 & 213
Schönberg, Arnold
Schoonhoven, Jan, 64
Schreib, Werner, 207, facing p. 213
Schwarcz, Yoel, 182
Scintilla, 157
Seale, Patrick, 9, 10, 13
Secomandi, Gianni, 185, between pp. 212 & 213
Sedgley, Peter, 201
Segal, George, 54
Self, Colin, between pp. 164 & 165
Selz, Peter, 133
Senses of Animals and Men, The, 95
Setch, Terry, 135, 136, 137, 138, 140, 141, between pp. 164 & 165
Severini, Gino, 80
Sewter, Charles, 183
Sillitoe, Alan, 47
Simak, Clifford, 162
Simetti, Turi, 63

Smith, Adam, 17
Smith, Richard, 145, 169
Snow, C. P., 177
Soper, Donald, 32
Southall, Derek, 145
Soutine, Chaim, 80
Spencer, Charles, 175, 176, 177
Spoerri, Daniel, 58, 117, 120
Stark, Werner, 46, 47
Steele, Jeffrey, 201
Steinberg, Leo, 165, 167
Steinvert, Kurt, 117
Stella, Frank, 196
Stepán, Ivan, between pp. 84 & 85
Stone, Henry, 115, 116
Strache, Wolf, 165
Stursa, Jan, 105
Study of the Sociology of Religion, 46
Sunday Times, 26, 45
Svenson, Gene, 69

Tafiri, Ras, 217
Takis, 194, between pp. 212 & 213
Tapié, Michel, 66
Tapiés, Antoni, 66
Tatlin, Vladimir, 196
Taylor, Simon Watson, 72
Tenn, William, 163
Thomas, Dylan, 36
Thoreau, Henry David, 42, 43, 45, 207
Thubron, Harry, 74
Tilson, Joe, between pp. 36 & 37

Tinguely, Jean, between pp. 36
 & 37, 58, 59, 60, 61, 63, 117,
 120
Tobey, Mark, 206
Tolkein, John Ronald Reuel, 47
Tomkins, Calvin, 50, 51
Trocchi, Alexander, 41
Tucker, Anthony, 184
Tucker, William, 74
Tunnard, John, 194
Tzara, Tristan, 37, 48, 49, 111

Uecker, Gunther, 63
Utrillo, Maurice, 81

van der Leck, Bart, 105
Van Gogh, Vincent, 80, 107, 215
Van Hoeydonck, facing, p. 165,
 188
Varèse, Edgard, 51
Van Vogt, A. E., 163, 184
Vasarely, Victor, 63, 201
Vermeer, Jan, 202
Villegle, J. de la, 58
Virgil, 153, 187
Von Guericke, Otto, 156
Vonnegut, Kurt, 163
Vostell, Wolf, facing p. 37, 58,
 between pp. 84 & 85, 120
Voyages to the Moon, 151

Wain, John, 46
Waiting for the End, 42

Waldberg, Patrick, 111
Walker, Kenneth, 57
Wall, Brian, 73, 74
Warhol, Andy, 25, 38
*Week on the Concord and Merrimack
 Rivers, A*, 43
Weichberger, Phillipe, 180, 181,
 between pp. 212 & 213
Weiner, Norbert, 95, 193
Wells, H. G., 163
Whistler, James A. McMeill,
 107
Wilde, Oscar, 88
Wilkins, John, 151, 152, 154
Willats, Steve, 201
Wilson, Colin, 78
Wilson, Frank Avray, 168, 169,
 170
Wise, Gillian, 74
Witkin, Isaac, 74
Wittgenstein, Ludwig, 190
Wofflin, Heinrich, 69
Wolfenstein, Martha, 5
Wolfram, Eddie, 192, 193,
 between pp. 212 & 213
Wols, Alfred Otto Schulze, 173
Wood, Michael, 45, 46
Wright, Frank Lloyd, 106
Wycliffe, John, 72, 216
Wunderlich, Paul, 146

Young, La Monte, 51

Zamagna, Bernard, 153, 154